Modern Pewter

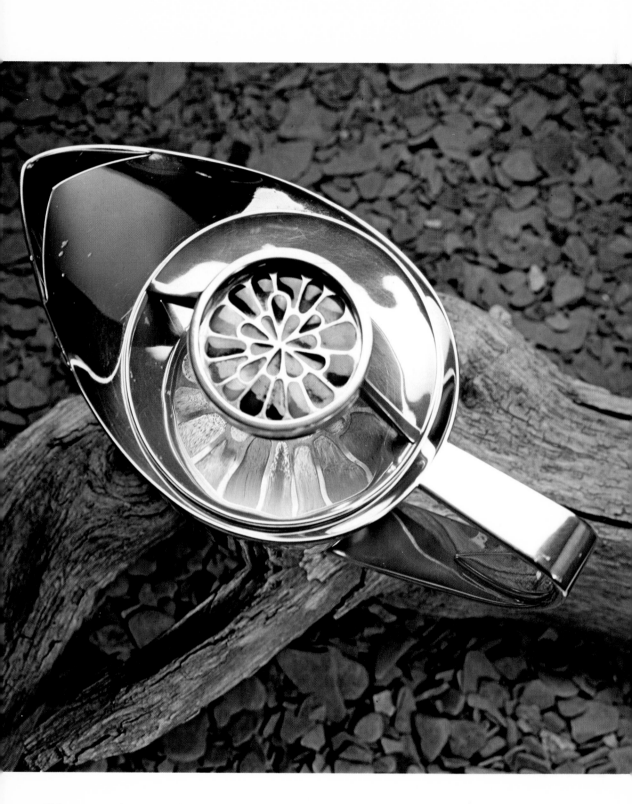

Eight-cup teapot by Frances Felten with plique-à-jour enamel by Margaret Seeler. The design, inspired by a ship's prow, allows the enamel to reflect in the concave cover (collection of Mr. and Mrs. Joseph Haun, Jr.; photo by Joseph Haun, Jr).

Modern Pewter, 1973.
Design and Techniques

Shirley Charron

 VAN NOSTRAND REINHOLD COMPANY
NEW YORK CINCINNATI TORONTO LONDON MELBOURNE

Frances, here is your book

Acknowledgments

To the pewtersmiths who generously allowed me to use photographs of their work; to my students from whom I never cease to learn; to my family, friends, and teachers who encouraged and had faith in me; to Nancy Newman, my patient editor, and her staff; to Margaret Seeler who taught me the art of enameling which I have been able to combine with pewter; to Frances Felten, master craftsman, my teacher and dear friend who posed for photographs, supplied me with necessary technical information, and was responsible for opening the world of pewter to me, I thank you.

Special thanks to Crown Publishers for allowing me to reprint material from *American Pewter* by J.B. Kerfoot (c) MCMXXIV, and for much of the historical background derived from this excellent book.

I also wish to credit the Macmillan Co. for allowing me to quote from *Pewter Design and Construction* by William Varnum (c) 1926.

All black and white drawings and photographs
are by the author unless otherwise credited.

Van Nostrand Reinhold Company Regional Offices:
New York • Cincinnati • Chicago • Millbrae • Dallas

Van Nostrand Reinhold Company International Offices:
London • Toronto • Melbourne

Copyright © 1973 by Litton Educational Publishing, Inc.
Library of Congress Catalog Card Number 72-9704
ISBN 0-442-21548-7

Published by Van Nostrand Reinhold Company
A Division of Litton Educational Publishing, Inc.
450 West 33rd Street, New York, N.Y. 10001

Published simultaneously in Canada by
Van Nostrand Reinhold Ltd.

16 15 14 13 12 11 10 9 8 7 6 5 4 3 2 1

The author and Van Nostrand Reinhold Company have taken all possible care to trace the ownership of every work of art reproduced in this book and to make full acknowledgment for its use. If any errors have accidentally occurred, they will be corrected in subsequent editions, provided notification is sent to the publisher.

Contents

Preface

The pewtersmithing craft is as old as the history of man itself. The pewtersmithing art is relatively new.

The early pewtersmith was a craftsman in the technical sense, a skilled workman. The history of early pewter leads us to believe that he employed very little creativity in the craft. Most wares were cast in brass or bronze molds, the origin of which is rather uncertain. Because the molds were expensive and hard to come by, they were used over and over again, and passed down from generation to generation, which accounts for the limited scope of early design.

There are still craftsmen today who produce only in this sense. Technical achievement being their only aspiration, they are content to reproduce early designs or copy the work of others. To make reproductions is no disgrace — as long as they are credited as such. To copy the work of others — change it a bit and call it your own — is not only a form of thievery but a degradation of the human spirit. Such workers are mice who nibble at the grains of human integrity.

There exists today a massive crafts movement that rightfully recognizes the unity of purpose in technical and aesthetic causes, thereby giving crafts its proper place of esteem among the fine arts. This movement has helped us return to the realization that the functional object is the highest form of art. The collector of modern pewter must recognize the difference between a craftsman and an artist-craftsman, and realize that an original hand-wrought work of art is worth much more than a reproduction or copy. Honest reproductions produced by technicians of integrity are nothing to be contemptuous of, but original works of pewter by recognized artist-craftsmen will eventually be more valuable than copies as they take their own place in the history of pewter.

In this book I have tried to link the present to the past because I feel that pewtersmithing, more than most crafts, is steeped deeply in a tradition that contributes greatly to its charm. On the other hand, it is time that this ancient metal was allowed to live its own life in our modern world. As much as pewtersmiths and collectors may long nostalgically for the security of the past, they must live now, in this world. Future civilizations excavating our ruins will have difficulty finding out just who we really were if we continue to copy our ancestors and bury ourselves in tradition.

Recently, someone at a crafts show looked at my shiny pewter and said, "Imagine taking an old metal like that and trying to make it look new!" My reply, which is one of the battlecries of this book, was, "Imagine taking a beautiful new metal like pewter and trying to make it look old!"

This book, intended as a course in pewtersmithing, is primarily concerned with the learning of technique and skills rather than stressing creativity to the point of watering down tech-

nical instruction. We need both creativity and technical skills, but we need the restrictions *before* the freedoms. We need to study materials and tools while realizing that creative design itself is the most important tool. There is apparently a tremendous need among modern craftsmen to produce only what is different, without regard to quality. We must not forget that true excellence is by its very nature unusual and outstanding.

Although my approach is technical, it is not intended to provide copy exercises for the unimaginative, but simply to be a vehicle for transmitting basic processes. I hope you will attempt your own designs, however modest. To copy or imitate the work shown here, much of which has been awarded prizes at the state and national level, would not only be dishonest and unfair to the craftsmen featured, but would also be a self-demoralizing waste of human energy. Creative impulses exist in all people, and are the essence of any human endeavor.

Any book on modern pewter naturally owes a great debt to one unequalled artist in pewter, Frances Felten. This book constitutes her life, her work, and her teaching approach, because I am her student.

France Felten is one of the few artist-craftsmen in the United States working consistently and solely with pewter. For the past thirty years she has derived her living fully from the production of it, and has been a fundamental force in promoting a revival of pewter for our contemporary culture. Through the promotion of modern pewter, which allows the metal to be itself, she has tried to discourage the assembly-line manufacture of dark, poorly designed "antique" reproductions. Through teaching summer courses and taking on young apprentices she has also become one of the few sources of new pewtersmiths in this country.

These young artists, many of them teachers, in turn have gone back to their studios, schools, and universities to further preach the word, that is, to instruct students in the Felten approach to con-

temporary pewter. Her love of the metal is contagious, and her converts frequently return to her year after year. All of the pewtersmiths whose work is featured in this book have at one time or another been her students or apprentices, and much of their work reflects the simplicity of line that is characteristic of her style. Her work is distinguished by the uncommon alliance of artistic taste and superior technique, not by the adoption of every trend of the moment.

"In my work, I do not try to make things that are modern or different; I merely try to make things that are not objectionable."

In this day of corny, trite, and often nonsensical social comments hidden under the guise of art, it is refreshing to see work that still speaks with refinement and elegance. The work, like the woman herself, has dignity and needs no gimmick. The integrity of her life is reflected clearly in her highly polished pewter — what better statement can a craftsman make?

Several years ago Frances Felten began collaborating with the enamelist Margaret Seeler, and several large commissions have resulted, most of them ecclesiastical in nature. One of their secular works is now part of "Objects USA," the Johnson Wax collection put together by Lee Nordness, which traveled the United States and Europe and will eventually reside in a permanent museum.

I wish to thank Frances Felten, an artist-craftsman of international repute, for graciously allowing me to utilize her pewtersmithing techniques — which represent a lifetime of experience — throughout this book. Much of the work featured here is hers, and has been awarded frequently on the state and national level. Her pewter is also included in the permanent collection of the Museum of Modern Art in New York. Without her help and cooperation this book would not have been possible.

I am grateful, too, for her introduction to designing pewter, an art at which she is a master. Thank you, Frances. I hope that this book will serve as an inspiration and guide to aspiring pewtersmiths as you have done for years.

Shirley Charron

Designing for Pewter

Pewter is best left to depend on form and line for its beauty, as most types of surface enrichment are out of place with the simple, rather robust contours this ware calls for. The softness of the material excludes delicate piercing and tracery, such as that used on silver, and also makes large flat surfaces impractical unless a very heavy gauge is used. Curved surfaces, grooves, domes, and flares can be planned for use where greater strength is needed.

The results will be more pleasing when the metal has been worked with as little disarrangement of its molecular structure as possible. This is why I prefer fiber mallets and wood stakes, except when there is some very good reason for using steel: removing dents, stretching, or strengthening by planishing.

The effects of light, shadow, and texture are just as important as those of line and form. In polishing pewter, its light-reflective quality must be considered, for the finish brings out the true character of the piece. If highly polished, its shadows will be very dark and its reflected elements and colors will be sharp and clear. With satin and brushed finishes the work appears to have a flat white tone over all. It is interesting and sometimes surprising to see how an article may be made to look larger or smaller, simpler or more dramatic, on the buffing wheel.

There are three factors present in the creation of any work of art — the ability of the artist, the demands of the medium, and the reaction of the viewer. The personality of each factor must be permitted to express itself, particularly that of the medium. When the maker learns to select elements that enhance the beauty of both object and material and to discard those that detract from it, the most utilitarian article takes on an aesthetic value. If the maker introduces a fresh direction in line or form or adds a little surprise such as an unexpected color reflection or a subtle change in contour, he gives the observer, while he discovers it, a part in the work's creation.

In my own work, I feel the greatest challenge is in designing not in three dimensions but in three tenses. A truly sound design must live above trends and survive so that it is in good taste for a long, long time to come. This pewter is a permanent material — it will long outlive me. Styles come and go — and it's a good thing they do! One of the most beautiful experiences of my childhood on the shores of the Hudson River was helping my mother in a gigantic housecleaning project. I still recall with glee wheeling a barrow full of early twentieth-century Art Nouveau creations to the boat dock and hurling them with great force into the deep channel. Every good pitch was an unadulterated joy.

The purpose of this book is not to set forth principles of design. That is a whole subject, on which many good books are available. Actually, there are no blueprints for any artistic procedure. A designer's greatest potential is the force of his own imagination. It is quite possible for rules and formulas on design to stunt individual creativity.

Let us first learn to see. Then let imagination

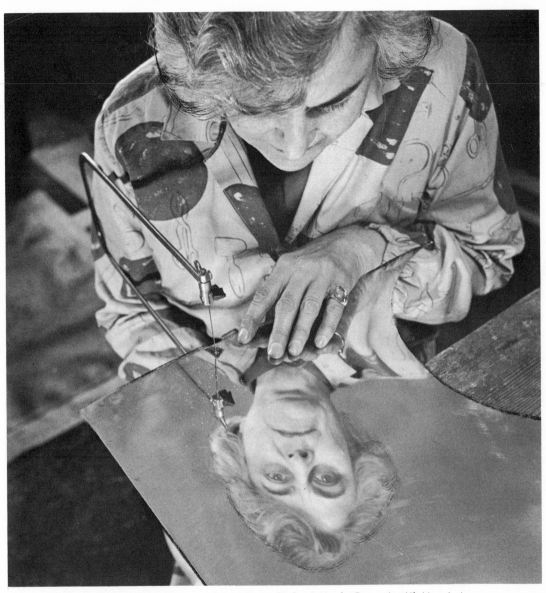

Frances Felten demonstrating pewter techniques (photo courtesy of Robert L. Nay, for Connecticut Life Magazine).

play with the things we have seen, and then — let us create. Seeing is more than just looking at things. Seeing is absorbing, like a breathing process, enjoying with other senses than sight, taking in everything made by man and nature, storing them in that great warehouse of your subconscious to someday be translated into things that are your very own. But they must be translated — not copied — particularly the works of man! Ideas are sacred things.

Design must be approached in freedom — not restricted by rules. You cannot put saddle and bridle on creativity and ride it over preconceived hurdles. Your own imagination must instinctively bring order, symmetry, and interest to your concept. I have never found a better definition of design than the quite uncomplicated one I learned in my first art classes: Design is the orderly arrangement of an idea. *Good* design is the orderly and *interesting* arrangement of an idea.

Frances Felten

9

Figs. 1-1, 1-2, 1-3. Modern reproductions of early American pewter, by Woodbury Pewterers, Inc., Woodbury, Connecticut.

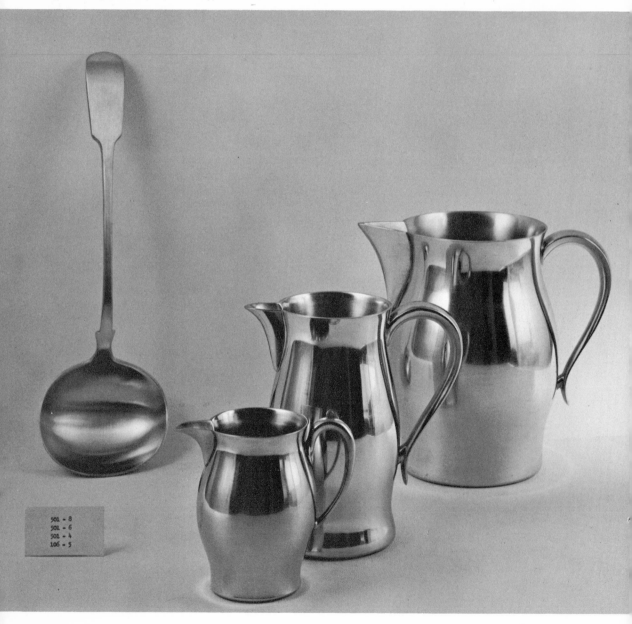

501 - 8
501 - 6
501 - 4
106 - 5

1. Revival of a Heritage

*"To begin with, there is no American pewter —
not even the latest and most negligible — that is
not rare enough to be collectible."*
— J.B. Kerfoot

It is not my intention to roam the ancient guild shops of England disturbing ghosts of pewtersmiths past; however, some background to modern pewter is necessary for a fuller appreciation of such a time-honored material. Serious students of pewtersmithing should aquaint themselves more thoroughly with its past history and glory by reading some of the histories referred to in the Bibliography.

Pewter antedates all records — it is believed to go back as far as the Bronze Age. Our first records of the craft show it was used two thousand years ago by the Greeks and Romans as well as the Chinese and Japanese. After the Dark Ages in Europe it emerged everywhere: Italy, Spain, Germany, the Netherlands, France, and especially England, the pewter center of the medieval world. Here, strong guilds were organized that laid down rigid laws and regulations governing not only the work and craftsmanship of the pewterer, but the social and moral life of craftsman and apprentice.

These guilds played an important part in the political, economic, and social life of England, and for over 500 years pewter was widely used in every English household. At the height of its popularity everything from tableware to bedpans were crafted from pewter. Clocks, shaving mugs, toys, bleeding bowls, ink-stands, nursing bottles, buttons, ecclesiastical vessels, surgical apparatus, and tavern ware were only some of the uses for it.

Most early pewter was cast in brass or bronze molds except for large plates, chargers, bowls, etc., which were hammered from flat sheets. The use of the spinning lathe was looked down upon and restricted because much poor work was produced by spinning the metal too thin to be serviceable. There existed at this time a group of English craftsmen called "triflers." The trifler was considered a poorer member of the trade, and made all sorts of little odds and ends from an alloy that contained much antimony. You see, in those days there were many formulas for the making of pewter alloy. The trifler's produce was insignificant compared to that of the "sad-ware men," who made plates and chargers, and the "hollow-ware men," who made pots and vessels for liquids. But triflers managed to earn a living because people who could not afford to buy expensive plates and coffee pots still bought little trifles such as spoons, salts, and buttons in much the same way as they do now.

The alloy we call pewter has varied through the ages, but tin has always been the primary metal. Most early pewter contained lead, which caused the metal to darken with age and gave a satin-like sheen. The lead alloy was used because it was cheaper than other tin alloys and was very malleable. During the guild era, pewter was graded according to its lead content. The very

finest contained no lead at all, but was composed of tin with copper, tin with antimony, or combinations of the two with a little bismuth added. Fine pewter contained 112 parts tin to 26 parts copper. The alloy known as "trifle" contained 83% tin and 17% antimony. The lowest grades were "ley metal" and "organ-pipe metal;" ley metal referred to tin with a lead content of 20% or more. Drinking vessels were usually made of ley metal, which was sometimes referred to as black metal — because of the tarnish.

In the 1760s in England antimony replaced lead as an alloy component in pewter, and the new material was called britannia metal. Britannia metal is almost identical with our present alloy — 91-93% tin, 6-7% antimony, and 1-2% copper — and is in no way inferior. There is some reluctance on the part of manufacturers to use the term because, within the past 200 years, much of this ware was made too thin, and proved unserviceable. The producers were to blame, not the alloy.

Fig. 1-2
Fig. 1-3

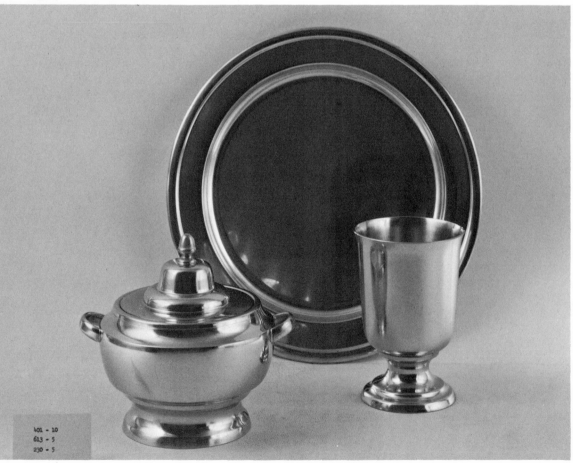

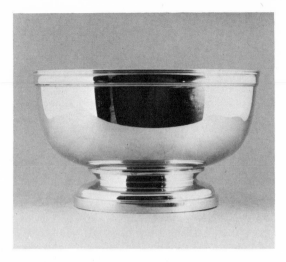

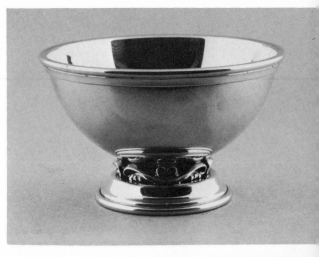

Figs. 1-4, 1-5, 1-6. Modern reproductions of early American pewter, by Williamsburg Pewter, Williamsburg, Virginia, in collaboration with Shirley Metalcraft.

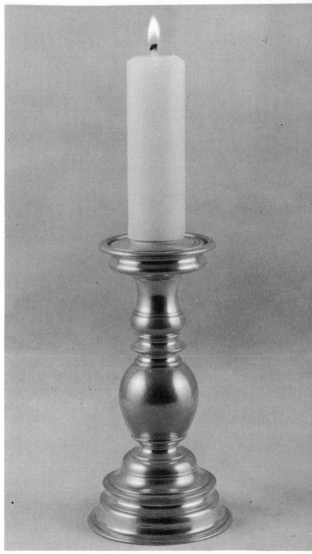

Pewter was equally important in the lives of our American colonial ancestors. The pewtersmith was a respected and, many times, an affluent man. Pewtersmithing reached its height in America during the years 1750 to 1850. Before 1750, it was still for the very wealthy, and, since most of what they had was imported from England, very little was produced here.

Much of the scant production of this era found its way back into the melting pot, and was recast into new pewter. At that time, the western world was dependent upon the British Isles for their supply of tin, and very high importation taxes were levied upon it. The American colonial pewtersmith could not compete in price with English wares unless he found a cheaper and more easily accessible source of tin. The melting pot was the answer, and people were encouraged to turn in their old pewter for new.

This earliest form of recycling is at least partially responsible for the scarcity of American antique pewter today. The scarcity can also be attributed to the fact that while the list of English pewtersmiths runs into the thousands there are only about 200 early American pewtersmiths recorded. Only one half of these are survived by specimens of their work.

By the middle of the nineteenth century the great era of pewter had ended both in England and America. What happened to make it lose favor so quickly and so completely? The industrial revolution and our resulting "throw-away" society

were chiefly responsible. As the pewter historian J. Kerfoot has put it, "It was the twilight of the gods of the hand-wrought. Before long, by those who were wakeful, the first hesitant cock-crows of our machine-made age could be heard in the night." The criteria was no longer beauty of form and material and pride in craftsmanship but how fast something could be stamped out and how cheaply it could be produced. With the advent of the automobile and railroads, man moved about so fast and so frequently that possessions became unnecessary burdens, not to be accumulated.

No longer was it important for a man to acquire lasting possessions that would be passed down with pride to his heirs. No longer was it important for a man to work with his hands and strive to create something that was as technically perfect and aesthetically pleasing as a mortal was capable of.

But this attitude did not last for long. Man is not a machine nor can he be made to function like one. His gradual dehumanization in an automated world prompted a return to values of the past and a revival of handcrafts, including pewter.

In recent years there has been private and commercial interest, both here and abroad, in the pewter craft. There is still a broad aura of mis-conception about modern pewter, but there is also evidence of a growing appreciation of the "new" shiny pewter as opposed to the old. Outstanding sales are proof of its popularity. There are not enough good pewtersmiths to supply the needs of the public. And, because of its rarity, American antique pewter has become a highly collectible item. Contemporary hand-crafted pewter is scarce enough to be highly collectible in its own day.

The metal's easy workability appeals to young and old, professional and hobbyist alike. Pewter has become more popular in schools and workshops because it is relatively inexpensive compared to the harder metals such as silver and gold, and also because it does not require long, tedious hours of raising and annealing with heavy and expensive metalworking equipment made of steel. The pewtersmith makes use of light hand tools that can be made or accumulated easily, and often old wooden chair legs, rolling pins, base-ball bats, etc. can be improvised for use.

The aesthetic significance of the new crafts movement, which has brought recognition of functional objects as art forms, perhaps plays the most important part in the revival of the pewter heritage. Through it, pewter has been reborn with a new prestige, as an art medium.

2. Modern Pewter

The bright modern pewter is a very usable metal, conducive to contemporary expression in functional objects or as an art medium. Unlike harder metals, such as copper, brass, silver, and gold, pewter requires a unique approach to forming, soldering, filing, and buffing.

Properties

Lead is now excluded from pewter by law in this country, and for this reason modern pewter does not darken with age as the old pewter did. After about 1760, various European countries began to exclude it legally, and in the United States it has been officially banned from the alloy for approximately 40 years. The absence of lead makes pewter completely safe for serving of food and beverages without danger of chemical action, as it has a high resistance to almost all weak acids. Standards for the manufacture of lead-free American pewter are set by The American Pewter Guild, which was founded in Columbus, Ohio, in 1958 by a group of pewterers, and has done much to disseminate accurate information about pewter, to develop metal standards, and to encourage the production of high-quality pewter from the technical as well as aesthetic standpoint.

The melting point varies according to the different proportions of the metals that are used, and, because pewter manufacturers are constantly striving to develop the ideal alloy, proportions have varied throughout the years. The alloy is always eutectic, which means that it melts at a lower degree of heat than any of its components — tin (449.4°F), antimony (1166.9°F), copper (1981.4°F). Pewter melts between 425°F and 440°F. (See the references table of melting points at the back of the book.)

The potential pewter admirer is sometimes disenchanted when he learns that the major component of pewter is mere tin. This lack of appreciation of the metal by most Americans is mainly a result of association with certain connotations of our language such as "tin-lizzy," "tin can," "tinny." Tin is a very pure, sanitary metal. The practice of lining cans with a thin layer of tin for consumer safety is evidence of this. It is also a valuable metal, and has many strategic uses. During WWII it became so scarce — the major tin resources of the world are Malaya, Bolivia, Indonesia, Thailand, and the Congo — that it had to be withdrawn from the consumer market.

Tin is also a brittle metal. If used alone it would crack and split under the stress of hammering. This is why it is alloyed. Antimony, a pure and hard white metal, is used in the alloy as a hardening agent. We are using more antimony in our pewter now than in the old britannia metal; therefore, although it is softer than brass, bronze, and the precious metals, our modern pewter is the hardest it has ever been. Given the proper care it will withstand the test of time and resist oxidation indefinitely. Some pieces still survive from two thousand years ago.

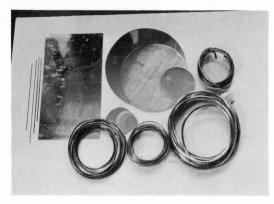

Fig. 2-1. Modern pewter is manufactured in a variety of sheet, circle, and wire sizes and thicknesses. The tubing for hinges, shown at left, is nickel silver.

cleaning process that removes with acid the oxides and scales formed under high heat. Pewter does not require chemical cleaning after soldering because it contains very little oxidizing metal, only 1½% copper.

Pewter requires a whole new technical vocabulary, but that does not mean it is a difficult craft to learn. It is simply a very different metal craft.

People seeing modern pewter for the first time often say that it looks like silver or stainless steel. The more discerning viewer, however, will notice its distinctive whiteness and surface softness that makes it look and feel quite unlike other metals. It is not a poor man's silver, nor does it try to be.

Manufacture and working processes

Modern pewter is manufactured in sheets, circles, strips, ingots for casting, and a variety of wires: round, half-round, and square. The wires come in sizes from ¹⁄₁₆ to 1½ inches in diameter. Sheet pewter is manufactured in thicknesses ranging from 30 gauge to 2 gauge, and the thicknesses most generally used range from 14 to 20 gauge. For general work, 16 and 14 gauge are most popular. Sheets are available in any size up to 24" x 48". Sizes most often used in schools and home shops are 16" x 24" and 12" x 24". Pewter discs are also available in a variety of diameters ranging from 2" to 20" and in gauges 14 to 20.

Price is determined by weight, and can fluctuate from day to day depending on market conditions. Therefore, a weight chart is necessary (see the weight chart at the back of the book), and a cost estimate is required when ordering. Most rolling companies have a minimum order requirement of 25 pounds for sheet, circles, and casting metal and 5 pounds for wires. Smaller quantities can be obtained from crafts supply houses but, of course, at a much higher cost.

There has been no significant change in the manufacture of pewter over the past 40 years. Technically, the preparation is still the same. The copper, antimony, and tin are melted in crucibles, thoroughly mixed, and poured into iron molds that form slabs of metal. These in turn are rolled gradually to the desired gauge, and cut to standard sizes.

Copper is added to the alloy for ductility, the property of metal that permits it to be drawn into wire, and for malleability, the property of metal that permits it to be beaten thin (forged) and compressed, stretched, and molded into other shapes. Addition of 1½% copper is sufficient to give pewter the necessary ductility and malleability but not enough to make it tarnish. This results in a pure, tarnish-free, white metal with properties ideal for metal working — provided it is treated gently and not rushed into shape. If it is hammered or beaten too rapidly it will split or crack. A gentle "seduction" of the metal is necessary and advised because pewter, in spite of its alloys, is not as ductile or malleable as gold or silver.

Pewter is soft enough to be worked with fiber mallets, and it does not harden or stiffen under hammering. Therefore, it does not require annealing, the process of heating and cooling that renders metals less brittle. Whereas most schools in the past hesitated to include metalsmithing in their school crafts program because of the time and expense involved in metalworking, they now find they have a metal they can afford that will produce professional results in a minimum of time.

Because it is a soft-soldered metal, it can be soldered very easily with a small flame not much bigger than a match flame. Harder metals require greater amounts of heat and higher-melting solders and fluxes. They also require pickling, a

Many traditional working techniques are still utilized in making pewter ware. However, very little casting is done today except for small appendages such as handles, knobs, paperweights, and other similar objects that are used with fabricated or spun ware. Some casting is done by commercial manufacturers of candlesticks, porringer

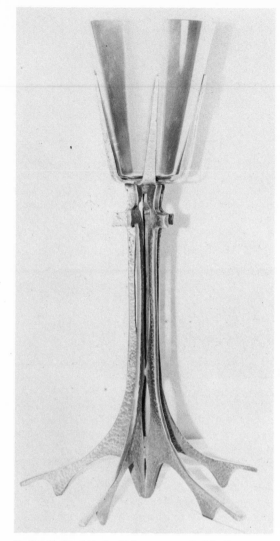

Fig. 2-2. Chalice, 14 inches high, cast pewter, by John Fix (courtesy Harkness Chapel, Connecticut College; photo by Andrew King).

handles, etc., but spinning is the most commonly used commercial method of pewter production. Spinning is the process of forcing metal over steel or wooden forms revolving on a lathe. Recently some good commercial cast pewter has been manufactured, mostly in the form of reproductions, that has the added virtue of being inexpensive enough to be accessible to the general public.

In an exciting revival of casting, a few artist-craftsmen today are employing it creatively to make one-of-a-kind pieces (figs. 2-2, 2-3). These are usually cast by the sand-cast or plaster-of-paris method solely for the purpose of achieving a

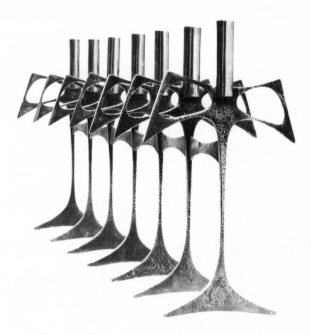

Fig. 2-3. Menorah, 27 inches long, cast pewter, by John Fix (courtesy Harkness Chapel, Connecticut College; photo by Andrew King).

17

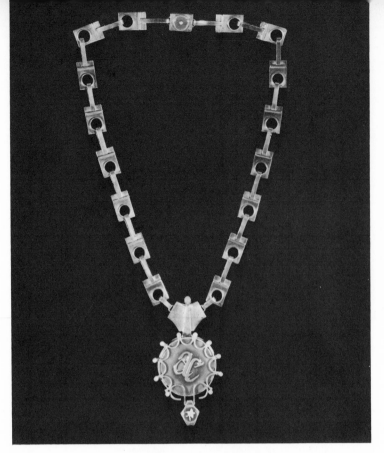

Fig. 2-4. Presidential chain, pewter, silver, enamel, by Libby Budd, design by Scott Palmer (courtesy Aurora College; photo by Arthur B. Barnes).

visually pleasing cast look and not, as in medieval casting, for multiple reproduction. The medieval pewtersmith did not approve of soldering pewter, and used this method only as a last resort. He preferred to raise his pieces in a manner similar to hard-metal raising. Pewter does not particularly lend itself to this technique because its molecular structure does not permit it to be stretched and raised in the same way as hard metals. Perhaps this is why so little raising was done in those days and most early craftsmen resorted to casting in molds. The technique of beating or hammering into molds was used for bowls, chargers, porringers, plates, etc., and is still done in much the same way.

Forming, fabricating, beating into molds, and soldering are the procedures most commonly used today, and work made by these handforming processes usually possesses more individuality and character than the quantity reproduction methods of spinning and casting. This book is concerned with handforming pewter, and will not go into the areas of casting and spinning, which are unique crafts in themselves, each worthy of a separate text.

Care and maintenance of modern pewter

Modern pewter does not tarnish and will not require polishing. It may become dusty and finger-marked after being exposed to the atmosphere for some time but can be restored to its original appearance by washing with a soft flannel cloth in warm soapy water or a chlorine-free household detergent. It should be rinsed in clear hot water and dried immediately with a clean soft cloth to avoid water-spotting. If water-spotting occurs, the stains can be removed with a mixture of whiting and water or with a good silver or pewter polish. Do not use a pewter vase as a flower container for too long, unless you wash it out from time to time. Never use a harsh abrasive or chemical dusting solution on the surface. Never put pewter in the dishwasher.

Do not put pewter directly on the stove as it has a low melting point. A pewter coffee pot must be used for serving coffee only and not for heating it. Eventually, pewter will show the marks of time — it is a soft metal — but this is what has contributed to its charm over the years. With care, it should last a lifetime.

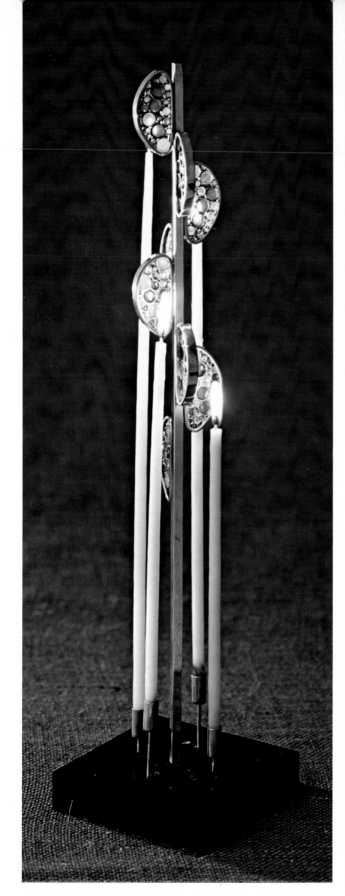

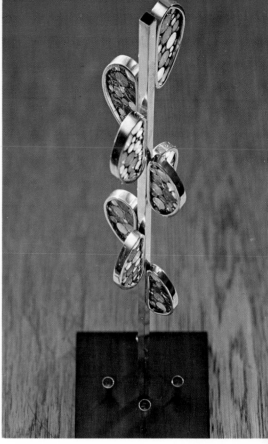

Candelabra with ebony and plique-à-jour enamel, by Shirley Charron (photos by Malcolm Varon).

Detail of candelabra.

Candlestick with ebony and cloisonné enamel, by Shirley Charron.

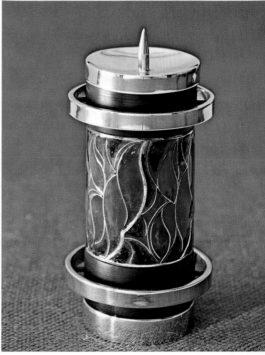

19

3. The Pewter Workshop

The earliest American pewtersmith made and sold his products in the same place. It is generally believed that the early eighteenth-century workshop in Europe or America consisted of one big room where all activity was carried on, from designing to selling, although there may have been a division separating the production from the display and sales areas. The early pewtersmith was, in other words, his own retail outlet.

Today, relatively few craftsmen have such an arrangement. Because most would rather make than sell pewter, and do not want to become involved in business complexities, they depend upon outside outlets to sell their work. Instead of the retail buyer, either mail or phone-order, crafts shops, or craft shows and organizations become the market for the pewtersmith's commodity. Since this obviates the need for a visible salesroom open to the public, most pewtersmiths maintain a studio-workshop right in their homes. Many sell from their homes, but on appointment only and only to established customers.

A home studio-workshop allows a great deal of diversity in basic physical layout. A basement, garage, attic, or other unused utility room can be converted into a pewter workshop. A functional working space can be improvised from almost any unused room or portion of the house — the craft does not necessitate a large area. I know of one pewtersmith who uses her entire house as a big live-in workshop. The kitchen stove serves as a soldering area and an unused guest room as the shipping department. Most craftsmen, who must use their houses for other social obligations, cannot afford this luxury, and must confine themselves to a more limited space.

As pewtersmithing appeals to many people of different ages, professional aspirations, technical experience, and backgrounds, no one shop can be expected to provide the ideal solution. Needs of the craftsman, nature of the room layout, and local facilities will determine the best plan for any given shop. Large, expensive equipment such as a wood lathe, a scroll saw, a band and disc sander, and a drill press are desirable for the advanced pewtersmith but not necessary for the beginning worker. Professional craftsmen will probably feel the need for a much more elaborately equipped shop. A beginner can begin to produce with a minimum of tools and improvised equipment and build upon what he has as his interest, business needs, and technical skills develop.

Of course, the actual arrangement of furniture and equipment will depend upon the specifications of the space available — location of doors, windows, gas lines, water lines, etc. Four basic areas are essential: a soldering area, a general metalcraft area, a raising area, and a buffing area. Three others are desirable: a design and layout area (this should be in another part of the house), a stock area for raw material storage, and a shipping department, which also can be in another part of the house.

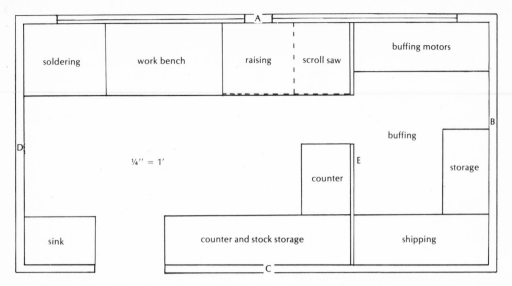

Fig. 3-1. Pewter workshop. The total area is 10 x 20 feet, laid out to follow the pewterer's working procedure.

Figure 3-1 represents a compact plan for a professional workshop. It contains all of the necessary features, and attempts to utilize the space in a way conducive to the natural progress of work encountered in the craft. A compact, well-organized shop will save you much time and many steps in getting tools. Wall *A* is the window wall, the one upon which most of the working operations will take place. This makes for pleasant working conditions, particularly if the view is pleasant, and affords an opportunity for adequate ventilation.

The soldering area (fig. 3-2) is in a corner close to the *D* wall, which has access to gas lines. Bottled gas or city, kitchen-stove variety, can be piped into your soldering area (fig. 3-3) and a gas-air torch used instead of a Bernz-o-matic torch, which uses disposable cylinders of propane gas. A gas-air torch is ideal for soldering pewter as it can be controlled with the finest precision, and empty cylinders never have to be replaced. The cost of operating a torch on your gas-fuel bill is nominal. It is not necessary to build an asbestos shield around the soldering area as the amount of heat required to solder pewter does not necessitate it. The bench top in this area can be

Fig. 3-2. Soldering area on *A* wall. Here a Bernz-o-matic torch system is used for heat.

Fig. 3-3. A gas-air torch may be used instead.

Fig. 3-4. Workbench area. The workbench is heavy hardwood.

Fig. 3-5. Workbench area. Stake table with vise and blowhorn stake covered with paper.

lined with hard sheet asbestos for safety purposes but this, too, is not necessary. Storage is below the bench.

The workbench area (fig. 3-4) should be a separate unit from the soldering area as the workbench requires sturdier construction. Its top should be constructed of heavy 2″ or 3″ hardwood. The storage area below the workbench is for stakes, sandbags, and similar equipment. A machinist's vice can be attached to the bench for holding stakes, or a stake-holder can be used. A v-board sawing space is also provided. A single large blowhorn stake (fig. 3-5) will eliminate the need for purchasing a variety of others. When working pewter, the stake should be covered with paper to prevent marring the metal.

The raising area shown (fig. 3-6) is simply a place where the craftsman, depending upon his preference, could have a raising table (or a tree stump and stool) for mold work. A scroll-saw area (fig. 3-7, right) is also convenient as this is a most useful tool and will save much time in production work.

The buffing area should be separated by a wall from the rest of the shop due to the large amount of dust dispersed in the process. This area will be the dirtiest part of your shop, and the partition will keep the rest of your tools and equipment free of tripoli dust. Also, a ventilating or exhaust duct to carry away dust is desirable in this area. Room may be provided for two buffing motors, one for hard buffing and blending (fig. 3-8) and one for a lampblack motor (fig. 3-9). Storage is underneath.

Fig. 3-6. Raising area with mallets, molds, sandbags, and a starting block. The two small molds were turned on a lathe; the large mold is waste stock from a salad-bowl maker. The starting block at top right is hand carved.

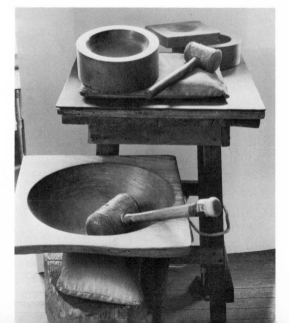

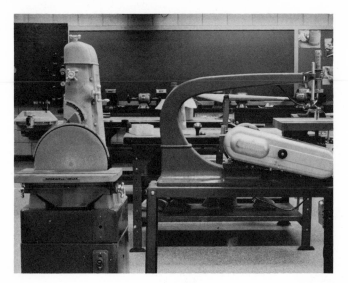

Fig. 3-7. Scroll saw (right) and band and disc sander (left) can share same area.

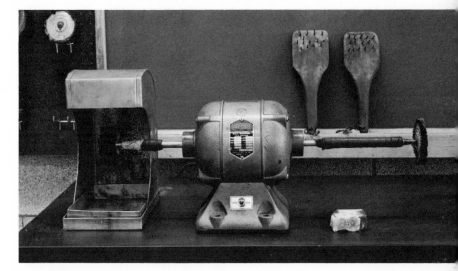

Fig. 3-8. Buffing area. A two-speed motor can be used for cutting and blending.

Fig. 3-9. Buffing area. The ideal setup is a buffing head with a 3-step pulley. With this system a 1/3 horsepower, 1750 RPM motor can also be used for 3400-3500 RPM and 900 RPM.

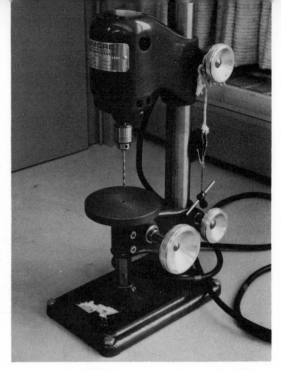

Fig. 3-10. Buffing area. A peg board on the *B* wall is practical for keeping buffs at hand.

Fig. 3-11. Counter area on the *E* wall provides space for a drill press.

Wall *B* has a peg board for hanging buffs, gloves, etc. (fig. 3-10). In this way, they are always at hand and easily distinguished from one another. They should be hung in separate areas on the peg board, according to buffing stages: hard, blend, lampblack. Storage is provided here in the form of tall shelving. Remember that all storage in this room must be enclosed to keep it free of dust.

Wall *C* shows the shipping area, which easily can be in the buffing room for it naturally follows that procedure. As the pieces are finished and buffed, they are packed up and sent out. Shipping supplies such as tissue paper, string, labels, and tape can be kept under this counter area. On the other side of the buffing-room wall, a small counter area *E* is left open for a bench drill press (fig. 3-11), bench sander, flexible-shaft machine, or any miscellaneous tools. The *C* wall also houses storage cabinets and shelves for raw material. Sheet and disc stock can be kept on shelves below the working counter while pewter wires can be hung on the wall above it. A sink, to the left of the door in the *C* wall, need not be large or acid proof, as long as it functions to wash pewter after soldering – and your hands whenever they need it.

About 5' of wall space is provided on *D* wall for hanging tools — a peg board can be used here, too — and need not be enclosed. A few shelves can also be placed here, if convenient.

This plan does not allow space for a wood lathe (fig. 3-12), which need not be in the shop because it is not used continuously. Its function in pewtersmithing is primarily to make molds and stakes. The variety of hardwood molds (fig. 3-13) and stakes a pewtersmith needs cannot be purchased commercially but must be turned to order on a lathe. You can pay a woodturner to do them for you at first, but eventually it will save time and money to invest in a wood lathe and learn the wood-turning art. It is not difficult, and it is perhaps the most useful auxiliary skill a pewtersmith can acquire. In addition to molds and stakes, a wood lathe can also be useful in creating appendages used in pewter-wood combinations such as turned handles, covers, and tray bottoms. The possibilities are endless.

The band and disc sander (fig. 3-7, left), if it is large, can also be put somewhere outside the shop. The design and layout area can be anywhere in the house although it is better to locate it in cleaner quarters than the shop. Double fluorescent lights running the length of the work area will probably be suitable — a lighting expert can best determine your specific electrical needs. While much of the equipment described here is not essential for beginning work, it should be installed as funds permit and the business grows if serious and advanced pewtersmithing is to be undertaken.

24

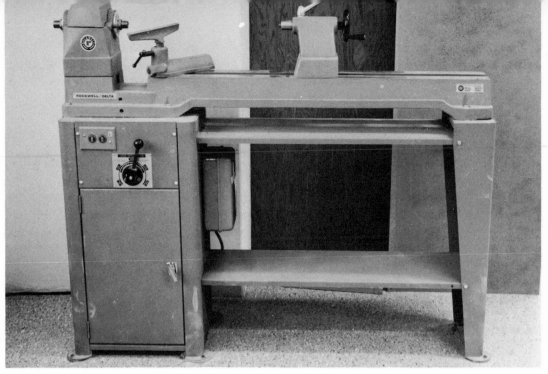

Fig. 3-12. A wood lathe does not need to be in the shop area, as it is not continually in use.

Fig. 3-13. Room should be found somewhere, perhaps along the *D* wall, for a collection of molds and stakes.

4. Tools and Supplies

Tools for Basic Procedures

Before you can learn to work with pewter, you need to become familiar with the tools of pewtersmithing. Basic procedures require tools for laying out a design and for measuring, cutting, and filing pieces. Shaping is done with hardwood stakes and molds, tapers, and fiber mallets. A number of miscellaneous tools such as bending jigs, bench hooks, and scoring instruments are also utilized. The methods of soldering and finishing pewter are unique to the craft; therefore special supplies and equipment are needed.

This chapter is devoted to introducing the basic and special tools. The following chapters will discuss procedures more thoroughly.

Layout and measuring tools. The tools shown in Figure 4-1 are used in drafting a design, in laying out a pattern, and in measuring and marking the pewter during various procedures.
1, 2. Dividers with extension leg and small dividers — for measuring and marking on metal
3. "All" pencils — greaseless pencils for marking metal
4. Drawing instruments — for layout work
5. Scriber — for scratching designs onto metal when marking the metal for sawing
6, 7. 45° triangle, 30/60° triangle — for layouts
8. Tape-beam compass — for laying out cone developments, where an extra-large compass is needed
9. Marking gauge — for measuring and marking metal at the same time (see the description of bending metal in Chapter 10)

10. Surface gauge — for leveling the top of a cylindrical or conical object (see Chapter 9, page 74)
11. 6″ steel rule — for measuring
12. Depth gauge — for measuring depth inside of objects
13. Trammel points — for converting a yardstick or long piece of wood into a large compass; used in cone developments
14. 12″ steel rule — for measuring
15. Protractor — for measuring angles or dividing circles
16. Centering head — used with combination square to find center of circle or disc (see the description of special tools, p. 36, for use of centering head with combination square)
17. Combination square — for trueing work to 90° and 45° angles

Cutting tools. The tools shown in Figure 4-2 are used for cutting pewter.
1, 2. Aviation shears and 11″ straight metal shears — for trimming away scrap metal after soldering
3. Sheet saw — (see the description of special tools, p. 35)
4. Small hand drill — for holding twist drill bits when drilling holes by hand
5. 8″ and 6″ depth jeweler's saw frames (see description of special tools, p. 37)
6. V-board and C-clamp — the block is for supporting metal while sawing, and is fastened to the bench with C-clamp
7. Jeweler's back saw — for cutting through hollow objects or hard-to-reach areas.

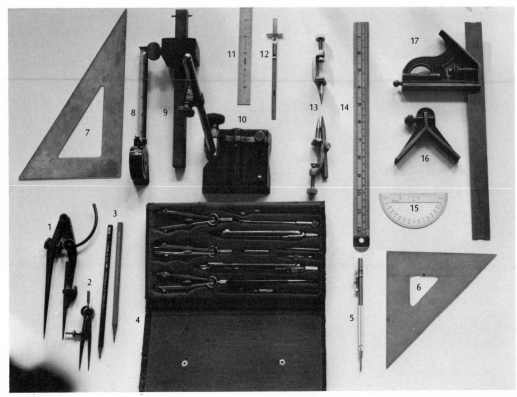

Fig. 4-1. Layout and measuring tools.

Fig. 4-2. Cutting tools.

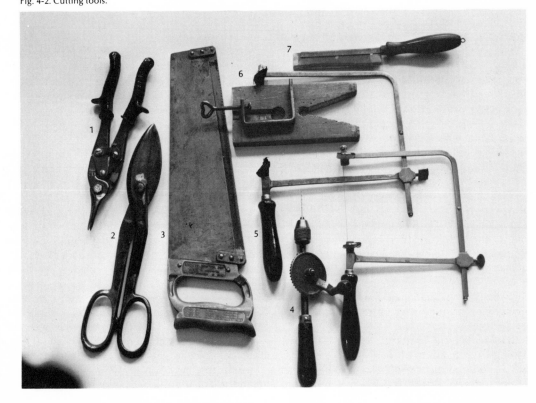

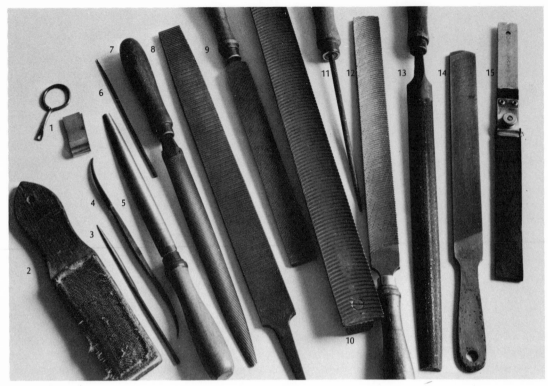

Fig. 4-3. Filing tools.

Files. The files and accessories shown in Figure 4-3 are those most commonly used in pewter-smithing.

1. Copper file cleaners — if scraped along cutting edge of file parallel with the cut, this harder metal easily picks the softer pewter from the file's teeth

2. File card — for brushing metal from files

3. Half-round needle file — for filing small areas

4. Half-round riffle file — for spot filing where the surrounding surface must not be scratched

5. 6″ single-cut file for soft metals, called a "cadillac" — for general filing in pewter work. Removes large amount of metal with smooth cut

6. Rat-tail needle file — for filing small areas, where a round file is needed

7. 8″ half-round, single-cut file for soft metals ("cadillac") — for larger areas than the 6″ "cadillac"

8. 10″ flat lead-float, single-cut file — non-clogging file for removing large quantities of stock

9. 8″ flat, double-cut "bastard" — coarse file for removing large quantity of stock

10. Curve-toothed file, called "vixen" — for long edges or surfaces where much stock must be removed smoothly

11. Coarse rat-tail file — round file for removing quantities of stock in rounded areas

12. Flat, shear-tooth file — for removing large quantity of stock. Action is similar to flat "bastard" but leaves smoother cut

13. Half-round "bastard" file — for use on either flat or curved surfaces

14. All-purpose file — this Nicholson's Handy File is smooth on one side, rough on the other

15. Emery file — flexible holder for attaching aloxite (abrasive) cloth strips

A file must be selected for a specific purpose, and should be cleaned often for efficient work as the impactions of metal interfere with smooth cutting. In using a file, note that the teeth act in a way similar to a series of knife blades. They cut only on the forward stroke, and should not be dragged backward with any pressure as the backward stroke removes no material, dulls the blade of the file, and roughens the surface of the work. Files used for pewter should not be used for silver or gold as any particles of a soft metal adhering to a precious metal may cause pitting when the precious metal is soldered or annealed.

Miscellaneous hardwood forming stakes, tapers, and molds. The art of pewtersmithing requires a variety of miscellaneous hardwood forming stakes and tapers such as those shown in Figure 4-4. It is best not to form pewter over steel stakes and anvils because they leave marks that are difficult if not impossible to remove. If a steel stake is necessary (for example, the blowhorn stake in fig. 3-5) it is advisable to cover it first with paper. It is impossible to list the exact stakes needed for pewtersmithing because each problem determines the dimensions and shape of the stake needed, but those in Figure 4-4 would probably cover almost any phase of the craft.

You can begin with forms as simple as old chair legs, rolling pins, wooden washing-machine ringers, or found forms. Sophisticated and expensive steel stakes are not necessary. A groove that is cut into a block of wood easily replaces the fluting stake. A round-domed bannister becomes a shrinking stake (see fig. 4-4). Do not attempt to collect these all at once, but simply acquire them as the need arises for the particular piece of pewter you are making. Eventually you will find that the stakes you have seem to cover any work situation you come across.

These wooden forms cannot be bought commercially at the present time, but must be made to order by a woodturner. Maple and birch are the best hardwoods to use for turning stock because they have a grain that finishes smoothly enough for the pewtersmith's purpose. The professional pewtersmith should eventually acquaint himself with the woodturning art in order to make his own stakes as well as bowl and plate molds (fig. 3-6). The needs here are more simple. A starting block and three or four large molds of different sizes in the form of waste stock from salad bowls are all that is necessary to produce a variety of sizes and kinds of bowls (see Chapter 6).

Fig. 4-4. Miscellaneous hardwood stakes and tapers. All have multiple uses.

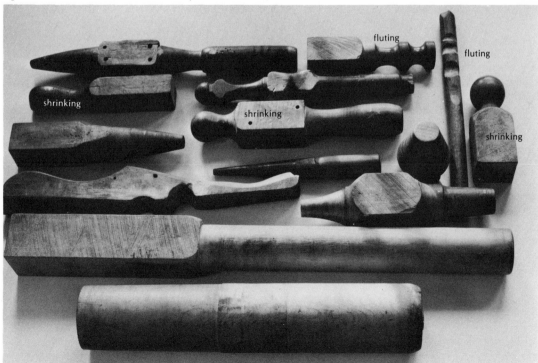

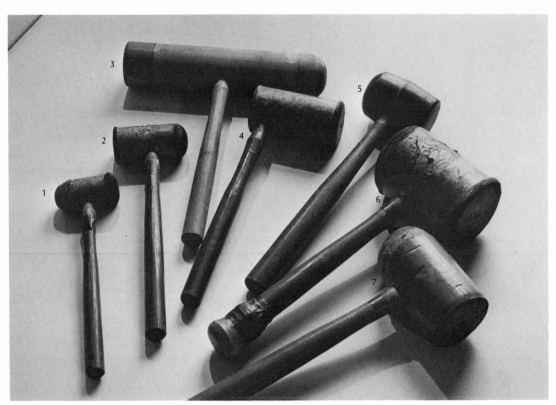

Fig. 4-5. Mallets.

Mallets. The mallets shown in Figure 4-5 are used for shaping the relatively soft pewter without causing dents and scratches.

1. Wedge and round-ended, 1¼″ diameter fiber mallet — for bowls and fluting spouts
2. Flat and round-ended 1½″ fiber mallet — for convex and concave shapes. The round end is for inside of bowls, etc., the flat end for forming pewter over convex stakes or forms
3. Extended-length fiber mallet — for inside of deep pieces
4. 2″ offset fiber mallet — for inside of deep pieces
5. Rubber mallet — for places where it is important to have a perfectly smooth area
6. 3″ diameter flat fiber mallet — for larger pieces
7. 2½″ diameter flat fiber mallet — for larger pieces

It is essential that the proper kind of mallet be used in pewtersmithing. The one that seems to produce the best results for general work is a fiber mallet. This is actually tightly rolled paper, and is not to be confused with the rawhide mallet. The rawhide mallet is too hard, has no give, and would only mutilate the pewter. The fiber mallet, which is perfect for pewter work, comes in a variety of sizes but only with flat ends. The ends must be made to conform to your needs by hand filing or shaping on a sanding machine. The rounded end of the mallet should be shaped so that it approximates a semi-sphere (fig. 4-6). The wedge-shaped mallet can be shaped in different degrees of sharpness depending upon your needs. A horizontal wedge is the one you will need most often (4-7a); however, a vertical wedge (4-7b) will come in handy on occasion as it allows you to pound the inside of a cone or cylinder. Both can be shaped on the same mallet if desired (4-7c).

The extended length mallet and the offset mallet (fig. 4-5) are used very seldom, and they are not really necessary for beginning work. They are custom-made and obviously are intended for use inside of deep pieces. The rubber mallet can be used in places where it is important to have a perfectly smooth area, such as the concave surface on the bottom of a pitcher or tankard.

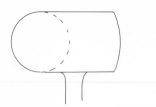

Fig. 4-6. The rounded end of a fiber mallet should be shaped to approximate half a circle; this diagram shows a cross section.

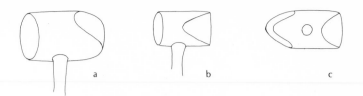

Fig. 4-7. Wedge-shaped mallets sharpened to varying degrees: horizontal wedge (a), vertical wedge (b), and both on the same mallet (c).

Miscellaneous tools. The tools shown in Figure 4-8 are used as aids in the basic procedures.

1. 12″ steel straight-edge, taped on one side — used as a guide for scoring metal for bending. Tape prevents slipping
2. Wooden bending jig — for bending boxes or other straight-line fabricated work
3. Wooden vise-jaw protectors (used in pairs) — for protecting pewter from the metal jaws of the vise
4. Bench hook — for clipping onto bench to make filing easier
5. Small bench hook — for clipping onto bench when filing small things
6. 6″ steel straight-edge, taped on one side — used as a guide for scoring metal for bending. Tape prevents slipping
7. Curved burnisher — for smoothing imperfections in metal in hard-to-get-at places

8. Commercial scoring tool — for scoring metal for bending
9. Tube grip — for holding hollow tubing or wire to be cut. Adjustable stop regulates length of tubing to be cut, and slot for saw blades ensures true cuts
10, 11. Jackknife — for deburring rough edges on metal, scraping away solder, or stripping solder before soldering
12. Straight burnisher — for smoothing imperfections in metal
13. Custom-made scoring tool — for scoring metal for bending
14. Hoe scraper — for scraping away excess solder in hard-to-reach places such as the inside of a cone or cylinder
15. Large flat burnisher — for smoothing large areas in metal
16, 17. Hollow scraper — for removing excess solder or deburring edges

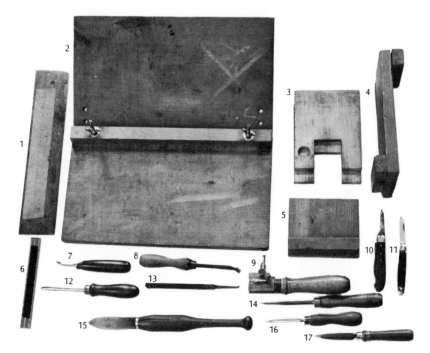

Fig. 4-8. Miscellaneous tools for basic procedures.

a

7½″

14″

inset

b

¾″

7½″

Fig. 4-10. Sample pattern for wooden vise-jaw protectors. Measure your own vise to determine the proper dimensions.

c

Fig. 4-9. Bending jig, average size.

4″

¾″

1¼″

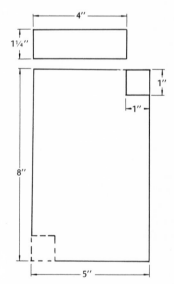

4″

1¼″

1″

1″

8″

5″

Fig. 4-11. Bench hook, average size.

Handmade miscellaneous tools. The following miscellaneous tools are handmade, and cannot be purchased commercially.

Bending jig (fig. 4-9). These can be made in any size you desire. This typical size accommodates itself to most situations (fig. 4-9a). Carriage bolts with wing nuts and washers are used. The head of the bolt is inset into the wood so that the board will lie flush on the bench (fig. 4-9b). The hinges are set in the wood at ends of boards so that the boards, when lying flat, are in tight and complete juxtaposition (fig. 4-9c).

Wooden vise-jaw protectors (fig. 4-10). Wooden vise-jaw protectors should be used in the machinist's vise when filing pewter. The pattern is just a sample because the shape will vary according to your particular vise. Measure it to determine correct size.

Bench hooks (fig. 4-11). Bench hooks are useful for filing metal or whenever you want a steady surface to brace the work against so it will not move. The dimensions for the average-size bench hook are given but a smaller one would also be useful in working on very small work. It is important to leave a cut-out area of 1'' on both sides, as shown in the illustration. This is necessary to allow the file (or saw) to follow through.

Scoring tool (fig. 4-12). A much better scoring tool than any that can be obtained commercially can be made by hand from a good, old file. Good-quality files are made of very fine steel — very tough, and durable — and make very good tools. The tang end is heated to red heat in a gas or blow-torch flame and, while it is soft, the file is placed in a vise. With a steel hammer the tip end of the tang is bent over about ⅜''. With a file this hook is shaped into a sharp point that is later ground extremely sharp. The tool should be curved so that it has a clearance that permits it to travel freely through the metal. The file, when pointed properly, should be just a little less than a 90° angle. The file is again heated to red heat and quenched immediately either in water or oil. This restores the temper and makes a good hard cutting tool. *Caution:* be careful not to overheat the file in tempering as this could cause it to crack. The color of the flame should be cherry red, not white.

Fig. 4-12. Handmade scoring tool.

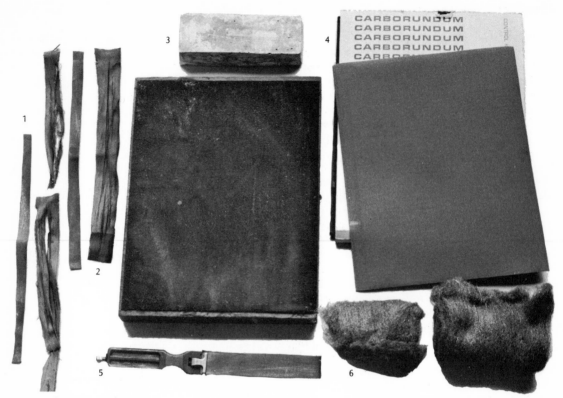

Fig. 4-13. Abrasive materials.

Abrasives. The abrasive materials shown in Figure 4-13 are used throughout the pewter-making process, but utmost discretion is advised in their use. Abrasive cloth should be used for smoothing edges only and never used on surfaces. Pewter has a long memory, and scratches put into its surface with abrasive cloth are difficult if not impossible to remove. Tripoli compound has been included in this group, even though it is used in the finishing process, as it is an abrasive used for cutting away metal below the level of scratches on the work. Tripoli is the *only* abrasive that should be used on the surface of the work.
1. Strips of worn abrasive cloth (aloxite) — for smoothing the inside of pierced work or other hard-to-get-at places
2. Emery board — a flat sanding area for leveling bottoms of cones, cylinders, etc. A coarse emery paper is used
3. Tripoli compound — an abrasive cutting and polishing compound for the polishing process
4. Carborundum aloxite — an aluminum-oxide cloth for smoothing edges only — never on surfaces!
5. Abrasive paper file — a flexible tool useful for

filing the outside seam of a cylinder or cone. Use only with aloxite
6. Greaseless steel wool — for cleaning metal before soldering. (Be sure to buy a brand that is greaseless or it could deter the flow of solder. Greaseless steel wool usually can be obtained in paint stores.)

Aloxite is a most useful abrasive. It is an aluminum-oxide cloth or paper that does not shed particles as emery paper does. One grain of emery, if embedded in a fiber mallet, could ruin a whole piece. The grades of carborundum aloxite most generally used are #400 fine, #320 medium fine (for general use), #240 medium, #180 coarse. Important: aloxite is gritless and therefore better than emery paper on pewter. Strips of worn aloxite are tacked to the work bench or held in a vise, and the work is run over it as the strips are held taut. When using an emery paper file, replacement sheets should be made from sheets of aloxite. Regular, coarse emery cloth may be used on the bottom edges of the work with a piece of emery paper or cloth rubber-cemented to a board or a bench hook.

Tools for Special Procedures

Although these special tools are not used all the time, they are often indispensable when the need for them arises. Tools described in the following section are for centering, trueing, sawing, and buffing pieces that cannot be handled in the usual way.

The sheet saw. The sheet saw (fig. 4-14 and fig. 4-2:3) is a hacksaw blade backed up with a thin piece of steel like an ordinary wood saw, and is used in the same way as a hand wood saw. The sheet saw is used for cutting long straight cuts in pewter or for cutting into the center of an entire sheet when it cannot be reached in any other way.

The cut is started on the waste side of the line, and drawn back over the material about three times before the forward push with the saw is begun. Pressure is gently applied to the cutting stroke (forward or downstroke) of the saw. The body of the saw that follows the hacksaw blade must engage with the saw cut. The drawing back of the saw should be an idling stroke in which there is no pressure. Sawing continues along the waste side of the line until the end of the cut. At this time you must be careful to support the piece being cut or it will bend the material at the end of the cut before it falls off.

This is not a saw for cutting curves. If a scroll saw is available it can replace the sheet saw for cutting straight lines or more intricate patterns.

Fig. 4-14. Tools for special procedures. The sheet saw is used like an ordinary wood saw.

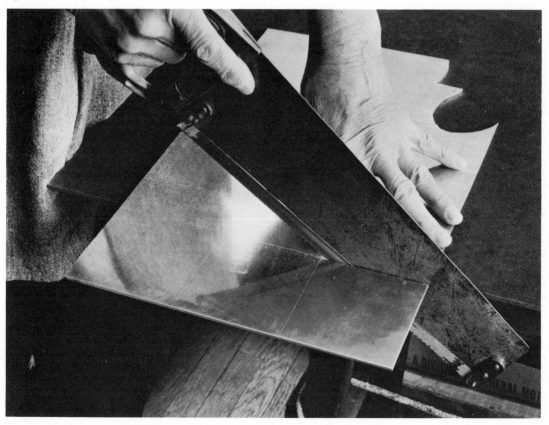

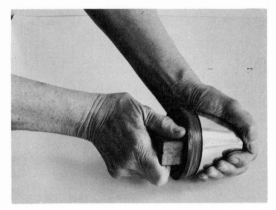

Fig. 4-15. Tools for special procedures. The tapered wooden block is moved from left to right with great force.

away after the piece is made. Next, turn the scale at any angle to the line you have just made, and make another line in the same way. Again, make sure that the legs of the centering head do not wander away from the edge of the circle. Where these lines cross is the exact center of the circle.

Fig. 4-16. The small end of the taper should not touch the inside of the conical shape.

The taper. The upper and lower ends of cylindrical and conical objects may be trued and made perfectly round by the use of a wooden taper (fig. 4-15) that fits inside of them. If made properly, the taper will go inside of any cylinder without marring the inside of the work (fig. 4-16). The small end of the taper should not touch the inside of the conical shape.

The tapered wooden block is moved from left to right and in a circular motion, with plenty of force. In going into the small end, be very careful not to distort the outside edge of the piece, that is, not to flare it (fig. 4-17). If a flare is desirable on a piece, however, the taper can be used in this way to advantage.

Fig. 4-17. A flare can easily result from the use of the taper.

The combination square. The combination square (figs. 4-18 and 4-1:17) is one of the pewterer's most useful and indispensable tools because it can be used to find the center of a disc or circle. A centering head (fig. 4-1:16) for this purpose fits onto the square with its legs at right angles. The legs are the same length so that when they are pressed against the side of a circle and held there the ruler itself will go right across the center of the circle. (It is important not to let the legs move or tip at this step.) A line is then drawn across the center of the circle with the fine point of a pencil, tipped in against the side of the scale so that the line will be fairly accurate, or a scriber, which is of course more accurate than a pencil because the line is drawn directly against the edge of the ruler. If a scriber is used, be very careful not to apply so much pressure that the lines cannot be buffed

Fig. 4-18. Tools for special procedures. The combination square is used to find the center of a disc.

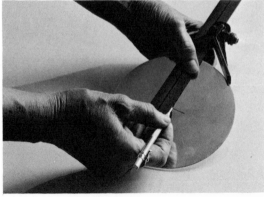

36

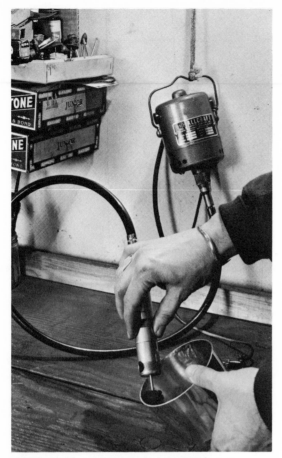

Fig. 4-19. Tools for special procedures. The flexible-shaft machine is used for buffing hard-to-reach places.

The flexible-shaft machine. The flexible-shaft machine (fig. 4-19) is used for buffing surfaces that are inaccessible to the larger buffing machine. It is not practical for large work because it tends to gouge small furrows in the metal if used with a great deal of pressure. Consequently, it takes too long to buff a large piece, but for small areas in hard-to-reach places it is an indispensable machine.

The jewelers' saw. I assume that most people have had some experience in using the jewelers' saw on smaller work before they attempt metalsmithing in hollow-ware; therefore, this section will explain only the specific use of the jewelers' saw pertaining to pewter. If you are unfamiliar with the tool, refer to the jewelry books in the Bibliography. I particularly recommend Lois Franke's *Hand-wrought Jewelry* for this information.

In selecting a jewelers'-saw frame (see fig. 4-2:5) for pewter work there are several things to consider. First of all, the jewelers' saw is really a delicate precision instrument, and the frame must be straight so that the two ends line up. Otherwise the saw will not run straight and true. A frame with a 6'' depth is best for pewter work. An 8'' depth might be useful at times, but it is harder to saw with for general work. Anything deeper is very awkward to use and has poor tension. The shallow, 2'' frames are of no particular use to pewterers. Be sure that you buy a frame that has an adjustment at the back. Spring frames without adjustments are made but these can be dangerous. The tension adjustment is difficult, which could result in your breaking the saw blade and being hit by one of the flying pieces.

The selection of blades for pewter work is governed by the thickness of the metal you are going to saw. Use heavier blades for thick metal, finer blades for thin metal. Two teeth should always be in contact with the edge of the material being cut. For intricate pierced work, a 3/0 to 4/0 blade is recommended. Fine blades are excellent for general work as long as you do not apply too much pressure when cutting. To tell if you are using too much pressure, loosen the blade (at the bottom connection) and see if it hangs straight. If you have been applying too much pressure, it will show a pronounced crescent curving toward the back.

V-boards (fig. 4-2:6) for pewter should be a bit larger than the ones used for jewelry, and you can very easily make them yourself. The V-board should have a straight groove cut into it close to the edge for cutting tubing. If you keep your saw blade in this groove while cutting tubing or wire, you will be sure of having cut it at right angles.

There are two ways to use a jewelers' saw in pewtersmithing. In most cases, the blade is inserted in the saw with the teeth pointing down — the blade only cuts on the downstroke. No pressure is exerted on the back or upstroke. In pewter work there might be times when you would like to use the saw with the blade pointing up rather than down, and move it like a hacksaw or sheet saw. For example, you might need to hold the work in a vise while you saw.

In pierced work such as porringers, saw just inside your line on the waste side but try to meet the line. If the sawing is done well on work such as this, it is traditionally considered rather pleasing to show some of the marks of the tool. A fine blade is used to make a very smooth cut, and if you want a more refined finish, run the work over abrasive paper strips (aloxite).

5. The Working Drawing

Inasmuch as many of the articles you will make are based on a cone or cylinder, it is extremely important to have a good understanding of the basic procedures used in developing drawings and laying out patterns from these shapes. Don't let this frighten you! You need not be a mathematical genius in order to become a pewtersmith. There are a few very simple formulas that you will need to understand, and once you are able to apply them, you're on your way.

Before you can lay out a pattern for a cylinder or cone, you must first determine the dimensions of your piece. You need to know the height, the width at the large diamter, and the width at the small diameter. Make an actual scale elevation drawing of the piece listing these dimensions (fig. 5-1).

Cylinder development

If the piece is a cylinder, making a pattern is a simple thing (fig. 5-2). You need only know the height (b) and the diameter of the circle (a). The diameter is multiplied by 3.1416 (or, if great accuracy is not demanded, simply by 3) in order to give your rectangular pattern enough width (c) to bend it around into a circle of the correct diameter by bringing side b around to meet side d. To make a pattern for this cylinder simply cut a piece of oaktag or metal that is 3″ high and 6″ (or 6.28″) wide.

Cone development

The cone is a different proposition. For one thing, the cone tapers and for another, you will be making a pattern for a truncated cone — a cone that has been cut off somewhere along its height at a plane parallel to its base. This conical development is the most necessary pattern in all your work because so many pieces are based on the cone.

Before you begin you will need the following items: a roll of 36″-wide white or brown wrapping paper, yardstick, triangles, compass, sharp pencils, trammel points or beam compass, and dimensions of your proposed object. The large roll of paper is necessary because in making a development for a large piece with a slow taper (one in which the small diameter is almost as large as the large diameter) it is sometimes necessary to extend the lines that represent the sides of the cone a great distance before they reach the point of intersection on the central axis — sometimes as much as 6′. In this case some kind of beam compass is also needed, which can be purchased or improvised by attaching trammel points to the ends of a yardstick or long rod of some kind. Trammel points can be purchased at hardware stores, and are fairly inexpensive.

A tape-beam compass can also be useful at this point. It is a regular steel tape measure that unrolls and has a hole in the end of it into which you can affix a pencil point. It's a very useful instrument, and quite accurate for laying out long arcs. A thumb tack holds down the tape casing, and it can be locked at any distance up to 6′. Two people are usually necessary — one to hold the tape casing in place and one to swing the arc. Tack or tape your paper down to a table or the floor so that it is stretched tightly. If not, it will wrinkle or buckle, producing an inaccurate pattern. An inaccurate pattern is worse than no pattern at all.

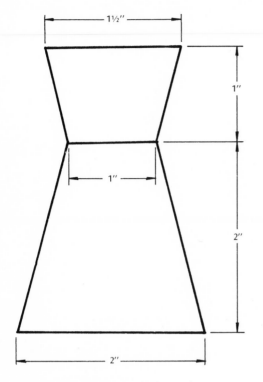

Fig. 5-1. Scale elevation drawing for a pitcher.

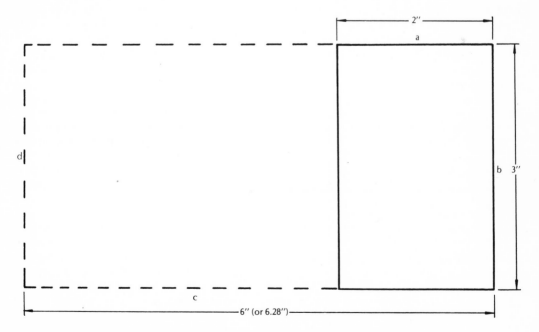

Fig. 5-2. Pattern for a cylindrical piece. The width is extended by a factor representing the circumference of a circle (diagram slightly reduced).

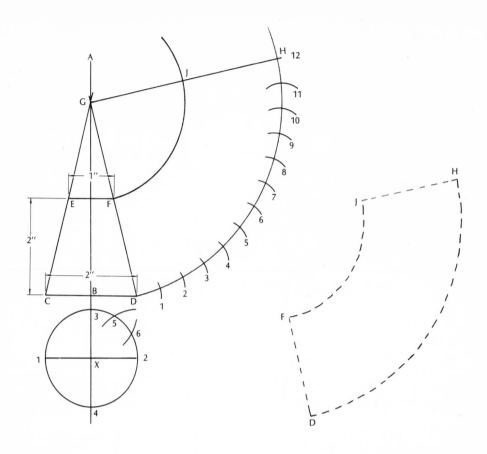

Fig. 5-3. The conical development is more complicated than the cylinder development.

Figure 5-3 shows how to make a pattern that will produce a truncated cone of given dimensions, determined by the elevation drawing.

1. Determine size of piece: height, large diameter, small diameter.

2. Draw horizontal line CD. This represents the large diameter of cone EFCD.

3. From center of line CD erect a perpendicular which extends indefinitely.

4. On this perpendicular line AB measure off height of cone as determined by elevation drawing.

5. At this point, draw a horizontal line EF parallel to base diameter CD. This represents small diameter of cone. Line AB is central axis of this cone.

6. Draw two lines connecting D and F and E and C which intersect line AB at some point. This point becomes G.

7. Using point G as a center and GF as a radius, draw an indefinite arc.

8. From point G with radius GD, draw another indefinite arc.

9. With a radius equal to BD, draw a circle with its central point somewhere on line AB.

10. This circle is divided into 4 equal parts.

11. A 90° angle is trisected by using radius X2 as a unit of measurement. Using point 2 as a center, lay off line 5 on circle; with point 3 as center, lay off line 6 on the circle. These 3 segments are equal and represent 3 of the 12 segments in the circle.

12. With compass or dividers, and using line 2-6 as a unit of measurement, lay off this measurement 12 times on arc DH, starting from point D. Point H is determined by the end of the twelfth arc.

13. Connect points GH. DFJH is the pattern for your conical object.

Cut the cone pattern out along these lines. If the pattern is to be used more than once trace it onto a stiffer oaktag, x-ray film, or even a piece of lightweight aluminum flashing. A paper pattern can become quite inaccurate after awhile. Aluminum flashing can be obtained in any hardware store, is light and easy to cut, and makes a very accurate pattern that can be used over and over again.

The conical spout

You might on some occasion want to fit a conical spout to a cone or cylinder (see fig. 9-33). On your elevation drawing show how long the spout will be and the approximate size of both diameters. This, of course, involves a truncated cone cut off at an oblique angle intersecting another cone (at the point where the spout joins the body of the pot). There is a drafting solution to this problem, but it is complicated and not necessary as an oaktag pattern of the cone can be fitted to the body of the pot by trial and error. (For those of you who would like to attempt the drafting solution, I refer you to Daugherty and Powell's excellent book on *Sheet Metal Pattern Drafting* in the Bibliography.)

Another way to find the correct angle for the spout is to model it in clay or modeling wax, directly onto the pot. Trace the shape of the angle onto a piece of paper, and cut the metal cone to that shape. This will give a quite accurate pattern. It will have to be trued up with files to make it fit perfectly, even with the drafting dimensions. If you use this method, be sure to clean away all traces of any modeling wax with carbon tetrachloride or trichloro-ethylene, which is somewhat safer to use. Use fine steel wool before soldering as you might run into difficulty if any trace of wax remains.

Pre-determining the capacity of a cone or cylinder

There may be times when you need to know how much a container or vessel will hold before you make it. Someone may order a pint mug or a "pint plus foam". There is a straightforward formula for determining the capacity of a cylinder in cubic inches. It can be used for determining the capacity of a cone — the shape of most pewter vessels — by a drawing made from an elevation of the cone (fig. 5-4a). Super-impose a cylinder over the cone, displacing space at the bottom of the cone to the top. This is accomplished by dividing the conical object in half by a horizontal line and erecting a perpendicular line through the sides of the conical object at the point of this horizontal line AB. In this way, you have transferred the space from the large end of the cone to the small end of the cone, thereby changing it into a cylinder. The cylinder is then calculated just as any cylindrical object would be (see fig. 5-2). Remember that no vessel is filled completely to the brim, so in determining capacity make your calculations

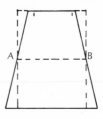

Fig. 5-4a. Scale elevation drawing of a cone, used to predetermine capacity of the conical or cylindrical object made from the pattern (diagram ½ size).

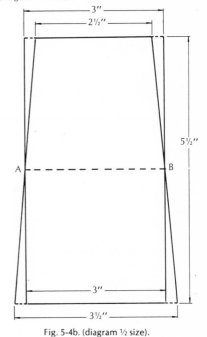

Fig. 5-4b. (diagram ½ size).

based on a size that is a bit shorter than what you want your object to be.

First, make an elevation drawing of pleasing proportions, showing top and bottom diameter and height. The capacity required should not determine the shape of your mug. You as a designer should be in control of this. Design proportions are considered first, and then they can be altered somewhat if the capacity is not correct. For a mug with a base diameter of 3.5", top diameter of 2.5", and height of 5.5" (fig. 5-4b) proceed as follows.

The formula for determining the capacity of a cylinder is:
$$d^2 \times .7854 \times h = \text{contents in cubic inches}$$
and
$$2 \text{ cubic inches} = 1 \text{ ounce}$$
Therefore:
$$9 \times .7854 \times h = 38^+ \text{ cubic inches.}$$
Since 2 cubic inches = 1 ounce, the mug will hold 19 ounces or 16 ounces and foam.

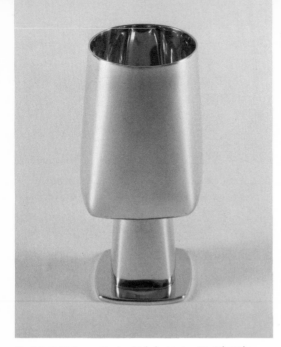

Fig. 5-5. Goblet vase, 5 inches high, by Marion Ray (photo by Hobbs Studio).

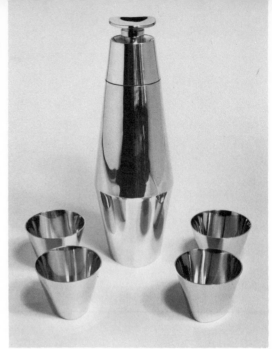

Fig. 5-6. Cocktail shaker and set of beakers, all with triangular bases, by Frances Felten and Shirley Charron.

Making a square base on a round shape

It is possible to introduce a little variety by changing the shape of the base on a round object. It can be made square, triangular, hexagonal, etc. In Figure 5-5, the circumference of the cup was divided into four equal parts on a piece of paper (fig. 5-7). The cup was placed on the paper and these four points marked off onto the cup itself. Then straight lines of the same height, perpendicular to the base, were drawn up the side of the cup at these points. After a pattern like this is drawn, the cup is placed on a rounded narrow stick (a dowel will do), which is held in a vise. Pressure is applied with your hands at each of the four points where the lines have been drawn, until a rounded square has been formed. No pressure is exerted at the top of the cup as this must stay round. The squareness must fade into the roundness at the top.

To divide a straight line into equal parts

Dividing a straight line of uneven length into any number of equal parts is useful in determining lengths of hinge wire, which always has to be divided into an odd number of pieces. In Figure 5-8, let AB be the line to be divided, say into seven equal parts. Draw a line AC at any angle from A; divide this line into seven equal parts with the dividers, such as AD', D'E', etc. Join the end

of the last space on line AC to the point B on the line BC. Now, draw the lines parallel to line BC, connecting points I' to I, H' to H, etc., which divides the line AB into the required number of equal parts.

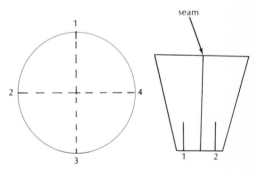

Fig. 5-7. Making a square base from a circular one.

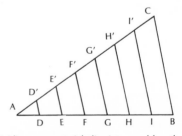

Fig. 5-8. Dividing a given straight line into equal-length parts is necessary when making hinges.

6. Using a Mold and a Starting Block

The Round Bowl and The Free-Form Dish

Contrary to general belief, it does take skill to make a shape fit a mold. A novice can beat a bowl in a mold, but it may not be a good one. Some beginners end up with a bowl that is bigger than the mold, and will no longer fit it.

Using a mold does not confine your own skill and creative ingenuity. Ancient Egyptians learned many thousands of years ago to make two-part dies, mold and punch, for jewelry, and they were a productive, ingenious people. There is nothing to stop you from using a mold or other device such as a starting block to help you make your work look better, as long as the work keeps its handmade character.

The round bowl

If you want a simple, very nicely made round bowl, use a mold. It will help you shape the bowl more quickly. You can "break" a bowl down in a mold, that is, take a flat disc and gradually hammer it into the shape of the mold, and then work it from there by hand in a variety of ways. The round bowl is often an integral part of many a more complicated piece (fig. 6-1).

The first step, of course, is to select the proper material. The following list may be of help to beginners in selection of gauges for bowls of any kind:

1″ — 5″ diameter bowl	18-gauge disc
6″ — 9″	16
10″ — 12″	15
over 12″	14

Next, select a 10″ disc of 15-gauge pewter, and file the burr edge off so as not to harm the wooden mold. Even these machine-stamped discs have quite a rough edge on one side, which must be removed or little chips will be dislodged from the shock of hammering and become embedded in the hammer. The metal chips will then be transferred to the metal, which will result in little blemishes pitting the whole surface. This could ruin the mold, mallet, and bowl.

Fig. 6-1. Server by Shirley Charron (collection of Albert Minzter). Two round bowl shapes were combined to fabricate this form.

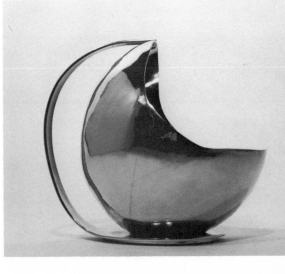

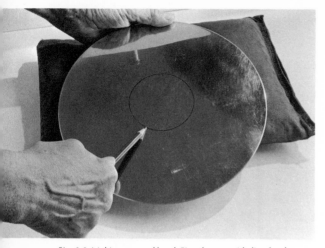

Fig. 6-2. Making a round bowl. First draw a guide line for the bottom.

Fig. 6-5. Pattern of the placement of mallet strokes used in raising. The blows must overlap to the left, right, and inward to the center.

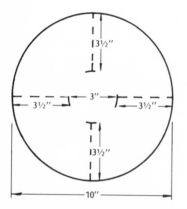

Fig. 6-3. The guide line may be drawn freehand or by measuring, as shown in this diagram for a 10-inch disc.

Fig. 6-4. Next, raise the edge in a large hardwood mold with a fiber mallet.

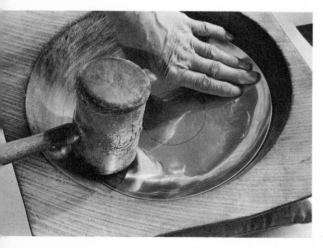

Draw in a guide line for the diameter of the bottom (in this case 3″) with an "All" pencil (fig. 6-2). This is done by holding the pencil rigid at a measured point and turning the disc to keep the line an even distance from the edge. Another way of doing this is to measure in 3½″ at four points (this measure is determined by the total diameter of the 10″ disc), then trace a 3″ wooden bottom setter with an "All" pencil onto the pewter disc (fig. 6-3).

Start raising the edge (fig. 6-4) by placing the disc in a mold of larger diameter than the circle. For a 10″ disc use at least a 12″ mold. The one used here is waste stock from a wooden salad bowl. These are usually thrown out by salad-bowl manufacturers, and are readily obtainable. Using a large, 3″ fiber mallet, place the disc against the end grain of the mold because the end grain is stronger and more resistant to splitting. Always use the largest mallet possible because it more nearly approximates the shape of the mold, and thus is closer to the size of the required arc.

Raise the edge by pounding around the outside perimeter of the bowl with overlapping strokes about ¾″ inside the edge of the disc (fig. 6-5). It is important to keep the blows overlapping around as well as inward. If blows are widely spaced, dents or crimping will occur. Always support the outer edge of the bowl against the mold. The first blows must be very gentle. It is good to establish a steady rhythm of blows (see

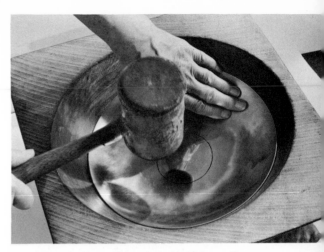

Fig. 6-7. Press the disc gently into the mold with your mallet as you work.

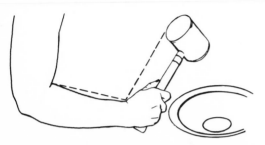

Fig. 6-6. Position of arm and wrist in raising. Shoulder is relaxed with elbow close to side but not rigid. Action comes from the wrist with a whipping motion. Elbow has freedom but is not brought into play during the actual forming process.

fig. 6-6). A three-stroke rhythm is the most natural, and you will probably develop it as you gain more practice. You can just get in about three overlapping blows before you have to turn your piece.

When the edge is free from crimps or irregularities, you may increase the force of blows slightly by raising the mallet head higher and letting it fall with a little more force. Blows are kept springy. The disc must be gently pressed into the mold with your mallet as you work (fig. 6-7). The need for a delicate touch can not be overemphasized. If you treat the metal very gently it will respond much better. If you hit too hard you will get a crimp or dent, and a crimp is a potential crack. Two processes are now taking place — the disc is being stretched and it is being shrunk at the edge to a smaller circumference. Stay away from the very bottom of the bowl where the guide lines have been drawn as this will be set flat later.

When the disc has settled nicely into the 12" mold it is ready to be forced into a 9" mold (fig. 6-8). Support it so that the edge nearest you is tipped inside the mold at a slight angle and the back of bowl is up and away from mold so that it does not touch the edge of it. Touching would cause indentations on the back that would be almost impossible to remove.

Begin pounding again at the outer edge of the bowl, and with light, overlapping strokes go around and into the mold. Gradually the bowl will begin to enter the mold, and the edge will settle into the side of it (fig. 6-9). Keep a light touch at all times, with close overlapping blows. Avoid hurrying and avoid spaced blows, at this time

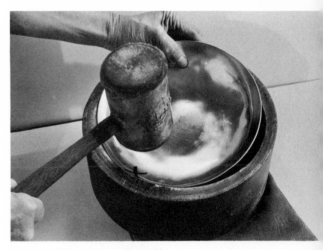

Fig. 6-8. And then, into a smaller mold.

Fig. 6-9. The bowl enters the mold gradually, settling into the side of it.

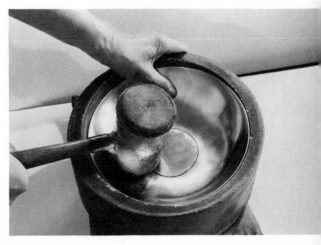

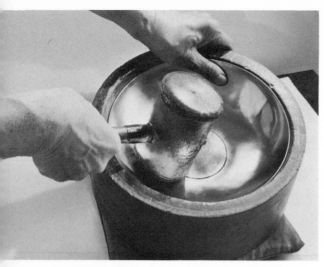

Fig. 6-10. When it is in place, remove dents by gently striking with the mallet, which is held in a choked-grip position.

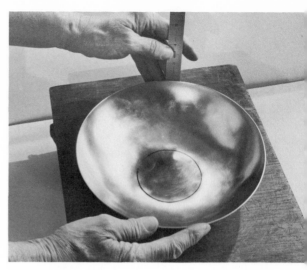

Fig. 6-11. Next, level the bowl to ensure that the height is equal at all points.

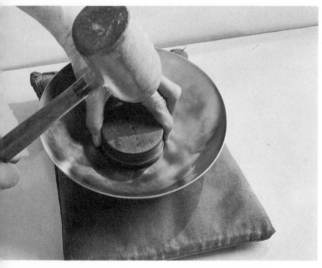

Fig. 6-12. Setting the bottom. Start directly on a sandbag.

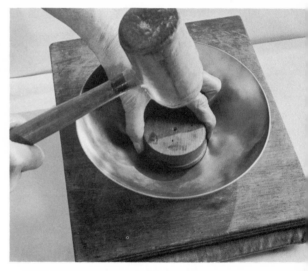

Fig. 6-13. Now place the bowl on a hardwood flat surface and repeat the same procedure using the setter and mallet.

particularly, or you will get dents and undulations that are very difficult to remove once they occur. Examine the outside of the bowl often, feeling for dents and bumps, and continue to tap gently into the mold until they are all removed. In this process the mallet can be held closer to the head (fig. 6-10) for more accurate placement. The position is referred to as "choking the grip." When finished, the bowl must conform to the shape of the mold except for the 3″ bottom, which has not been pounded.

When the desired shape is achieved, and the height of the bowl is equal at all points (fig. 6-11), the bottom is set with a 3″ hardwood round disc at least ¾″ thick. First, the center circle should be redefined clearly and restored to its 3″ diameter. During hammering it may have expanded. Trace the bottom setter again with an "All" pencil. Next, start directly on a sandbag (fig. 6-12), and place the bowl on the flat surface of the bag. Place the setter so that it conforms to your penciled line. The setter should have a slightly rounded edge on bottom, which should be perfectly smooth.

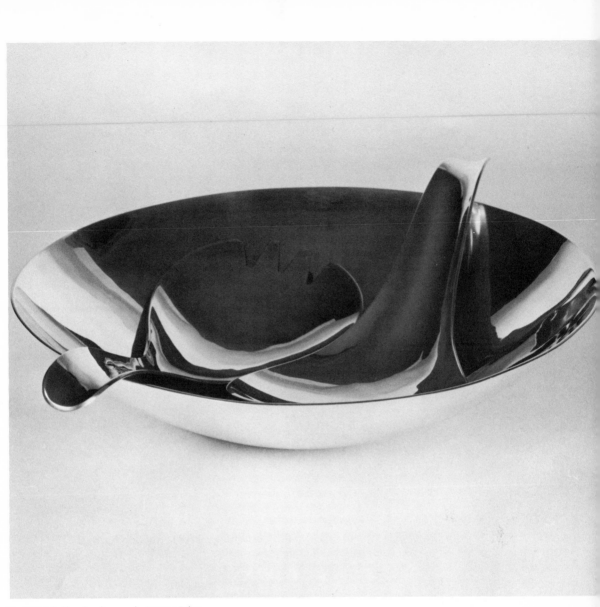

Fig. 6-14. Salad bowl and servers by Frances Felten.

Hold the setter firmly, and strike a sharp blow against the end grain nearest you, using the rounded end of the mallet. Do not try to set the bottom with one blow or a series of hard blows in the center as this is never successful. Instead, move the setter slowly in a circle, striking a blow at each turn until you have covered the circumference and the bottom looks clearly defined.

Now, place the bowl on a hardwood flat surface and repeat the same procedure, using setter and mallet (fig. 6-13). If the bowl doesn't set evenly, hold with even pressure and move gently forward on the hardwood surface. Rub-marks on the bottom of the bowl will indicate to you where high spots are — tap them down gently with the flat face of the mallet. Height of bowl should be measured again after setting, and if it is a little off, the high places can be filed down.

The edge now can be filed flat or roughed flat against an emery-paper board. Your bowl is now ready to be buffed on the edge, back, and inside, in that order (see Chapter 12).

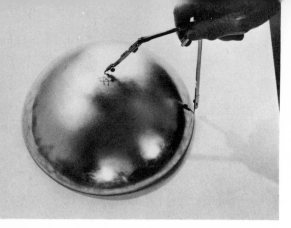

Fig. 6-15. Attaching a base. First, find the center of the bowl.

Fig. 6-16. Use this point as a center to draw a circle of the same size as the base.

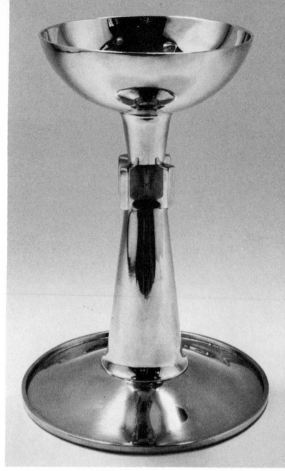

Fig. 6-17. Chalice by Frances Felten.

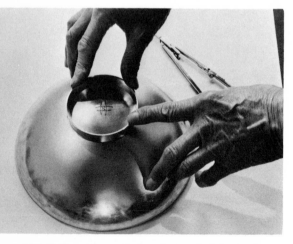

Fig. 6-18. Then make sure the base ring is perfectly level and conforms to the shape of the bowl.

Attaching a base to a round bowl

Even if the center has been marked on the back before forming the bowl, stretching can change the bowl's shape so that the center must be relocated. Rest one leg of a compass, or divider, against the edge of the bowl (fig. 6-15) and set the pencil of the compass slightly beyond the place that looks like the center (it would be impossible to guess the exact center.) Draw an arc. Repeat this procedure on the opposite side and then on the two points perpendicular to this axis. This will give you a rough rectangular form. By drawing the diagonals of this shape you will find the center of the bowl — it is the point where the diagonals intersect. Use this point as a center to draw a circle, to size, for the base of the bowl (fig. 6-16). Procedure will be the same whether you are using a simple ring or a taller one such as that shown in Figure 6-17.

The ring must be perfectly level and conform to

angle of bevel

Fig. 6-19. This is done by filing a bevel with a half-round file or hollow scraper on the inside edge of the ring.

yellow ochre

63-37 63-37

300 Belmont

Fig. 6-20. Finally, the seam is soldered from the outside for ease in cleaning.

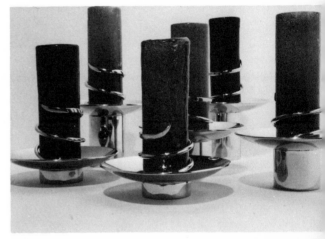

Fig. 6-21. Candlesticks by Shirley Charron. The design is derived from the simple principle of applying a base to a round bowl.

the shape of the bowl (fig. 6-18). This fitting can be accomplished on a round bowl by filing a bevel on the edge of the ring toward the inside (that is, the edge that must fit with the smaller circumference) with a half-round file or hollow scraper (fig. 6-19). If there are still discrepancies, a strip of aluminum-oxide paper (aloxite), about 80 grit, can be taped on the bowl, and then the ring can be carefully rotated over the abrasive until there is a perfect fit. Success of your soldering depends upon the fit.

Clean the joints with non-greasy steel wool and then line the seam with flux and 63-37 solder (fig. 6-20; see Chapter 8 for description of soldering.) Use one pellet of 300 Belmont solder on each side of the vertical seam. Both sides of the previously closed vertical seam of the ring should be coated with a thick application of yellow ochre to prevent it from opening in the soldering. Important: do not bring ochre to the point of joining. If it mixes with the flux and solder, it will prevent the flow of the solder.

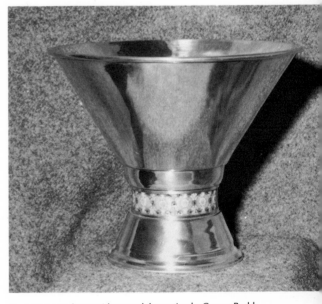

Fig. 6-22. Footed vase with enamel decoration by George Budd, Libby Budd, and Arthur B. Barnes (photo by LaVerne Kelson).

49

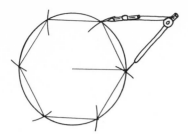

Fig. 6-23. Hexagon bowl. First divide a pattern into 6 equal sections by marking off the radius on the circumference with a compass.

Fig. 6-24. This pattern will produce a bowl with scalloped edges.

Variations on the round bowl

Hexagon bowl. Smooth the edge of a 16-gauge pewter disc. Make a pattern by tracing a disc on cardboard or oaktag, and tracing the outline with a pencil. Divide the circle pattern into 6 equal sections by marking off the radius on the circumference with a compass (fig. 6-23). Draw connecting lines to form a hexagon. This hexagon pattern, as it is now, will give you a bowl that has a deeply scalloped edge (fig. 6-24). If you desire the fuller, rounder look of the bowl in Figure 6-25, then you must extend the pattern halfway between the straight line of the hexagon and the edge of the circle (fig. 6-26).

Before the bowl is formed, the hexagon pattern is scribed onto the pewter disc. The bowl is formed as a round bowl. After it is completed, carefully cut the bowl to a hexagonal shape on the scribe lines, using tin snips or aviation shears. Corners will stand high. Leave them this way or use your thumbs to press the edges into the desired curve. File edges and polish.

Fig. 6-25. Hexagon bowl with rounded edges by Frances Felten.

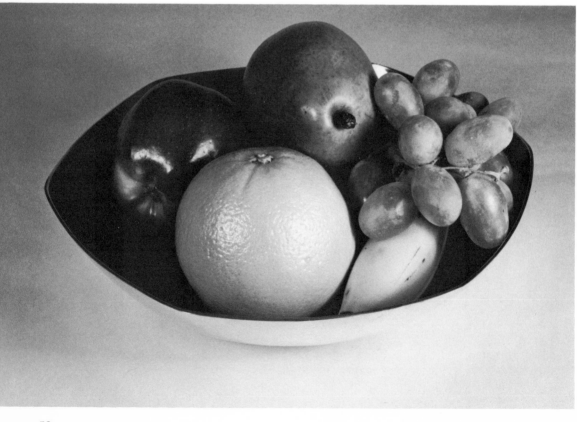

Fig. 6-26. The rounded effect can be made by altering the pattern as shown.

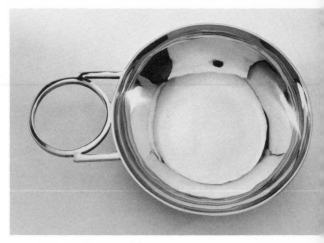

Fig. 6-27. Porringer by Frances Felten.

The porringer. In deference to its place in the past glory of pewter, a bit about the porringer. These functional little bowls appear time and again throughout the history of English and early American pewter. Although their original use is not altogether certain, their many reported functions include that of wine-tasters, ash receivers, nut holders, vegetable bowls, porridge dishes, children's bowls, and even receptacles for blood-letting, which was a medical custom of the times.

Their contemporary use can be just as varied and functional, so there is no point in dismissing the form as an oddity of the past. Part of the charm of modern pewter is in the preservation of some of its romantic past, yet it would be foolish to adhere slavishly to the rigid design specifications of our puritanical ancestors. Their formal, geometric pierced handles reflected their times and personalities, and we should reflect ours. In Varnum's, *Pewter Design and Construction* (1926) one of four design fundamentals for making a porringer is that its "design must be in the spirit of the period — adapted to pewter design."

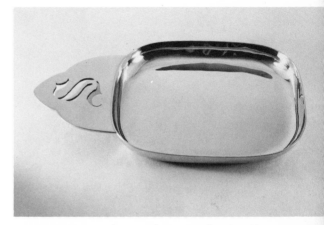

Fig. 6-28. Monogrammed porringer by Frances Felten, design by Marjorie Rowland.

Fig. 6-29. Porringer by Frances Felten.

The following description depicts the making of a classical porringer shape, but the same techniques can be adapted to any bowl shape or handle design. One thing that differentiates a porringer from any other tray or dish is that it is a flat-bottomed bowl with steep sides. Another is its side handle. If you are making a porringer, I will therefore assume that you want to preserve these two characteristics. However, the possibilities for creative play with the porringer are unlimited. Figures 6-27, 6-28, and 6-29 show but a few.

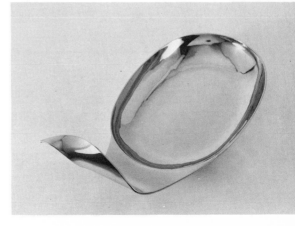

Using 14- or 16-gauge, the porringer bowl can be formed in a flat-bottomed wooden mold designed for that purpose (figs. 6-30, 6-31) or in successively deeper round-bowl molds. Also the whole piece can be made in a starting block. In the two latter cases the bottom would be set with a 3½" bottom setter on a flat surface.

If the bowl is formed in a special mold designed for that purpose, the steep sides are raised and made to conform to the mold by using the flat edge of the mallet in a pulling stroke toward you (fig. 6-32). If they are raised in a bowl mold or starting block, then they must be made steeper by shrinking (see Chapter 9) against a round-domed wooden stake of approximately the curvature that you desire the edges to have (fig. 6-33).

The handle of the porringer is cut out of 10- or 12-gauge pewter, and any pierced work is cut out before joining (fig. 6-34). To mark the handle accurately for joining, it is necessary to place a block of pewter under the opposite side of the bowl (same thickness as the handle) so that the bowl will not be tipped (fig. 6-35). Scribe the line along the edge of the bowl onto the handle. Now cut this line at an angle that conforms to the angle of the side of the porringer. This is accomplished by holding the saw at that approximate angle and "freezing" your wrist, at that angle. Sawing action is from the elbow (fig. 6-36).

If the angle is not cut correctly, the fit may be corrected with a half-round file. The handle is now placed against the porringer bowl and lined up with 63-37 solder (fig. 6-37) for soldering. It is best to keep the flame directed on the handle rather than the porringer bowl because the thicker metal of the handle will take longer to heat, thus preventing burning.

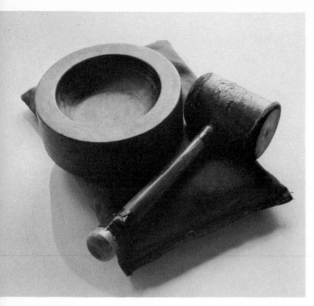

Fig. 6-30. Mold made especially for porringers. It has 3½-inch flat bottom and steep sides.

Fig. 6-31. Pattern for a 6-inch porringer mold.

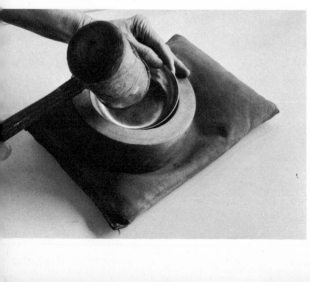

Fig. 6-32. Raising a porringer. Use the flat edge of a slightly worn or rounded mallet to avoid marring the metal. Pull the mallet toward you as you pound.

Fig. 6-33. If they are raised in a bowl mold, the steep sides of the porringer can be formed by shrinking against a round-domed wooden stake.

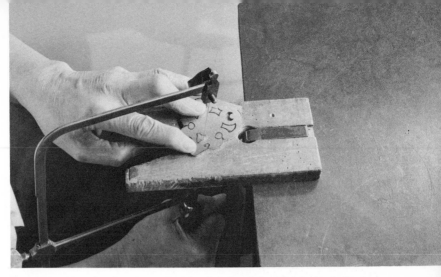

Fig. 6-34. Any pierced work on the porringer handle is done before it is joined to the bowl.

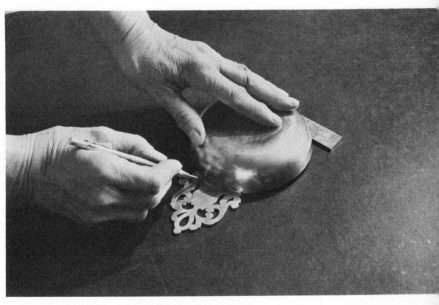

Fig. 6-35. Then the bowl is used to mark the handle.

Fig. 6-36. And the handle is cut at an angle that conforms to the side of the porringer.

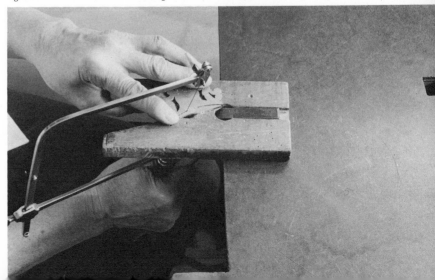

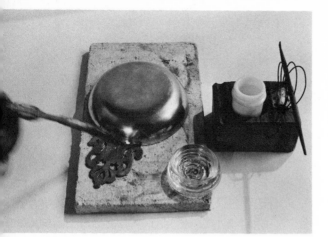

Fig. 6-37. Finally, the handle is soldered to the bowl.

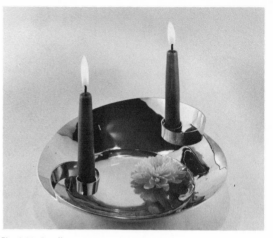

Fig. 6-38. Candle centerpiece by Frances Felten.

Fig. 6-39. Wall sconce by Joan Pond.

Fig. 6-40. Candlesticks, 6 inches high, by Hilda Kraus (photo by Yvette Klein).

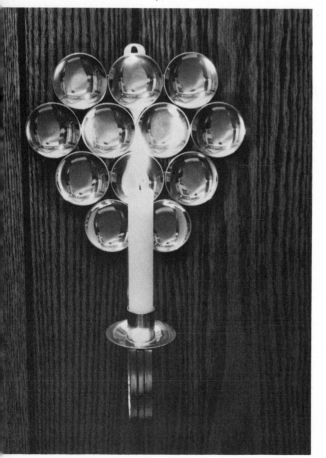

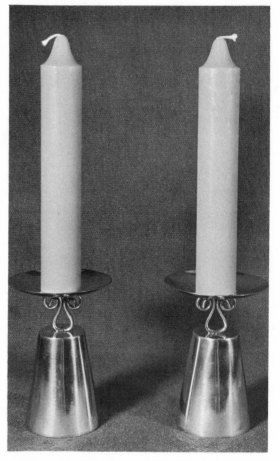

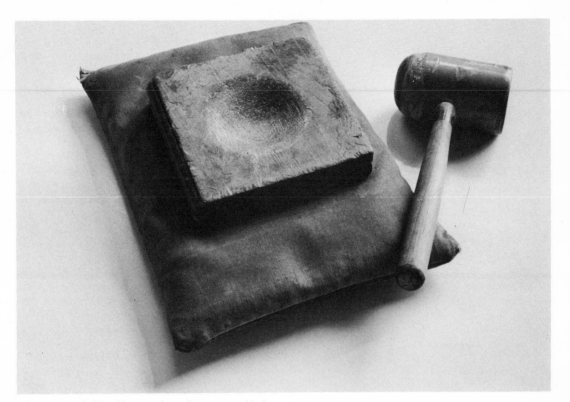

Fig. 6-41. Any and all bowl forms can be made in a starting block.

The free-form dish

In spite of its modest appearance the unassuming little starting block (fig. 6-41) can be one of the most important tools of a pewtersmith. Any and all bowl forms can be made in a starting block. If you have no turned molds, no waste stock from salad bowls, no molds of any kind, you could still make pewter bowls of various sizes and depths with nothing but this little starting block and a sandbag. Of course, round bowls are more easily made in a round mold. Free-form dishes, however, are more easily made in a starting block. Figure 6-42 shows the approximate dimensions of a starting block, which can be any size as long as the relative proportions remain the same. You can easily make one in hardwood by carving into the block with wood-carving tools and sanding, or, of course, by turning on a wood lathe.

Because the pattern for the dish is a symmetrical one, it is necessary to mark the center for the bottom as accurately as possible. This is accomplished by measuring in from each end and side to find the center (fig. 6-43). A bottom setter is traced onto the center of the form with an "All" pencil.

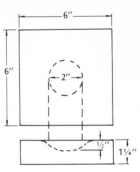

Fig. 6-42. Pattern for a starting block. Top view is shown above, and side view is shown below.

Fig. 6-43. Making a free-form dish. Find the center on a pattern by measuring.

55

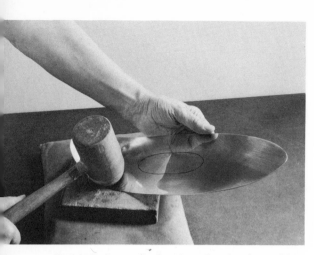

Fig. 6-44. Begin pounding from the ends, and work toward the center.

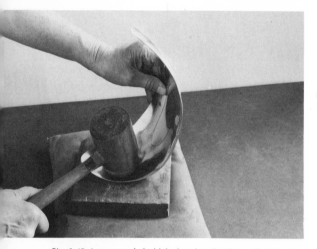

Fig. 6-45. As you work, hold the bowl so that the end rests on the end of the depression in the starting block, and so that there is air underneath the form.

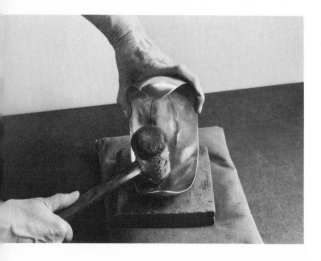

Now, begin pounding from the ends and work in toward the center (fig. 6-44). The starting block and mallet must be used as a unit. Think of the mallet as being hinged so that the end of the mallet always strikes in the deepest part of the depression. The end of the bowl rests on the end of the depression in the mold and is held at a slight angle so that there is air underneath (fig. 6-45). Only in this way can the form be accomplished. The shape moves in a circular pattern under the striking mallet, and the movement is determined by the shape of the bowl. In this case, movement is more longitudinal than circular. Concentrate on one end until the form begins to deepen. The bowl is kept moving to achieve a smooth overall surface — otherwise edge marks of the mold might show. Do not allow crimps to form on the sides. Keep working all over the whole area of the bowl at the same time.

For a symmetrical bowl you must keep comparing sides and ends for depth and regularity of shape. The shape more or less forms itself. It will turn up into a hollow crescent shape as you work on it (fig. 6-46). You will have trouble hammering inside of this, so press the ends apart, and repeat the hammering procedure.

When the desired depth has been achieved, rest the piece on a flat surface and press the ends apart, using the weight of your body if necessary (fig. 6-47). In doing this, the sides will rise by themselves, and a pleasing free-form bowl will appear (fig. 6-48).

Set the bottom on a flat surface by using a free-form bottom-setter shape (fig. 6-49).

Fig. 6-46. A hollow crescent shape results.

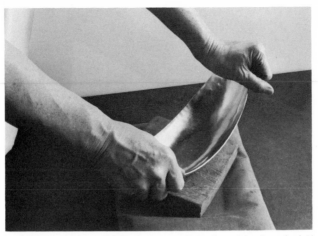

Fig. 6-47. Press the ends of this crescent apart, using the weight of your body if necessary.

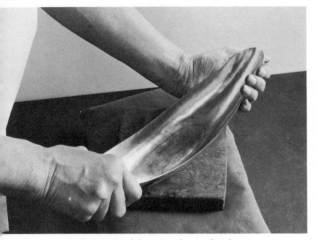

Fig. 6-48. Final shape is a pleasing free form.

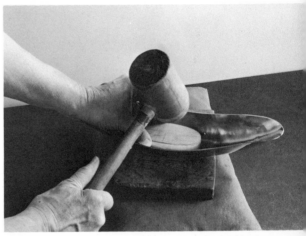

Fig. 6-49. Finish the dish by setting the bottom on a flat, hard surface.

Fig. 6-50. *Platypus,* free-form bowl by Frances Felten.

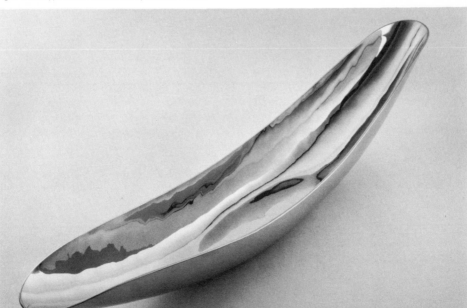

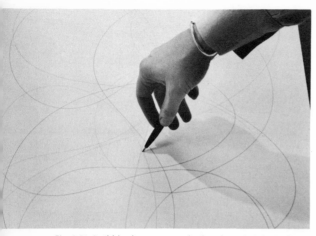

Fig. 6-51. Scribble-shape patterns for free-form designs. Make large flowing lines quickly, and without any thought of their appearance.

Fig. 6-52. Trace the chosen shapes with a marker.

Fig. 6-53. Cut them out, and trace onto oaktag or other cardboard for patterns.

Fig. 6-54. Then scribe this pattern onto a sheet of 16-gauge pewter, and proceed as in making a free-form dish with a starting block.

Scribble shapes. An effective way to arrive at free-form design, and one that I have found successful in teaching young people, is the technique of "scribble shapes." Most people with limited design ability find it difficult to draw a free-form shape that does not look contrived and labored over. This technique forces a freedom and spontaneity of line that would be impossible for them to arrive at any other way. On a large sheet of paper scribble large circular or oval flowing lines with a pencil or fine-point magic marker, quickly and without any thought of their appearance (fig. 6-51). Study the shapes, decide which ones would make pleasing free-form bowls, and then trace their outlines with a wide-point felt-tip pen or a pencil of another color (fig. 6-52). Cut the shapes out and trace onto cardboard or oaktag for patterns (fig. 6-53). Trace and scribe the pattern onto a 16-gauge pewter sheet, and proceed as you would in making free-form bowl with a starting block (fig. 6-54).

An amazing variety of pleasing shapes can be arrived at this way, and it is really quite difficult to come up with a bad form while using this technique (fig. 6-55).

58

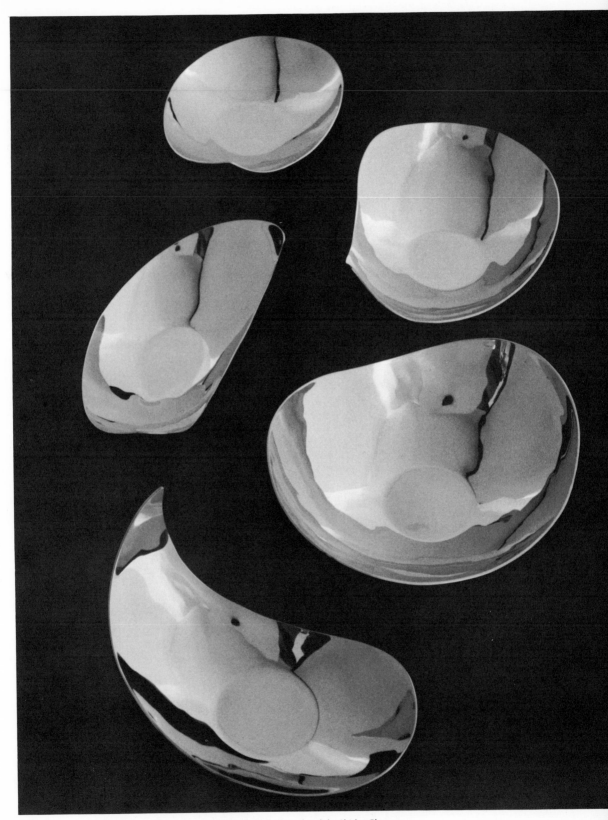

Fig. 6-55. Scribble-shape bowls by Shirley Charron.

7. Strengthening Metal

Felten Salad Servers

The best way to mix a salad is with your own hands. Because this is not usually considered proper, these salad servers designed by Frances Felten have been created to be the next best thing: extensions of your hands. They follow the contour of the palm, and are very similar in shape and function to the hands. They are short enough to fit the palm, but long enough for you to manipulate.

The demands of pewter also dictate this design, for pewter salad servers are much stronger and more stable in a stubby, robust form than they would be with long, delicate handles. Pewter, being a very soft metal, doesn't lend itself well to serving implements and flatware. Even if 12- or 10-gauge pewter is used it will bend or give in use unless something is done to strengthen it. The

making of salad servers best shows how pewter can be strengthened.

The old saying, "a house is as good as its foundations," is used so much because it is very true. Any piece of work is only as good at the finish as it is at the beginning. It is extremely important, therefore, to have a good beginning. The servers should be traced accurately, cut accurately, and filed well at the edges for refinement before being used in the mold.

First, make a pattern out of aluminum flashing or tin cans that have been cut apart and straightened out. The pattern is traced onto a sheet of 16-gauge pewter with a scriber rather than a pencil because a scriber's permanent line can be seen easily and is close enough to the pattern to be cut accurately (fig. 7-1).

Fig. 7-1. Felten salad servers. First trace the pattern onto a 16-gauge pewter sheet with a scriber.

Fig. 7-2. Cut it out with a jeweler's saw, except for the tines.

Fig. 7-3. Pattern for the tines.

Fig. 7-4. File the cut-out shapes to remove rough edges.

Next, cut out the servers with a jeweler's saw (fig. 7-2). A set of salad servers consists of the traditional spoon and fork, but actually, you don't need a fork — two spoons would work just as well. What we have therefore, is a symbol of a fork that really serves as a second spoon, and so the tines are made short and stubby to give just a suggestion of teeth. This part of the design is functional too. Long slender pewter tines would bend. Important: the tines are not cut out until after the bowl is formed. The servers are first treated like two spoons except that lines of the fork tines have been traced on one of them (fig. 7-3).

The pieces must be filed to remove any burrs or rough edges, and then the bowl is ready to be shaped (fig. 7-4). Both pieces should be made together, step by step, so that they can be compared frequently (fig. 7-5). This is much wiser than finishing one piece completely, and then trying to make the other piece match it.

Using a shallow starting block and a round mallet, hammer the bowl of the spoon and fork so that they are equal to one another in both depth and treatment (fig. 7-6). The bowl is shaped rather shallow, which is perfectly functional. You don't need a deep spoon for lettuce to cling to.

Fig. 7-5. Compare the two servers frequently, step after step.

Fig. 7-6. Raise matching bowls with a shallow starting block and round mallet.

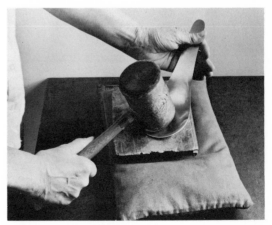

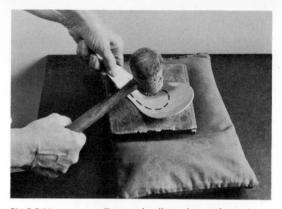

Fig. 7-7. Next, use a smaller round mallet to deepen the section where the bowl joins the handle. You do not need to draw in the dotted line shown on the bowl — it was done here to indicate the area that would be strengthened.

Fig. 7-8. Pattern for this deepening.

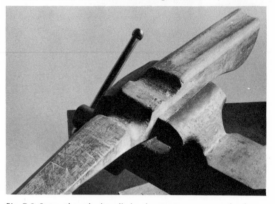

Fig. 7-9. Strengthen the handle by shaping it over a wooden bar that has two grooves either turned or filed in it.

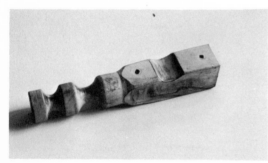

Fig. 7-10. Any wooden bar with a u- and s-curve can be used.

Fig. 7-11. A wedge-shaped fiber mallet is used to shape the handle over this bar.

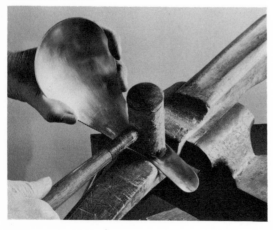

Next, using a smaller, round mallet, deepen the tapering part where the bowl joins and flows into the handle (fig. 7-7). (Never use a mallet larger than the depth of the curve you wish to produce.) It is important to try to keep that depth flowing rather than abrupt, so that the approach to deepness is gradual and finally runs down into the handle to a degree of depth that will begin to give strength to that part of the spoon (fig. 7-8).

Now, using a wooden bar that has two grooves either turned or filed in it (fig. 7-9 or 7-10) and a wedge-shaped fiber mallet, the shaping and strengthening of the handle begins. It is beat into the form lengthwise, thereby making a long groove in the handle (fig. 7-11). This in itself makes it much stronger and more pleasing to look at. We have created a U-curve, going longitudinally down the handle, and an S-curve, going around the end of the handle, that will fit the palm of the hand. If the S-curve and U-curve are formed correctly, the handle will actually curve over the heel of the hand. The S-curve is formed by beating the handle over the bar, around it, over the form, and into the groove at the same time.

The two pieces are checked again to see that they are as nearly exactly alike as handwork can make them. If not, this sort of correction can be done by laying one piece on top of the other, beating them very gently in the groove of the bar, interchanging them, and beating them together again.

The tines of the fork are now ready to be cut out with a jewelers' saw and fine blade (fig. 7-12). A 3/0 blade is a good one to use as it leaves very few saw marks. The tines must be filed after cutting so that they are quite smooth, and later they are buffed in the regular buffing of the edges and surface (fig. 7-13).

The edges now require refining, even though they have already been filed smooth. You can give a little character to your design by changing the angle of the edge to the surface of the piece. This is done by filing the edge of the bowl horizontally so that the thickness of the metal is broadened in appearance (fig. 7-14).

The curve in the handle might need to be made a little more fluid. After beating it, it may be somewhat out of line. Sight down along the line of the handle to see that it really flows evenly with no breaks and no sharp angles, and that it is a complete and very satisfying curve. The small, tapered handle end can then be rounded again. Flatten out the file stroke so that it shows the thickness from the top of the spoon. This does a great deal for the character of the whole piece, and is a form of surface enrichment that is easily achieved.

As it seems wise to work your system out in an orderly manner, the edges are usually buffed first (see full description of buffing in Chapter 12). If you have done the edges, you won't forget them. Badly buffed edges are the mark of many an amateur pewtersmith. To buff them correctly, approach the piece from the convex side with the buff corner (fig. 7-15). Use muslin buff of about 4″ to 5″ in diameter with a medium-hard surface and good, square corners. The piece is held with the tines up as it is brought in very carefully to the corner of the buff. "Wiping down" with the buff, that is, moving the work in a downward action over the edge of the buff, first on one side, then on the other, will cause the buff to flutter through to the concave side, thereby polishing all edges of the tine. The long groove of the handle is buffed with a narrow razor-edged muslin that has been used a bit and isn't too sharp. Using a sort of angular approach down the handle groove keeps you from running over edges or "spindle-knicking" your work. Care must be taken not to touch the spindle of the machine with the work.

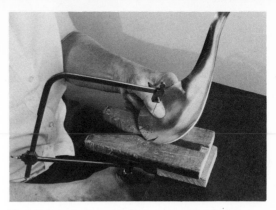

Fig. 7-12. Next, the tines of the fork are cut out (see fig. 7-3).

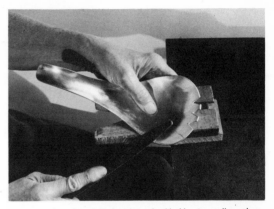

Fig. 7-13. The edge of the bowl may be filed horizontally so that the metal appears thickened.

Fig. 7-14. Pattern for filing the edge of the bowl.

Fig. 7-15. Buff the edges first, so you won't forget them.

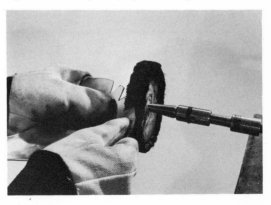

Tape can be applied to the spindle to prevent this. The back is buffed next, and last of all the inside is buffed (fig. 7-16). Check to see that there are no file cuts or sharp edges showing. The servers are now ready for blending and lampblack finish, the final steps in the polishing process.

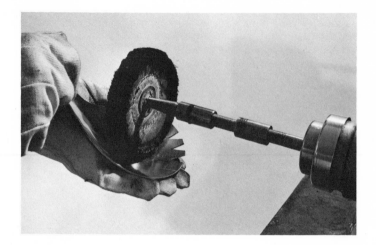

Fig. 7-16. The back is buffed next, and last of all the inside is buffed.

Fig. 7-17. Salad servers by Frances Felten.

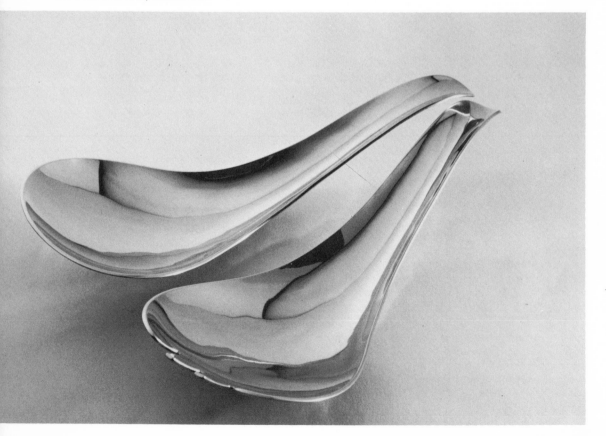

Setting up for soldering

The ease with which pewter can be soldered is perhaps one of its most appealing features. A well-soldered seam can barely be detected in most cases because pewter contains a large amount of tin and is soldered with a tin-lead solder that is very close in color to pewter. A well-soldered seam is really stronger than the metal itself because in the soldering process some of the low-melting alloy in the solder coheres with the body of the piece.

The set-up for soldering is a simple one (fig. 8-1). Tools and supplies required are:
1. Small Bantam unit Bernz-o-matic propane gas torch and matches
2. 60-40 tin-lead solder
3. 63-37 tin-lead solder
4. Belmont 300 solder (cadmium solder — but cadmium is in a nontoxic amount)
5. Bismuth solder (not shown)
6. Pewter flux (1 oz. glycerine to 7 drops of hydrochloric acid)
7. Yellow ochre
8. Double cotton glove
9. Solder shears
10. Sharp knife
11. Turntable
12. Brush
13. Thin sheet asbestos
14. Various small pressure clamps (hair clips, etc.)
15. Glass caster cups.

Fig. 8-1. Soldering tools and materials.

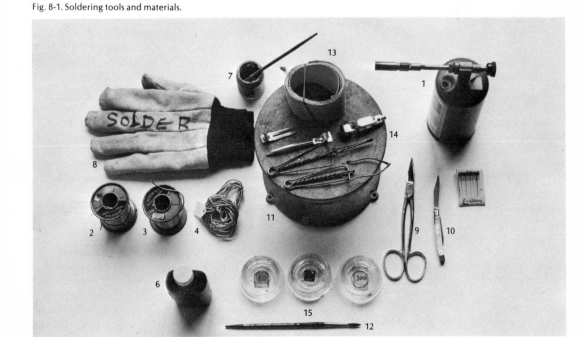

hottest point

Fig. 8-2. Know where the hottest part of the flame is before you begin to solder.

The small Bernz-o-matic torches, which use a propane refrigerant gas, are very efficient and ideal for soldering pewter. Very little heat is required, and the torches should be adjusted to the smallest flame possible. Do not turn the gas valve off too tightly or you will throw off this delicate adjustment. For pewter, a steady blue flame with a very sharp tip is necessary. The hottest part of the flame is the bright blue area (fig. 8-2). Try the torch out — hold it down, hold it up, see if it burns steadily — before trying it on your metal. Remember that heat always rises and that the flame will point straight upward when you hold the torch vertically.

The solder used for pewter is a tin-lead alloy. (The tin is always mentioned first in naming a formula for solder.) Plumber's solder is 50-50, half tin and half lead, and melts at 414°F. The melting point of the solder is lowered by adding more tin to it; therefore, 60-40 melts at 370°F. and 63-37 melts at 358°F.

The 63-37, the lowest melting tin-lead solder, flows the best, and its higher tin content also gives a better color match. It is also just as strong as 60-40, and should be used whenever 60-40 is not necessary. The 60-40 must be used for the first soldering whenever two or more seams are planned close together. Then, on the second soldering with 63-37, there is no fear of the first seam opening up, because it was soldered with a higher melting-point solder.

Another way of lowering the melting point of tin-lead solder is by adding cadmium. One that is particularly good is Belmont 300, which is used when one seam comes in contact with another. One piece of Belmont 300 is used on either side of the vertical seam (see fig. 6-20). This solder, as its name implies, melts at 300°F. Bismuth is another ingredient that can be added to tin-lead solder to lower its melting point to about 241°F. Bismuth solder is occasionally used for patching purposes but it is very brittle and not very strong. It does not hold.

Glass caster cups are excellent for holding the solder as they can be labeled from underneath, where the label is protected and yet still visible from the inside. Do not use plastic cups because the hydrochloric acid in the flux, if allowed to sit in plastic, could produce a chemical reaction that might affect the flow of solder.

The solder is applied with a brush. A good small but full sable with some spring in it will save much time and patience.

Very sharp solder shears, sold especially for cutting solder, will also save time. A sharp jack knife can be used for stripping solder.

Yellow ochre, which is a clay, is used moist as a sealing compound to prevent seams from opening up at the point of application. It should be made in a thick paste, and applied generously at critical places, but not allowed to mix with the flux or it will stop the flow of solder.

Every metal requires a different flux. Your success in soldering is dependent upon the suitability of your flux to the metal and solder you use. For pewter, the best flux is glycerine and hydrochloric acid (1 ounce glycerine to 7 drops hydrochloric acid). You may find other sources recommending a 10 to 1 formula, but 7 to 1 is the formula that leaves the least flux residue, a tin oxide that is formed during the soldering process and has to be cleaned away. The more hydrochloric acid, the more residue. Hydrochloric acid is used in many fluxes, and is commercially known as muriatic acid.

Use a double, cotton work glove for holding objects in your hand to be soldered. Asbestos gloves are too clumsy, and the piece will not get hot enough to require them. Turn one inside out so that it will fit the opposite hand, and you can make one double cotton glove from a pair of gloves.

A turntable is indispensable. It allows you slowly to turn the piece, following the flow of solder with your torch. This is especially useful when soldering a bottom. Thin sheet asbestos and a variety of small clamps, hair clips, etc. are used as holding devices for certain soldering processes (see fig. 8-9).

Secrets of the flame

Before cutting solder it should be stripped with a sharp knife or edge of shears to insure its cleanliness (fig. 8-3). Solder that sits around on a workbench can accumulate grease, dirt, or oxidation that can prevent it from flowing. Scraping the top layer away with a sharp tool is a worthwhile precaution. Important: make sure your hands are clean and free of grease before you begin to solder. Cut only as much solder as you think you will use as it is not good to let it sit out in the caster cups for a long time (fig. 8-4). Humidity will collect in the flux and retard the flow. Also, solder that sits in flux for a long time can corrode and give you trouble. The solder will flow best if cut in small pieces — 1/16 or as small as you can possibly cut them using the solder shears. Cutting two pieces at once will save you time.

The seam or area to be soldered should be cleaned thoroughly with a greaseless steel wool (fig. 8-5). If it is a cylinder or cone, it should be cleaned both inside and out. Do not use a dirty piece of steel wool that you have used for other purposes, or one that has been sitting around on the workbench. Extreme cleanliness is important in the soldering process.

A tight fit is of course essential for good soldering. Your seam will only be as good as the fit of the two pieces you are attempting to join. With a brush, coat the seam fairly generously, but not too sloppily, with flux. Too much flux can postpone the melting of solder because it has to be heated itself before the solder can flow. It can also run down on your hand and burn you if you are holding the object, as glycerine can burn with a very pale blue flame that can't be seen. The purpose of the flux is to keep the joint clean, to keep oxides from forming (they can cause pitting and burning, and stop the flow of solder) and to cause the solder to follow it through a tight place into the seam. The solder would not flow without the flux; it would just melt and stay there. The flux affords capillary attraction.

Small pellets of solder are then picked up on the wet fluxed brush and carefully placed approximately ¼" apart on the seam to be soldered (fig. 8-6). Always make sure that your brush is thoroughly dry and free of water before placing it into the flux. Water and glycerine don't mix. The glycerine will absorb the water and later cause popping and spitting of the solder and flux. A small amount of flux should be left in the caster cups in order to wet the solder pellets.

If a drop of solder should happen to fall off your brush onto the soldering bench, forget

Fig. 8-3. Strip the solder to ensure cleanliness.

Fig. 8-4. Cut two strips at the same time into small pellets, in order to make your work go faster.

Fig. 8-5. Before soldering, clean the seam thoroughly.

Fig. 8-6. Then pick up the pellets on a brush wet with flux, and place them about ¼-inch apart on the seam.

Fig. 8-7. Keep the flame moving in front of the solder.

Fig. 8-8. In soldering a ring, place the solder pellet on the inside, and heat directly from underneath.

Fig. 8-9. When a piece has to be clipped to hold it in place during soldering, use low-pressure clips and protect the metal with sheet asbestos.

about it and take another. That much solder is dispensable, and not worth risking problems that will result if it picks up dirt or grease from the workbench. The same is true of excess cut solder left in the caster cup overnight. Throw it out and cut fresh pieces.

Keep the flame just in front of the solder and always keep the torch moving (fig. 8-7). The boiling point of glycerine is about 290°F., so when the flux begins to boil, you are approaching the melting point of the solder. It will flow very soon after that. If you have trouble melting a particular piece of solder, don't stay with it. Place another one near it and melt that. Usually, the first one will then be attracted and melt also — solder attracts solder. Lead the flow of solder with your torch to direct it, as solder will follow the flame. Soldering a band or ring involves the same principles as a cylinder or cone (see Chapter 9). The solder pellet is placed on the inside of the seam and run through to the outside by heating from underneath (fig. 8-8). The 60-40 is used here because another seam will involve very close soldering, requiring 63-37. The flame should approach from directly underneath so that the heat is equal on both sides and so that both sides of the seam are heated at the same time. Solder will flow toward the heat, so if one side is heated before the other, it will flow toward that side. A well-soldered seam is one that goes all the way through. It is called a "wet seam", which doesn't mean a leaky seam but simply a thoroughly wetted seam.

Occasionally, it is necessary to use gentle clips or clamps to hold a part down while soldering (fig. 8-9). Hair clips are perfect for this as the pressure is just right for pewter and they come in a variety of sizes and shapes. Other commercially purchased soft-solder clamps can also be used. When using the clips be sure to protect the metal with pieces of sheet asbestos. In most instances the piece can be "tacked" (spot-soldered) in a few places, then the clamps removed, and the rest of the seam run through.

Forming a Cylindrical or Conical Object, Making Spouts, Handles, Bottom, Attaching a Lip, Shrinking Metal, and Wood Combinations

Forming a cylinder or conical object

In pewterwork, the nature of the metal itself demands simplicity. Just as surface decoration or overembellishment of any kind are inappropriate and a contradiction to its quiet dignity, intricate and contrived contours are an illogical taxing of its functional limitations. Because hand-wrought pewter does not particularly lend itself to the making of pyriform shapes — shapes with double-curving sides, like pears — most pitchers, cups, tankards, or beakers, are based on, or adaptations of, the cylinder or cone. (fig. 9-1). If you have an incessant desire to make pyriform shapes, work in silver. These shapes also can be easily spun in pewter. If you are flexible enough to let the demands of the material guide you in design, you will find an abundance of innovative and creative potential within the realm of pewter's limitations (figs. 9-2, 9-3, 9-4, 9-5, 9-6).

In fabricating a cylindrical or conical object, you first need an accurate pattern (see the description of the cone development in Chapter 5). You must trace and cut the pattern accurately, realizing that the regularity of each operation will be dependent upon the regularity of the operation that went before it.

The cut-out piece is shaped around a cylindrical bar, preferably a smooth wood one, and formed or fabricated by hand as much as possible (fig. 9-7). There will be more resistance from the metal at the ends of the form, and therefore it will be difficult to bend this small arc with the fingers. Instead, use the largest mallet you can manipulate comfortably. The more nearly you cover the edge or end of the piece, the fewer dents will be found in the finished article (fig. 9-8). The regularity of the curve should be maintained throughout the hammering. If the surface does not feel smooth to the touch, tap out the irregularities on the wooden bar.

Next, spread the seam apart enough to admit a flat file, and file the edges straight that are to meet and be soldered, until they fit perfectly for the entire length of the seam. It is possible to fill slight openings in the middle of a seam with solder, but openings at the ends are very difficult if not impossible to fill (fig. 9-9). The only way you can fill an opening at the end of a seam is to press the entire seam against a piece of asbestos and flow the solder down to the end of it. It would be best to avoid this procedure altogether by fitting your seam very carefully. When you hold an unsoldered seam up to the light, no daylight or very little should show through.

When the seam is ready to be soldered, pewter flux is applied to the entire length, on both the inside and outside surfaces. Cover it well and carefully, but not too liberally, or as mentioned before, burning flux may run over your hands

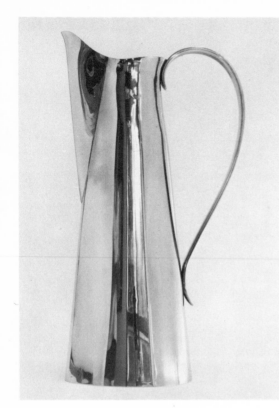

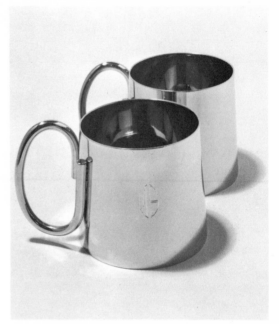

Fig. 9-1. Pitcher, 16 inches high, by Frances Felten (collection of Mrs. Edward Eyth).

Fig. 9-3. *Hurricane Ash Tray* by Frances Felten. This design for outdoor living protects cigarettes from the wind, and disposes of them in a deep container. The width of the base prevents overturning.

Fig. 9-2. Tankards, 12 ounces, by Shirley Charron (collection of Muriel Scott).

Fig. 9-4. Vase with gold and enamel base, by George Budd and Libby Budd (photo by LaVerne Kelson).

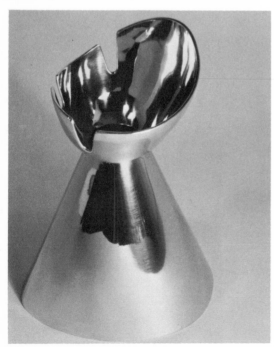

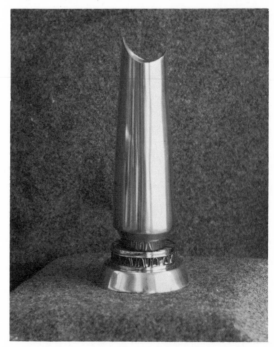

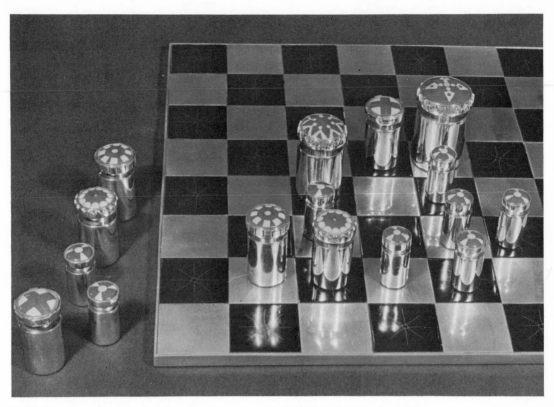

Fig. 9-5. Chessmen and chessboard, pewter and cloisonne enamel, by Hilda Kraus. (Photo by Yvette Klein)

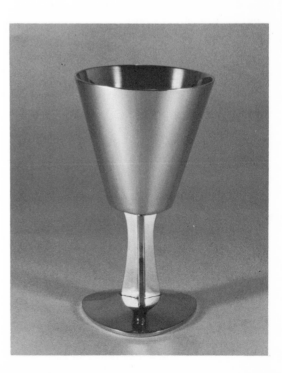

Fig. 9-6. Goblet with triangular base by Frances Felten.

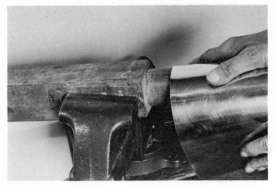

Fig. 9-7. Making a pitcher. First form the piece by hand around a cylindrical wooden bar.

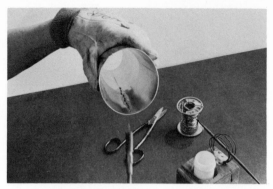

Fig. 9-10. As in soldering the ring, Figure 8-8, place the solder pellets on the inside and heat directly from underneath.

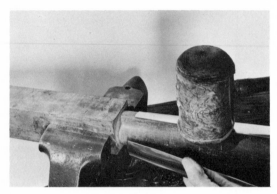

Fig. 9-8. You can make the ends conform to the bar's shape by tapping them gently with a fiber mallet.

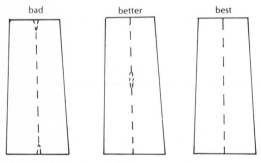

bad better best

Fig. 9-9. Fit the seam very carefully to prevent soldering problems.

Fig. 9-11. If the piece is too large to be held by hand, it can be held together with binding wire and asbestos, rested on a wooden bar, and heated from underneath.

even though you cannot see it. Another danger is that the burning flux may draw the solder out of the seam and melt it. Therefore, use just enough flux to keep the seam moist and clean.

Place the solder on the inside of the seam and apply the heat on the outside, from underneath (fig. 9-10). In this way, it is drawn through the seam to the outside as it begins to flow. If the

cone or cylinder is too large to be held comfortably in the hand with a soldering glove, it can be held together with binding wire and asbestos, rested upon a wooden bar, and heated from underneath (fig. 9-11). Enough solder must be left on the inside to form a fillet, or rise, on the seam. If lumps form instead of a regular fillet, they are still preferable to having no solder left on the in-

Fig. 9-12. File the seam smooth on the inside after soldering, using a diagonal motion, which prevents you from filing a channel in the piece.

Fig. 9-13. Incorrectly filed seam, showing a channel.

side. If all of the solder is melted through the seam, it will be weak on the inside and difficult to finish.

Rinse and dry the seam very carefully before using tools on it. Tools will become rusty from filing wet metal. Carefully file the seam with a "cadillac", the coarse-tooth single-cut file that is made especially for soft metals. File the inside seam with the half-round side of the file, using a diagonal rolling movement (fig. 9-12). If you file a straight line forward down the length of the seam, you are liable to file a channel into the piece (fig. 9-13). Filing across the seam will give you better results. Keep the seam conforming to the arc of the cylinder or cone so that the thickness of the metal is not worn away at any one place, especially not at the ends of the seam, as this is a potential danger spot in filing. This wearing down can be prevented by freezing your wrist and filing in a forward and upward motion as you approach the end of the seam. If you run your fingers around the inside, it should feel like the inside of any regular cup.

Now file the outside of the seam, taking care that it follow the contour of a perfect circle and have no flat spots at any point. It should feel smoothly round in the hand. Important: do not use abrasive cloth or emery paper of any kind on the seams. Small particles will be dislodged that will be pressed into the metal under the heat of the buff. The seam, if filed correctly, can be polished smooth on the buff without further finishing.

Level the bottom of the piece by running it over a coarse emery paper that has been glued to a level board. Make sure not to rock the piece. Pulling it toward you in one direction in a turning

Fig. 9-14. Leveling the bottom. Pull the piece toward you over coarse emery paper, in the direction of the arrow.

motion will give you more control than moving it back and forth (fig. 9-14). As the bottom becomes level, hold the piece in both hands and rub it around and around on the emery. Test it on a perfectly flat surface. Metal surface plates are made for this purpose but they are very expensive. Plywood boards (hardwood) are a suitable substitute as long as they are checked with a straight edge occasionally to be sure they are maintaining their level. Never hammer on them or the surface will be ruined.

If you are making a true cup shape, in which the top is equidistant from the bottom at all points, the best way to level the top is to use a surface gauge. This is a vertical rod with a scriber

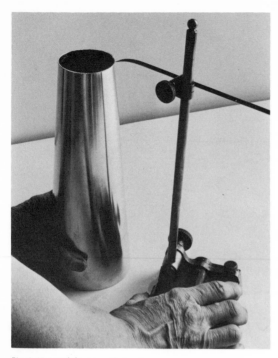

Fig. 9-15. Level the top with a surface gauge.

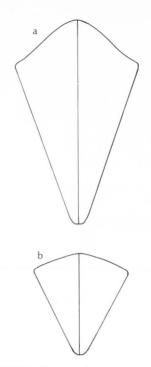

Fig. 9-16. Two kite-shaped patterns for spouts.

attached. The scriber is set so that its point touches the lowest place on the pitcher top (fig. 9-15). Just below that level, so that it doesn't catch over the edge, the piece is slowly revolved. The bottom is kept in contact with the surface board so that both the surface gauge and the cup stand on the same level and are perfectly flat. The scriber will give an accurate line parallel with the bottom of the piece. It is wise to go around the edge twice to make sure that there is no discrepancy in line, that nothing has rocked, and that the piece has not been accidentally moved out of level line.

Then trim the top. If there is a great excess anywhere, trim it with shears. The best way to do this is to hold the piece with the top facing you, and trim the excess off with the shears. You can see the line this way, and the shears will work with greater ease than if you simply attack the form from the outside. If there isn't a great excess, file the top until it is level. Any burrs remaining should be removed from both edges with a file, if they are on the outside, and with a hollow scraper or a knife blade, if they are on the inside.

Spouts, handles, and bottoms

Spouts. The pattern for the usual spout is kite-shaped (fig. 9-16a, b). Make a kite-shaped form that is regular on both sides, and test it by fitting it to the pitcher and taping it on with a little masking tape. When you have one that looks approximately the way you want it, use that pattern. As long as the pattern can be folded down the center and is equal on both sides, it will make an adequate spout. Then trace the pattern onto the pewter and cut out the spout. It is usually made from pewter the same thickness as the body of the pitcher, 16 gauge in most cases.

Form it over any long, flat, wedge-shaped stake — you can make your own stake from a piece of hardwood. The center of the spout must be kept at the center of the stake, and each side hammered down until the desired shape is achieved (fig. 9-17). Keep the opening in proportion with the shape and size of the pitcher.

It is good practice to put the spout on before the handle because if any adjustments have to be made, the handle can be adjusted more readily

74

Fig. 9-17. After cutting out the spout, form it over a flat wedge-shaped stake.

Fig. 9-18. Draw a line around the inside seam of the spout, in order to mark the opening on the pitcher wall.

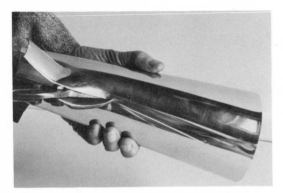

Fig. 9-19. Cut out the opening, and file away the excess.

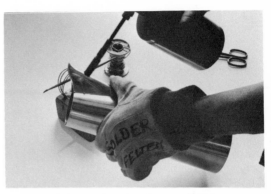

Fig. 9-20. Tack the spout into place, for easy soldering.

than the spout. It is also wise to apply the spout to the seam side. That way, there is less seam to be polished. It will also prevent you from applying the handle to a seam, where the solder may be drawn out. Before attaching the spout, draw a line around the inside of it to mark the opening for the spout (fig. 9-18). A very fine scribing tool — a dental tool perhaps — is perfect for this. Cut out the opening for the spout with shears and file away the excess (fig. 9-19). Take care not to file entirely down to the line that indicates the inside of the spout, but only very close to it, testing the spout for fit from time to time. The better this fit, the less will have to be filed away from the inside later. One of the things that makes an elegant pitcher is a clean spout, not one with a little ridge around it to catch anything that goes through.

Now, hold the spout on tightly with your thumb or a piece of masking tape while you tack it into place with a small piece of 63-37 solder on each side of the spout. This makes it possible to remove your fingers or the tape, and, if the spout is in contact with the body of the pitcher at all points, you can proceed to solder the seams of

the spout, working from the bottom up to the top of the pitcher (fig. 9-20). If masking tape was used, make sure no adhesive remains as this can deter the flow of the solder.

After soldering the spout, rinse and dry the piece thoroughly, then proceed to file the place where the spout joins the pitcher, using a round, rat-tail riffle file. This tool is almost indispensable here because it has a curve that keeps you from filing away too much of the edge. If too much is filed away here, you could cut through the area where the spout attaches to the pitcher.

After the edge is filed smooth, buff it with a razor-edge buff at the seam where it joins the pitcher. A small razor-edge buff will fit inside the spout also, but for the lower part of the inside use a small, conical felt buff. Take care not to over-pressure in this operation because felt buffs tend to melt out solder from seams very easily.

The Self-Contained Spout. The self-contained spout is one that will give you the greatest scope for originality. It is fun to make, and one that you will probably utilize often in the production of modern pewter. It is a very small spout but can be

75

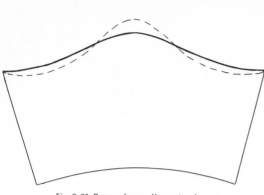

Fig. 9-21. Pattern for a selfcontained spout.

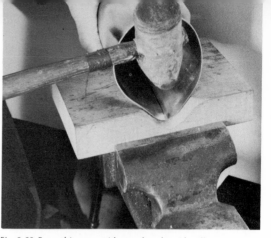

Fig. 9-22. Form this spout with a wedge-shaped mallet in a groove in a block of wood.

quite adequate for a good pour. More important — it eliminates the need for soldering.

In making a pattern for a pitcher with a self-contained spout, allow for a higher protuberance on the top side of the pitcher-body pattern where the spout will be (fig. 9-21). The spout is usually opposite the seam, in the middle of the pattern, because the handle should be applied on the seam. If you tried to beat the spout out on the seam, the seam would probably split open.

After making the pitcher, draw a line from the very highest point of the spout to the bottom of the pitcher, directly opposite it. This is the straight line upon which the spout is formed. Beat out the spout from the inside by laying the pitcher on a hollow block of wood in which you have filed a groove that approximates, as nearly as you

possibly can, the actual spout shape. Use a wedge-shaped mallet to beat the spout out over the edge and into the contour of the groove in the block of wood (fig. 9-22). Use the straight line you have drawn on the inside of the spout to see that it is beaten out to the proper length and that it is regular on both sides. Check to see that the curve down the front of the pitcher is a pleasing one. The top of the spout should look even when viewed from the top of the pitcher, and both sides should match. You must now file the top of the pitcher to make it follow the curve of the spout in a graceful and unbroken line.

Variations on the self-contained spout can be made in many ways, but that is your design problem — you take it from here!

Fig. 9-23. Martini pitcher for two, with rosewood stirrer, by Frances Felten.

Fig. 9-24. Cocktail shaker by Frances Felten (collection of Dr. and Mrs. Alexander Marsh).

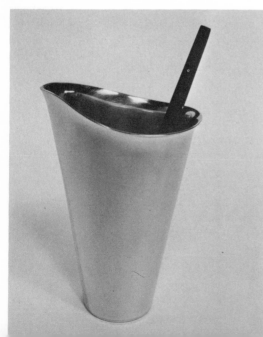

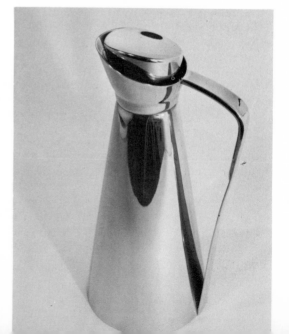

Fig. 9-25. Pattern for a strap handle.

Fig. 9-26. Form the handle after polishing it, using a round bar smaller than the smallest curve of the handle.

Handles. The type of handle described here is a conventional strap handle, a little wider at the top than at the bottom. You can form it from a simple pattern (fig. 9-25), after experimenting with a piece of cardboard on the pitcher body to see how large you want the handle to be. For this handle, 8-gauge pewter is used. The inside handle edge is rounded, by filing, a little more than the outside, which is just slightly "broken," or rounded just enough at the edge, to carry out the appearance. The rounding makes the handle more comfortable to the hand. The handle should be polished well before it is put on because it is much easier to manage when it is still flat.

After polishing, form the handle over a round stake. Any round bar of wood smaller than the smallest curve of the handle will do. It may be a bar that is specially made, or it may be a broom handle. The forming is done by feeding the handle across the bar about ⅛″ at a time, and beating it as you do so, using the flat side of a large substantial mallet (fig. 9-26). You can also mold the form with your hands and beat it with the mallet until the curve seems just about right — evenly and cleanly flowing and without any flat spots, which are beaten out as they occur. When the upper part of the handle seems right (like the illustration), turn it around and give a slight curve to the bottom, where it joins the pitcher.

There are of course innumerable variations on this type of handle. You may want to make a flat joint where most of the end of the handle is filed away and flows into the side of the pitcher. Use your own design on this problem! You can adapt the technical procedures for the conventional handle described here in any way you choose.

File the points of contact of the handle with a half-round file until they fit quite evenly against the side of the pitcher. Buff the back of the pitcher now so that any blemishes are removed before the handle is attached — and is in the way. The point of attachment is marked on the outside and inside of the pitcher with an "All" pencil. In this way it can be seen from both sides however you hold the pitcher. The bottom point of attachment is also marked. The bottom of the pitcher has not been attached yet so that you can hold the handle — by the top or by the bottom or with your hand inside the pitcher, if necessary — to solder it. It is also possible to use masking tape to hold the handle in place until you are able to tack it securely. This has the added advantage of allowing you to stand away from the pitcher to see if the handle placement is visually satisfying. Again, be sure to remove any traces of tape adhesive in solder areas or it may deter the flow of solder.

The solder is now applied, one pellet on each side of the handle, and fused at those points (fig. 9-27). This tacking will hold the handle while you finish the soldering. One point of contact is soldered first, flushing the solder through so that it makes a good firm joint, and then the other one. Rinse and dry both joints thoroughly, making sure that there is no water remaining in

Fig. 9-27. Tack the handle onto the pitcher.

spots that can't be seen. The water would be drawn into the buffs and would redeposit buffing compound over the whole piece. It is very difficult to remove water from a buff. Check the finish on the inside to make sure that no scratches or blemishes have occurred in handling.

Bottoms. You are now ready to apply the bottom. Draw a circle about ⅛" wider than the bottom of the pitcher, cut it out, file only enough to remove the rough edge, and buff. The outside edge does not have to be perfect as this will be trimmed away later. A precut pewter disc, slightly larger than the intended bottom, may be used if available. The extra width of the bottom piece leaves a little shelf on which the solder pellets are placed, and this helps the solder flow into the seam. It is very difficult to flow solder into a seam that is cut to the exact size of the pitcher — it's practically impossible.

Place the bottom piece on a flat asbestos square, and put the bottom rim of the pitcher body in contact with it. A turntable is a useful device here, as you can turn it around to see that the bottom is protruding all the way around. It is also useful in the soldering process itself. You can slowly turn the pitcher and thus follow the flow of solder without interruption.

Before soldering the bottom, protect the vertical seam with yellow ochre made into a thick paste so that it really covers. Yellow ochre alone is not enough to keep the solder from flowing out. One small pellet of Belmont 300 solder is placed on each side of the seam. Never place a pellet of solder directly on a seam because even low-melting solder, when it starts to flow, can attract

higher-melting solder strongly enough to pull it out of the seam. Instead, start the flowing on either side, and very quickly flush the solder over the joint before it has a chance to open up. The 63-37 solder is used for the rest of the bottom seam (fig. 9-28).

To make sure that the pitcher is in firm contact with the bottom all the way around, press the piece down (if necessary) and turn it as you solder, making sure that the solder flows to the inside of the seam. With this "wet seam" the bottom can't be forced off by the weight of the liquid in the pitcher or pulled off in any other way.

On many articles, particularly containers that hold a large enough quantity of liquid to be very heavy, a convex bottom is advisable. Don't get carried away with the doming, however. In restraint, you can make a stronger bottom by doming, which follows the engineering principle of the arch. The slight doming that strengthens the bottom also shows from the inside, and is aesthetically pleasing. This doming can be done in the bottom of any bowl mold that gives the desired shallow depth, using a rubber mallet to insure a perfectly smooth surface. Proceed in the same way that you would pound out a small bowl and of course, do it before you buff the inside of the bottom.

When the bottom is attached and the piece is rinsed and dried thoroughly, trim away the excess around the edge with shears as closely to the body of the pitcher as possible, without letting the shears bite into it. Then file the edge seam on the bottom very smooth, buff the whole piece and — a pitcher is born!

There are, of course, variations on spouts and handles that the making of this pitcher does not cover. A conical spout can be used (see description of the conical development in Chapter 5). The built-up handle is another way to vary the basic form (figs. 9-31, 9-32). These variations are rather traditional in feeling, but it is good to understand their construction should you ever have occasion to use them (fig. 9-33).

The diagram shows the construction of a simple hollow handle, and a profile of the handle has been drawn in suitable proportion to the cup. To make this built-up handle, form the handle with bands of an appropriate width of 16-gauge pewter. Then place the bands in a flush contact at all points on a large, flat piece of 16-gauge pewter. Check to see that the bands stand at right angles to the flat piece. Solder with 60-40, trim the excess away, and file. When applying the handle to the cup, use 60-37 solder.

Fig. 9-28. The bottom is attached last of all.

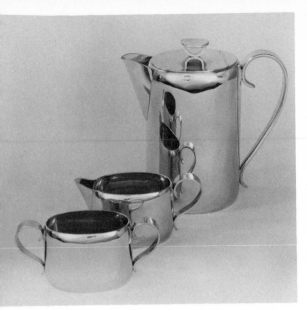

Fig. 9-29. Oval coffee service by Frances Felten (photo by Franz Kraus).

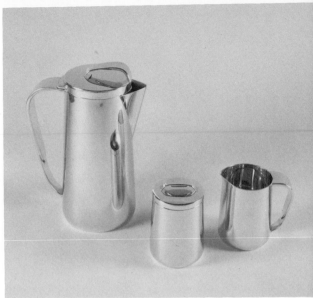

Fig. 9-30. Coffee service by Marion Ray (photo by Hobbs Studio).

Fig. 9-33. Coffee and tea service. Built-up handles and two different spouts are shown in this set by Frances Felten (collection of Henry Pasco).

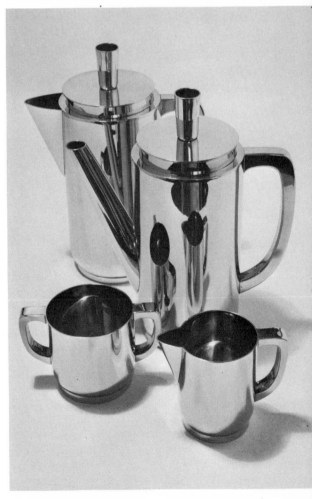

Fig. 9-31. The built-up handle. The drawing shows construction of a simple hollow handle.

Fig. 9-32. After the handle is formed it is attached to the pitcher with 63-37 solder.

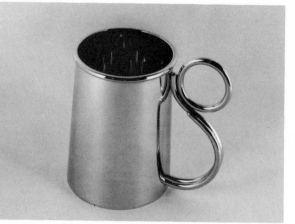

Fig. 9-34. *"Give me of thy sparkling ale, Landlord, and be sure 'tis in the pewter mug . . . for the soft shine of pewter doth enhance the mellow flavor of thine ale."* — Lafayette. Tankard, 16 ounces, by Shirley Charron (collection of Zachary Dwight Martin).

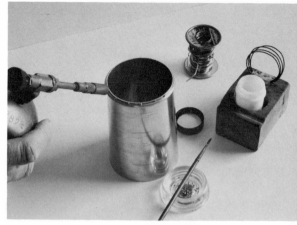

Fig. 9-35. Attaching a lip. Force the ring down below the edge of the cup to make a shelf for the solder pellets.

Attaching a lip to a cup or tankard

A band, or lip, may be added to the top of a cup or tankard as an enrichment and to show thickness. The contours of the lip depend on the type of wire used. You can use half-round wire, half-round wire of two different sizes brought together to give the effect of molding, or a flat strip (see fig. 9-39). Again, this is where your creative ideas come into play. For a lip similar to the tankard in Figure 9-34 use half-round wire and form a ring to fit the top — the fit must be very tight. The wire is drawn between two sticks until it is perfectly straight and flat at all points before it is formed into a ring. There can be no kinks or little bumps in the wire or these will become spaces between the wire and the cup. The ring should be just slightly smaller than the top of the cup, which will take care of any small kinks that may still be left in the wire and will also allow for the fact that when heated the wire will expand more readily than the body of the cup. (The heat will be more concentrated at that point, and while the body of the cup will dissipate the heat, the wire will attract it and conduct it throughout its length causing it to stretch out.) Therefore, form the wire ring as a force fit, one that you have to tap on very gently with a mallet. It should be forced down until a bit of the cup is extending above the wire, which makes a shelf on which to put the solder (fig. 9-35). Remember that such a shelf is important in making a clean seam. Use yellow ochre and Belmont 300 to protect the seams, and solder the band with 63-37.

Shrinking

Shrinking metal is probably one of the more difficult processes in pewtersmithing and in some cases one to be avoided. Used with discretion, however, it can enhance form and surface (fig. 9-36). Shrinking is the beating in of the metal upon

Fig. 9-36. Bud vase by Shirley Charron.

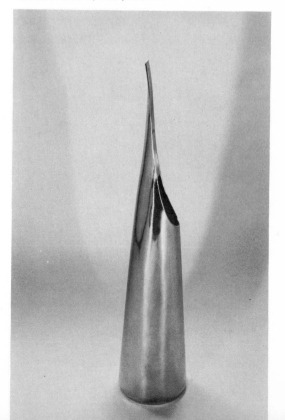

itself so that the molecules are forced to crowd in upon each other. The metal is thickened and the object becomes smaller where shrinking occurs. The easiest and best way to learn this process is to shrink in the bottom of a cylindrical or conical piece. Preferably, start with one in which the small end of the shape is at the bottom because if you shrink the large end you have that much further to go in order to push the metal in upon itself.

Start with a conical shape such as a pitcher with a self-contained spout. After leveling the bottom select a stake that has a rounded end and fits inside the pitcher with very little room to spare. Of course, if you have a conical stake that is just the size of the pitcher, you're in luck, but it will probably be smaller. If the stake does not have a rounded end, shape it with a rasp and a fine file until it has the proper curvature.

Start by beating with a flat mallet about ¾" up from the bottom of the pitcher. This dimension of course is optional, depending upon how far in you want the shrinking to go. The most practical way to attack this is by beating it in an octagonal pattern. Beat one side down over over the roundness, then turn the pitcher to the opposite side, and beat that down over the roundness. Continue making quarter turns and beating the

Fig. 9-38. Finally, every point in the shrunken end should be in contact with the curved stake.

Fig. 9-37. To shrink bottom of pitcher, beat down the shape until it approximates a square, then an octagon, etc.

sides down over the roundness until the shape approximates a little square with rounded ends (fig. 9-37). Then make one-eighth turns, beating the side down over the roundness, until an octagon is achieved. Beat down the points of the octagon over the roundness until the whole thing is shaped to a roughly round appearance. Go around again, several times if necessary, trueing up the round over the curve, and checking to see that every point in the bottom of the pitcher is in contact with the curved stake (fig. 9-38). Then round out the bottom by turning it on a tapered stake (see fig. 3-5), and you have successfully completed the shrinking.

I hope this will inspire you to do other shrinking, but don't get too ambitious with it because you can only take it so far before the metal cracks. Pyriform shapes can be approximated this way but it is very difficult and discouraging. It is not really a shape for hand-forming, but one that is better done with the harder metals and the techniques for working them.

Wood combinations

Combinations of materials are always attractive, and one of the first combinations pewtersmiths think of is metal and wood — usually the precious woods, like rosewood, ebony, teak, and walnut. Ebony is the most difficult to obtain in any quantity, and walnut is the easiest.

A wood handle can enhance a pewter piece considerably. It should be carefully planned so that the grain does not run *across* any of the narrow details of the handle (fig. 9-42). This kind of handle will break eventually. The grain should be on a diagonal so that there is always long grain on each part of the contour of the handle (fig. 9-43).

There are two common types of handles that can be made from wood. One is a straight handle, used for a side pouring pitcher (see fig. 9-41), which requires a socket fit, and the other is the traditional curvilinear shape. The latter can be attached at the top only or at the top and bottom by the use of metal plates and pins (fig. 9-40) or by sockets and pins.

A socket fit can be used for either type. It must be built to fit the handle and must in some way be attached from the inside. This can be done by soldering a plate of metal inside the ferrule or socket. The attached screw runs through and into the handle. Solder the metal plate or socket onto the body of the piece after the wood has been attached to it. It is possible to work in this order

Fig. 9-39. Tankard, pewter and teakwood, by Miriam A. Isherwood (photo by Paul Darling).

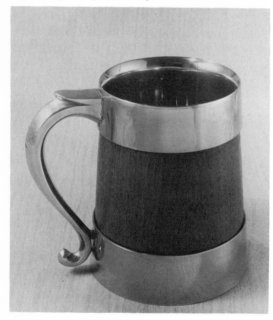

Fig. 9-40. Pitcher with walnut handle by Shirley Charron.

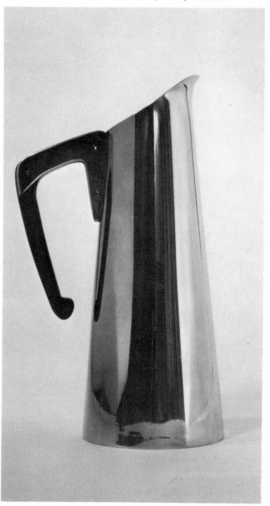

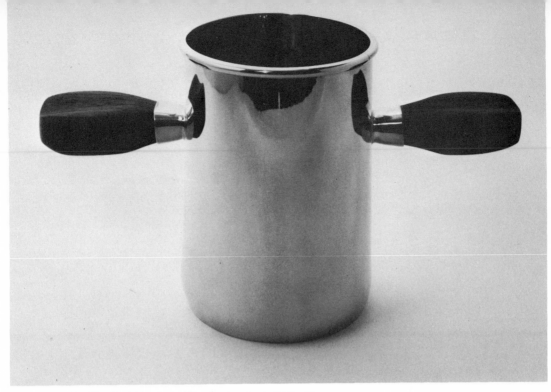

Fig. 9-41. "Two-fisted" tankard, 36 ounces, with walnut handles, by Shirley Charron.

because the melting point of pewter is so low that by keeping the flame applied to the seam, the wooden handle will not be scorched or disturbed in any way. If you wait to fit the wooden handles into the metal sockets after the sockets are attached, problems in fitting can occur.

The handles may be fastened to the sockets with epoxy cement, as this is now an approved method in commercial industry, and seems to work. But using a pin is advisable as a double precaution against the handle falling out. The pin fits in a hole drilled through metal and wood. This is a force fit and the pin has to be gently tapped in with a mallet. (See fig. 9-40, in which the pins are visible.) The pin should be made of silver. Pewter is too soft for making such a part. Pins and hinges should never be riveted. The pin should fit perfectly, with a tight fit that holds itself in by friction. In this way, if the handle ever breaks and has to be replaced, the pin can be tapped out easily.

Fig. 9-42. The grain of the handle should be carefully planned so that it does not run across any of the narrow details, as shown, incorrectly, here.

Fig. 9-43. Instead, the grain should be diagonal so that there is always long grain in each contour.

Remember that, following in the best tradition of pewtersmithing, you are making these pitchers and cups not just for yourself, or just for today, but for people in many years to come. If constructed properly, artworks in pewter should live a lot longer than we do.

10. Decorative Boxes

Bending Metal,
Hinging,
Setting an Enamel or Knob, and
Fitting a Cover

We all live in boxes. They offer a form of security. We all like to have a very special secluded spot to hide things in, too. I suppose there is a certain assurance in it or perhaps simply a whimsical desire to return to childhood reveries of treasure chests. In any case, boxes seem to hold a special fascination for most of us.

For the craftsman, they offer a whole new field for creativity — for play, a freedom to go outside one's self, an excuse to be extravagant. Boxes are salable because they offer the buyer a chance to be extravagant for a functional object — an expensive stamp box for the man who has everything! No one really needs an expensive stamp box but it will sell more readily than an expensive painting because the buyer can indulge himself in the belief that he is buying a functional object as well as work of art.

Boxes don't really have to hold anything. They can be merely guises for creative expression. They offer a wide scope for new ideas, and contain limitless technical challenges, as well as a chance to practice such basic skills as bending metal, hinging, setting decorative pieces, and fitting covers.

Bending metal

Start with a very simple rectangular box (fig. 10-1). First, determine the length, width, and depth of the box. Then make a pattern from these dimensions, using the length of the box, width of the box, plus twice the depth of the box (fig. 10-2). This pattern, which represents the bottom and long sides of the box, is cut out from the metal, and an amount equal to the depth of the box is marked off and scribed on each side with a marking gauge set to the depth of the box (fig. 10-3). Hold the block of the marking gauge tightly against the edge of the metal and draw it along, letting the scriber in the marking gauge make a mark that exactly parallels the edge of the metal. Do this for both sides. Lay the piece of metal on a piece of scrap wood or heavy corrugated cardboard. Using a steel straight-edge that has a strip of tape applied to the back to keep it from slipping, take a scoring tool, and score several furrows on the scribed lines (fig. 10-4). This cuts out enough metal so that a bend can be made at a mitered angle. The groove should be scored about half way through the metal (fig. 10-5). If you

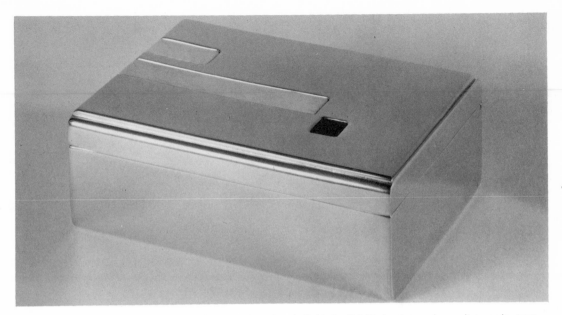

Fig. 10-1. Decorative box, pewter, ivory, ebony, by Marion Ray (photo by Hobbs Studio). The box has a mahogany lining and an inset hinge.

Fig. 10-2. Pattern for a box. This pattern shows the relation of the bottom and the two long sides. The dimensions, of course, are optional.

Fig. 10-3. Bending the box. First use a marking gauge to mark off and scribe the lines for the sides.

Fig. 10-4. Score these lines with a scoring tool.

Fig. 10-5. The groove should be about halfway through the metal.

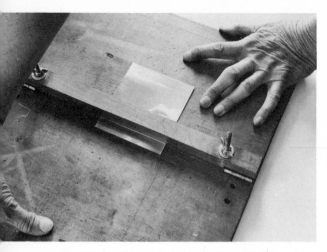

Fig. 10-6. Place the piece in the bending jig so that the line of scoring barely shows.

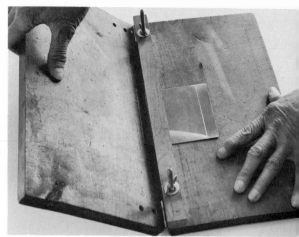

Fig. 10-7. Raise the loose flap of the bending jig slowly.

Fig. 10-8. Then check to see that the corners are right angles.

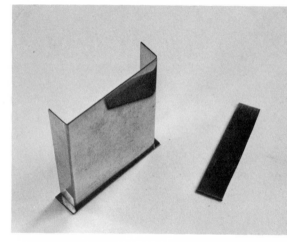

Fig. 10-9. When cutting the end pieces, leave extensions of 1/16 inch on each of the three sides to make a shelf for the solder.

score too deep — more than half way through — the metal might crack or break. If you do not score deeply enough, the bend will be quite rounded and possibly irregular.

Next, put the piece into a bending jig, and tighten the bending board with the thumb nuts (fig. 10-6). Leave the line of the scoring so that it barely shows beyond the bending bar, and raise the loose flap of the bending jig rather slowly (fig. 10-7). If it is raised up too quickly, the side might break right off. If it is raised up slowly, the bend will come out clean and neat. Turn the piece, and bend the other side in the same way. Check the corners to see that the sides are bent at right

angles. If not, adjust them by hand so that the top measurement at each end of the box is the same (fig. 10-8).

The two end pieces should be cut to extend approximately ¹⁄₁₆" beyond the bottom and beyond each side of the box (fig. 10-9) and then cleaned. The extension leaves a little shelf for the solder pellets. Use 63-37 solder. Later the extension will be trimmed away. Solder the ends by standing the box up on the pieces that you have cut and cleaned (fig. 10-10).

Check to see that the top of the end piece is placed even with the top of the sides, and after both sides are soldered trim away the excess

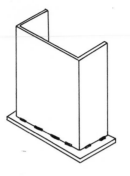

Fig. 10-10. Solder one end by standing the box body on it, and then reverse for the other end.

Fig. 10-11. After soldering, trim the excess metal with straight-edge or aviation shears.

metal with straight-edge shears or aviation shears (fig. 10-11). Cut as closely as possible without cutting into the body of the box itself. The box is protected during filing by a piece of masking tape placed about ⅛" from the trimmed seam. The seam can be filed cleanly without scraping the body of the box by holding the file flat (fig. 10-12). With the file, round off the burr that is left. Remove the tape, and clean any sticky residue away with a cleaning fluid such as carbon tetra-chloride, so that the adhesive will not be transferred to the buff. The body of the box is now ready to buff.

Hinges

Simple hinge. The cover that will be hinged to the box is easily made. Draw a pattern for the cover from the dimensions of the body of the box, but plan it a bit larger than the box all around, which is necessary for the type of hinge being used. In the box described here the cover overhangs about ⅛" at each end, ⅛" at the front, and approximately ³⁄₁₆" at the back. This leaves just a little extra for the application of the solder and also a little stop to keep the box cover from opening too far. Then cut it and file it as you would any flat piece of metal.

This hinge lies on the outside of the body of the box and is attached at every other knuckle to the body of the box. The remaining knuckles are attached to the cover. This hinged cover opens beyond a right angle, and therefore is more suitable for lightweight covers and for small boxes that will not tip over when opened this wide.

Fig. 10-12. Finally, file the seam clean, holding the file flat so as not to scrape the body of the box. Masking tape is used to protect the box against a slip of the file.

Hinges usually consist of an odd number of segments of tubing. The more segments that are used, the stronger and more stable the hinge will be.

For this simple box, use only three sections of nickel-silver tubing, approximately ³⁄₃₂" in diameter. Such small tubing, if it were pewter, would melt very easily during the soldering and would not be strong enough to stand the wear and tear of opening and closing the box many, many times. Sterling-silver tubing is more easily obtainable than nickel-silver tubing, and is practical to use except that it tarnishes very readily. Nickel silver is the best color match for pewter, is

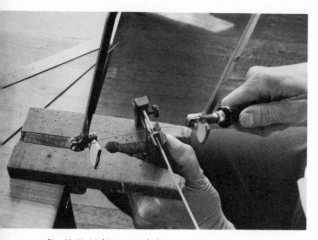

Fig. 10-13. Making a simple hinge. A tube grip holds the tubing while you cut it with a jeweler's saw.

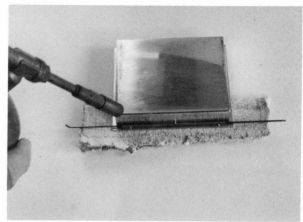

Fig. 10-14. Tack the long middle section of the hinge to the body of the box with one small pellet of solder, and then tack each end section to the cover.

also a non-tarnishing metal, and is very hard.

After selecting tubing of a suitable diameter, get hard-drawn, hard-tempered, nickel-silver wire to fit the inside diameter of the tube. Tubing can be cut by hand and eye, but it is difficult to get a square cut and an exact measurement this way. Square cutting and fitting is necessary so that the hinges don't bind in closing, and no gaps show. It is advisable, therefore, to have a tube grip, which is designed to cut tubing accurately. It has a moveable block that can be set at a specified distance from the cutting slot. It is then screwed tight with a thumb screw so that each time the tubing is moved up to the stop, sections of equal length are cut, using a fine blade on a jeweler's saw (fig. 10-13). If you are making many boxes, cut tubing segments in the necessary lengths, and store them for future use.

This box hinge has one long middle section that will be attached to the box body and two shorter sections that will be attached to the cover. The length of the entire hinge should not be longer than the box, of course. Cut the two end sections so they extend the hinge to about ⅛″ from the end of the body of the box on each side.

Insert the hinge wire, or pin wire, into the tubing and let the cut tubing with wire lie alongside the body of the box. Prop up the box cover with a piece of heavy asbestos sheet that holds it at a very slight angle, and place the box on top of the cover with the predetermined overhang on each side. Space the hinge properly against the box, in contact with both box and cover.

The long middle section of the hinge is tacked to the body of the box with one small pellet of solder, and each end section is tacked to the cover (fig. 10-14). It is very important that these end sections be firmly in contact with the middle section, so that there is no space between them, or the hinge will have a sloppy fit. The end sections are tacked by placing a pellet of solder at the far end of each piece. In this way, if it starts flowing too much during tacking, it will not reach the middle section and lock up the hinge. After the three pieces are barely tacked, remove the pin wire.

The middle hinge section is completely attached to the body of the box by adding another pellet or two of solder. Never fuse all of the solder at one time. If you apply heat over the entire hinge section, the tacked spot will open up and the hinge could roll away. One end can be soldered, permitted to cool for a few seconds, and then the other end soldered until the whole piece is completely in contact with the body of the box. Follow the same procedure with the end segments on the cover. The pin wire is now simply inserted back into the hinge tubing. If the fit is a bit tight, file down the wire with emery paper or steel wool.

The set-in hinge. The set-in hinge is practical to use on a box with a heavy cover, such as one with an applied decoration like an enamel, stone, or piece of wood. A heavy cover should open only to a right angle so that the box does not tip over. The set-in hinge is what prevents it from opening wider.

Three sides of the box body are made the same depth and the back side, upon which the hinge will be applied, is made shorter by the width of

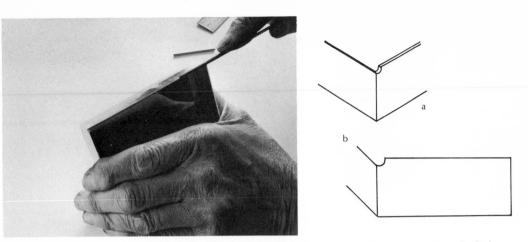

Fig. 10-15. Making an inset hinge. This photograph and drawing illustrate how to make the space necessary for the hinge.

the diameter of the hinge tubing. A round gap is filed in the joining edge of each side (fig. 10-15 a, b), deep enough to accept the hinge tube and allow it to drop in flush with the back of the box. The end sections of the hinges will then, of necessity, be soldered to the body of the box, and must extend beyond its ends far enough to make a little shelf for the solder pellets (fig. 10-16). The pellets will thus be held in place, and the molten solder will not flow inside the tubing, causing an obstruction to the passage of the pin wire or freezing up the hinge.

Having tack soldered the end sections to the body of the box, you should place the box on the cover and tack solder the alternate hinge sections (fig. 10-17). Be extremely careful that the solder doesn't flow beyond the joining of each section. This would lock the hinge, spoil the box, and cause you a great deal of trouble in unsoldering these parts.

From here on, treat the box the same way as for the simple hinge. Remove the pin and flush solder each section so that the whole hinge joint is soldered in contact with the box and cover.

Fig. 10-16. The end sections of the hinge are soldered to the body of the box.

Fig. 10-17. The alternate sections of the hinge are then tacked to the cover.

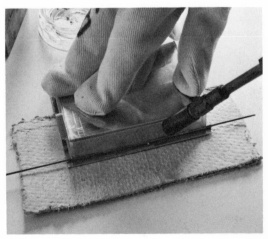

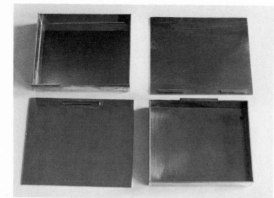

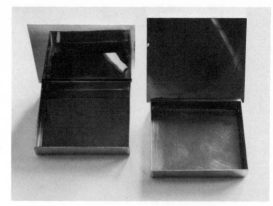

Fig. 10-18. Both inset hinge (left) and simple hinge (right) allow the cover to lie flush on the box. In the inset hinge the end sections are on the body; in the simple hinge they are on the cover.

Fig. 10-19. The inset hinge (left) opens only at a right angle and the simple hinge (right) opens beyond a right angle.

Fig. 10-20. Making a book hinge. File a groove, through the middle of the two bearings, that equal the circumference of the hinge tubing.

Fig. 10-21. If the hinge is to open full swing, the groove is filed to half the diameter of the tubing.

Fig. 10-22. If the hinge is to open at a right angle, the groove is filed the full depth of the file into a U-groove.

Figures 10-18 and 10-19 show that a box with a simple hinge (right) opens beyond a right angle, and a box with an inset hinge (left) opens at a right angle because it is stopped by the hinge's flush contact with the back of the box. (The inset hinged box shows a reflection of the body of the box in its cover.)

The book hinge. A book hinge is an offset hinge that is often used for the covers of coffee pots, tankards, and other round objects. Straight hinges cannot be used on curved surfaces. The leaves (or bearings) of this hinge should be made of a heavy-gauge pewter, the thickness of which equals or is greater than the diameter of the tubing used. The book hinge in Figure 10-20 is 10-gauge pewter with a hinge tubing $3/32''$ thick.

Cut two pieces of metal and place them together in a ring clamp. File a groove, the size of the circumference of the tubing, down through the middle of the two bearings (fig. 10-20). To facilitate this, a bevel is sometimes filed on the inner side of the bearings before they are put into the clamps. The bevel makes a little channel in which to place the file. A half-round file or joint file can be used, but a joint file is preferable because it is the same thickness over its full length.

The groove must be filed to a depth determined by the angle or arc to which you want the hinge to open. If the hinge is to open a full swing, the groove is filed to half the diameter of the tubing (fig. 10-21). If it is to open only at a right angle, the groove is filed the full depth of the file into a U-groove rather than a semi-circle (fig. 10-22). Filing to varying depths will vary the angle the hinge is to open, and this angle is decided by the weight of the cover.

Fig. 10-23. After filing the groove, solder the hinge by holding it in a ring clamp.

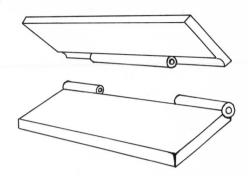

Fig. 10-24. Attach part of the hinge tubing to the cover bearing and part to the bearing that will go on the body of the piece.

Solder the hinge to the bearings by holding it in a ring clamp (fig. 10-23). The knuckles of the hinge will be in an odd number, and the greater number of them are applied to the bearing attached to the body of the article rather than to the one on the cover (fig. 10-24). If you are applying the hinge to parts that come together flush, cut the bearings of the hinge to equal dimensions. In the case of a tankard or an article with an overhanging cover, cut the bearing of the hinge that will be attached to the cover shorter than the one attached to the body of the tankard.

The only way you can tell where they should be cut is by measuring them against the parts themselves. The measurement is determined by the amount that the hinge is to be offset from the body of the tankard.

First, the body of the tankard is traced and scribed onto the bearing of the hinge (fig. 10-25). Allowing for its slight overhang, the cover is then scribed onto the upper bearing (fig. 10-26), which is the shorter bearing in this case. The hinge is then cut, fitted, and held in place while it is soldered with 63-37, first to the body and then to

Fig. 10-25. To attach the hinge bearing, first trace the outline of the body of the piece onto one bearing.

Fig. 10-26. Then, allowing for a slight overhang, trace the outline of the cover onto the other piece.

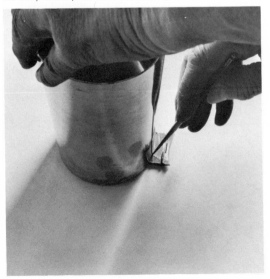

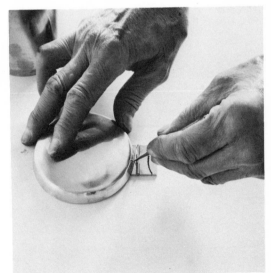

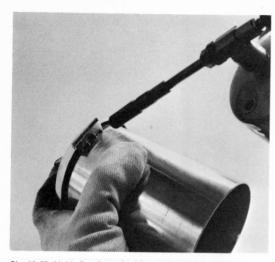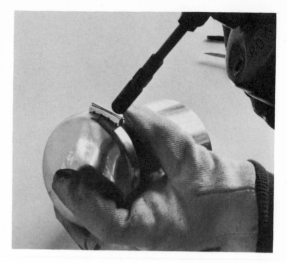

Fig. 10-27, 10-28. Cut, fit, and solder the bearings in place.

the cover (figs. 10-27, 10-28). You may apply yellow ochre to the knuckles of the hinge to protect them in the second soldering if you are worried that they will open up, but if you use the lower melting solder they probably will not be disturbed.

Setting an enamel or knob

The frame setting. One of the most practical ways to set a rectangular or nearly rectangular enamel is in a frame setting (fig. 10-29). This method lends itself quite well to compensating for the irregularities of a shape that does not have exactly squared corners.

To begin, make a rectangular backing for the enamel of light plywood or ⅛" hard-pressed Masonite, which is more practical because it will not warp or twist. Measure the enamel and make a rectangle that will fit under it, extending approximately ¹⁄₃₂" all around. If the enamel is irregular, some areas will be more than ¹⁄₃₂" from the edge, but the frame will compensate.

Fig. 10-29. Box by Frances Felten with enamel by Kate Neufeld set in cover.

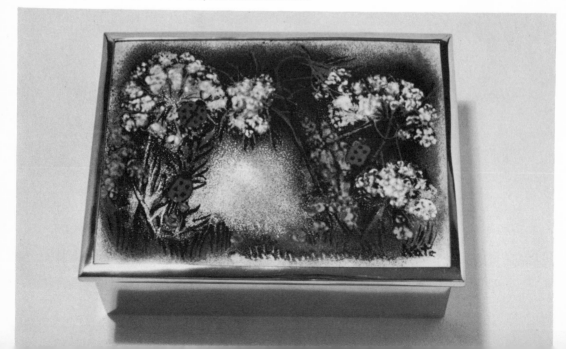

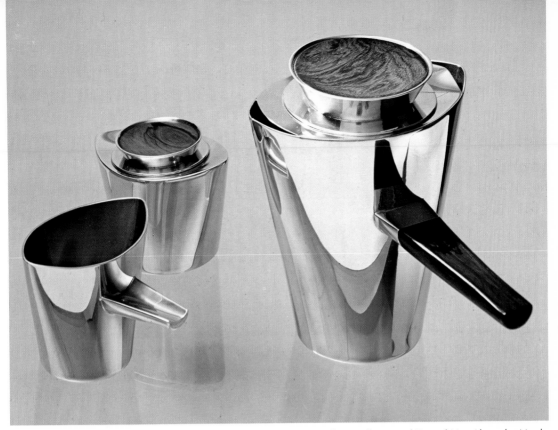

Coffee service for ambidextrous people, with rosewood, by Frances Felten (collection of Dr. and Mrs. Alexander Marsh; photo by Malcolm Varon).

Coffee service with plique-à-jour enamels reflecting in covers, by Frances Felten and Shirley Charron (photo by Malcolm Varon).

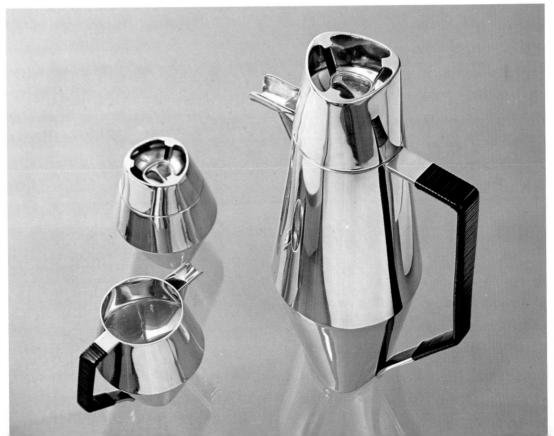

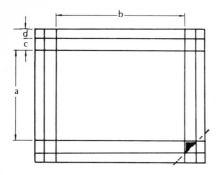

Fig. 10-30. Pattern for frame setting; a represents the width of the backing for the enamel; b represents the length of the backing for the enamel; c represents the combined height of the backing and the enamel; d represents 3/16-inch allowance for turning over the enamel. To make the corner, cut at the dotted line and then cut out the area specified by the black triangle.

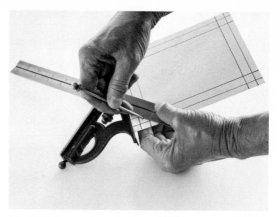

Fig. 10-31. Corner shown in Figure 10-30 is cut at a 45-degree angle.

Fig. 10-32. The black triangle shown in Figure 10-30 is snipped out with shears, leaving an extension equal to the thickness of the metal all around.

Fig. 10-33. After the sides of the frame have been bent up, the enamel is cemented to the backing and the two are in turn cemented to the cover frame.

Plan a pattern for the actual metal frame to go under the Masonite or wood backing (fig. 10-30). The frame's extension on all sides should equal the height of the backing plus the height of the enamel plus about $^1/_{32}''$ allowance for the turn-over and $^3/_{16}''$ beyond that for the framing itself. This piece must be drawn with a square, and scribed exactly on the metal to fit. Use 20-gauge pewter. Make sure the corners are square — this should be a perfect rectangle.

The miter, or bevelled corner joint, on a frame is usually a 45° angle, so a piece must be cut off at each of the joining edges at a 45° angle to the point where the ends of the frame will meet (fig. 10-31). The left-over corners — those that will be folded in over the enamel — are snipped out with shears, leaving an extension equal to the thickness of the metal all around (fig. 10-32). This will allow for neatly soldered corners. This extension is filed at a 45° angle so that when the frame is bent up, these upper mitered corners will also come together in a flush joint above the enamel itself.

After the miter is cut, score along the scribed lines about halfway through, bend on the inside line, solder at the corners, and file smooth. Then cement the enamel to the Masonite backing with contact cement, and cement the backed piece in turn into the metal box-like frame, making sure that the fit is tight and perfect (fig. 10-33). It is

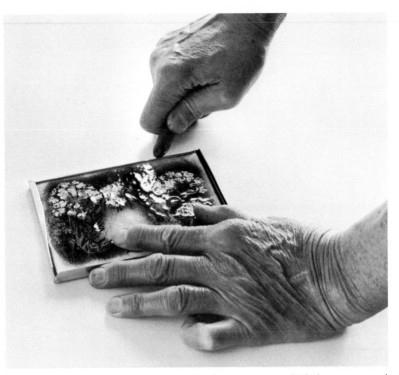

Fig. 10-34. Using a wooden burnisher, start bending the outer segment of side down over enamel.

important to place it in very carefully so that there is no need for pushing afterward, which might crack the enamel.

Using a wooden burnisher, start to fit the top part of the frame by bending the outer line of metal over the enamel (fig. 10-34). Don't try to press the whole side down at once. Start in the middle of one side, and work toward the corners. Remember to press against the edge of the hardboard backing and not against the enamel. Work down the metal very gradually to the surface of the enamel, a bit at a time, and work each side out from the middle toward the corners. No matter how careful you have been in measuring and cutting, you may find that the corners do not meet accurately. In that case, use a knife-edge needle file to file away a bit of the upper mitered corners to make them fit down on the enamel in a perfect 45° joint. The enamel can be protected during filing and buffing with an old sheet of x-ray film, which is ideal for this purpose. It is very

tough, and it takes a lot of filing to cut the surface.

Solder the corners of the frame with 63-37 solder — it gives the best color match. Cut the solder pellets very fine because the thin-gauge metal of the frame cannot stand too much heat. Let the solder stand high in lumps and file it away rather than trying to fuse it right down into the joint, because it could get underneath the frame and make a bump in the smooth surface.

If hinges are to be applied directly to this cover, they should be applied before the enamel has been inserted and fitted into the frame of the cover. It is more difficult to solder the hinges on after the enamel is inserted because you have to solder against closed space and dead air. After the hinges are on, the cover must be placed on a piece of wood or the edge of a table, with the hinge sections overhanging, during any subsequent work. This is to prevent you from distorting the top by pressing against the hinge sections.

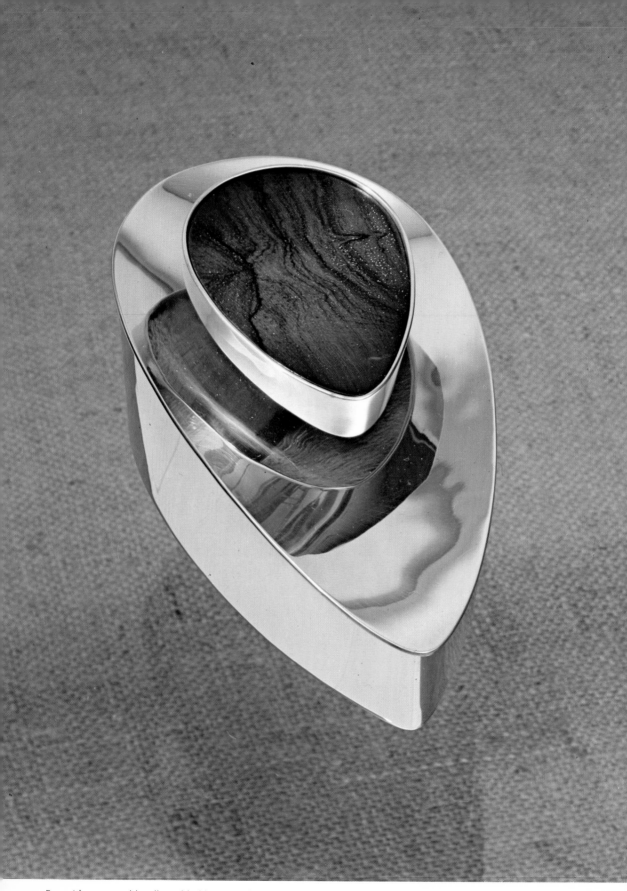

Box with rosewood handle and hidden avocado enamel by Frances Felten. The enamel reflects in the cover (collection of Mrs. Harry Nair; photo by Malcolm Varon).

The band and double-band settings. The band setting is another way to set a decorative piece on a box top. The band may be applied directly to the box top or it may be put into a knob or raised handle for picking up the cover. Figures 10-35 and 10-36 show the use of a double-band setting in a most exquisite yet functional way. In both cases the double band, which consists of an outer band running the entire vertical length of the setting and an inner band that sits on top of the decorative piece, protects a delicate plique-à-jour enamel that easily could be broken if it were not enclosed in a sturdy, high "fence." (Fence is the metalsmith's term for this sort of band.) The height allows the enamel to reflect in the band as well as on the cover, and makes a very elegant, practical setting.

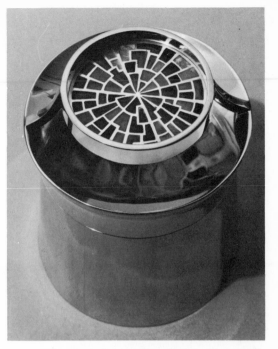

Fig. 10-35. Cannister by Frances Felten with plique à jour enamel by Margaret Seeler (photo by Margaret Seeler), purchased for Johnson Wax Company's "Objects USA" travelling exhibit.

Fig. 10-36. Candy box by Frances Felten with plique à jour enamel by Margaret Seeler (collection of Henry Pasco; photo by Margaret Seeler).

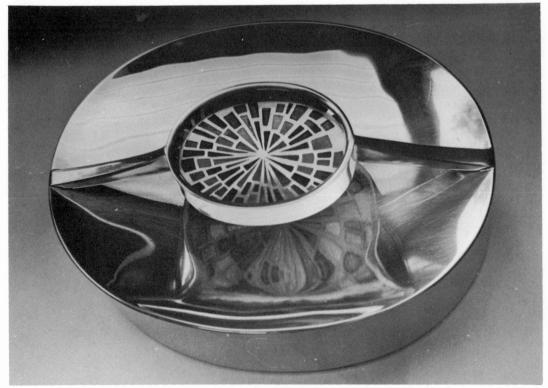

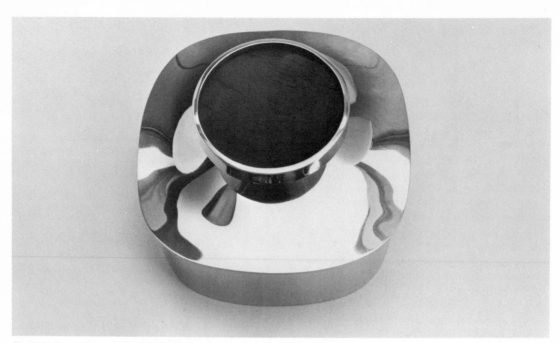

Fig. 10-37. Box with wooden knob in double-band setting, by Frances Felten.

For the wooden knob set in a double-band setting, shown in Figure 10-37, it is essential to make and fit all parts before they are assembled, and to assemble them in the correct order. An outer band (fig. 10-38, c), is made to go around the wood (b) so that it will fit quite tightly. It should be as nearly perfect a fit as possible. The band is made of heavy 14-gauge pewter, and cut to stand about ¼" higher than the piece being set. If the edge of the wood is perfectly regular, this fence can be used just as it is without an inner band. The inner band (d), however, adds richness and protection that are worth the extra hazard of soldering it. The inner band (d) should fit very

Fig. 10-38. Making a double-band setting. Cover of box (a), wooden knob (b) outer band for wood (c), inner band for wood (d), table (e), and post (f) must be assembled.

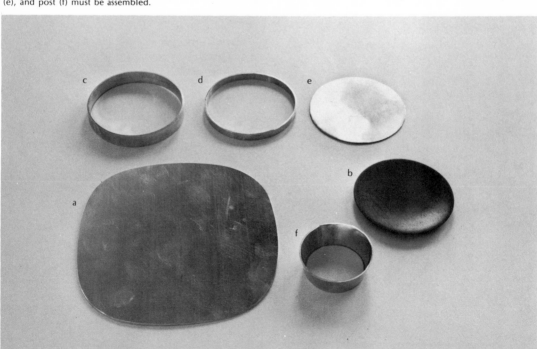

tightly inside the outer band, or fence — tightly enough to require a force fit. No gaps or spaces should show between the two bands. The inner band should stand slightly higher than the outer one, by at least $\frac{1}{32}$" which will form a ledge for the solder pellets.

A flat table (e) under the two bands, similar to a setting for a cabochon stone, must have a small hole cut in it so that if the wood should get stuck while fitting, the set piece can be poked out from underneath. Make the table just slightly larger than the wood, and scribe the diameters of the top fence and bottom post (f) on it before you cut the hole in the table. The post gives the knob height, and may be made in any form you want. In the post illustrated here a conical development produces a tapered cone. Measure the circles to be scribed on the table very carefully so that they are centered. On the top surface of the table scribe a diameter equal to the outside of the *fenced* wood piece. On the bottom of the table scribe a diameter equal to the diamter of the end of the post you will attach to the handle.

Now, having formed and fitted all the parts, go on and assemble them. It is advisable to do the buffing steps as you go along because some places are difficult to reach after the setting is put together. Solder the outer band to the top of the table (e), where the diameter has been scribed. Solder the post to the underside of the table, where the diameter has been scribed, so that it comes directly under the center of the table.

Clean and buff these parts now, as the post will not be reached easily later on. Solder the post to the center of the box cover (a) which has also been pre-buffed. Next, cement the wood on the table with contact cement or epoxy. Be sure that you set it in very carefully and press down tightly, so that there is firm contact and the wood is not tipped. The inner band is now put in over the wood. See that the seam in the inner band is not placed directly over the seam in the outer band. Stagger them, or they will open up in the second soldering. Use yellow ochre on the inner seam of the inner band and use 300 solder on either side of both these seams in the soldering process.

Be sure that you have firm, tight contact all around between the two bands and between the inner band and the surface of the wood. When the fit is perfect, line pellets of 63-37 solder all around the ledge formed by the bands and proceed carefully to solder (fig. 10-39). Remember that the wood is in there! You can protect it with a sheet of asbestos, but the wood will not be scorched unless you are careless with the torch.

However, a sheet of asbestos or x-ray film should be used to protect the wood during filing. Use a coarse file first, then a finer, single-cut mill file. File away the protruding bit of inner band so that the whole double-band shows as one level piece of very heavy metal. Leave the asbestos in place during the buffing, too. A light touch here, so as not to pull out the solder from the seam.

Fig. 10-39. When the fit between the two bands is perfect, line solder pellets all around, and solder the bands together.

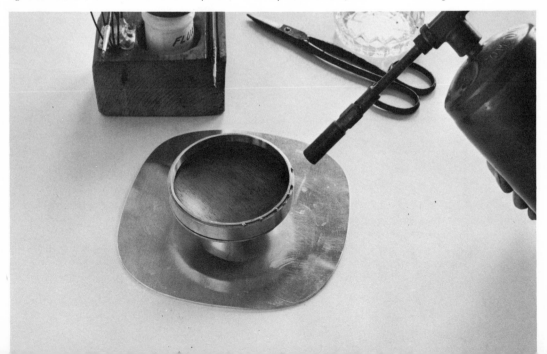

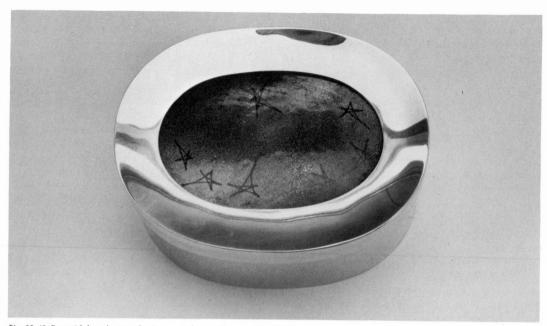

Fig. 10-40. Box with bezel setting by Frances Felten, with enamel by Ann Landis.

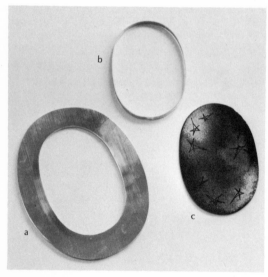

Fig. 10-41. Making a bezel setting. Cut-out for cover (a), bezel band (b), and enamel (c) must be assembled.

The bezel setting. The bezel setting is unique in that the enamel, stone, or piece of wood is set underneath the cover itself (fig. 10-40). Such a setting is particularly necessary when the enamel is burned, or is irregular around the edges, or is misshapen in any way. A slab of stone that is quite irregular around the outside can still be successfully set if the irregular part is hidden by the bezel setting. In jewelry-making, a bezel is a thin piece of metal that is formed in a band and pushed over a stone to hold it in place. In this case, we are using a bezel band setting on the underside of a cover to hold an enamel in place. You may want to use this setting for purely aesthetic reasons, as well as for problems that demand it.

The cover is cut out of rather heavy stock, 14-gauge at least, so that it will visually show that the enamel is sunk below the top level. The hole in the cover, of course, should be slightly smaller than the enamel itself so that it covers the top edges of the enamel and holds the enamel in place. The bezel, or band, is fitted to the enamel and seamed (fig. 10-41). Use a thin gauge here, 20 or 22. The band doesn't have to fit perfectly as long as it can be bezeled over the underside of the enamel to hold the piece so that it doesn't shake. If your enamel or decorative piece is irregular, you can use bezel prongs, attached on the underside of the cover, rather than a bezel band.

Apply a little epoxy on the underside of the enamel before you set it, which ensures that it will stay in place. It will adhere to the small ledge, on the underside of the cover, that is inside the bezel band. Remember, the hole in the cover is slightly smaller than the enamel itself for this reason. The

bezel band is now soldered to the underside of the cover with 63-37 solder, and 300 on the seam. The bezel is held on by hair-clip clamps and asbestos (fig. 10-42), and is heated from underneath. This is important — if you were to heat such a thin gauge from above, it would probably melt before the solder reached the correct melting temperature, and began to flow. Instead, the heat of the flame is directed at the heavier piece of metal, and the heat from this piece causes the solder to flow without causing harm to the bezel band.

The enamel is set face down into the cover, which serves as its frame. A wooden burnisher is used to push the bezel down over the underside of the enamel (fig. 10-43). This has to be done with great care, a little at a time, until the fit is perfect. You now have an enamel sandwich — cover holding the enamel in on top and bezel holding it in below. If your cover is to have a band to hold it in place on the box (see below, this chapter), it is preferable to add it after the enamel is bezeled in. It is much easier to use the burnishing tool without being confined by the band. Figures 10-44, through 10-52 show a variety of ways you can apply these setting principles to make interesting, individual, and highly decorative boxes.

Four ways to fit a cover without hinging

Some containers need covers that fit more closely than hinged covers. This fit is achieved by attaching a band to either the body of the container or to the cover. Bands are usually made of 16-gauge pewter, cut to any desired width, or made of wire. The wire is often ¼" wide by ¹⁄₁₆" thick or ⅜" wide by ¹⁄₁₆" thick.

Band attached to inside of cover for close fit. First, of course, you make your box in any shape you desire. If it happens to be a cannister that will be picked up a great deal (see fig. 10-46), a wide band on the inside of the cover prevents the cover from falling out when the box is handled. If it is an ordinary box cover that will be lifted off by a handle, the band may be narrow. Usually a band of about ¼" wide is wide enough to hold firmly and narrow enough to slip out of the box easily.

In fitting the band to the box, make a slip fit that can be removed easily. Put a strip of masking tape on the outside of the band wire. Fit this taped wire strip inside the box as tightly as you can, with the piece of masking tape between the box and the band. Push it together tightly, mark for your cut-off, and cut off the excess end of the band.

Fig. 10-43. The bezel is pushed down over the enamel with a wooden burnisher.

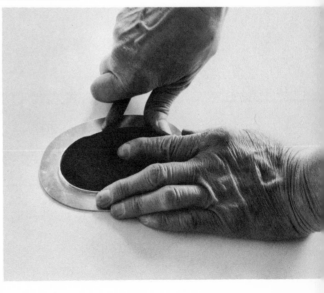

Fig. 10-42. First the bezel is soldered to the underside of the cover cut-out by heating from underneath.

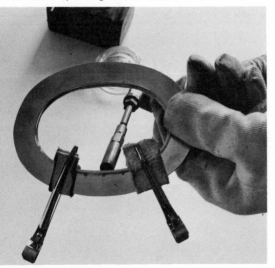

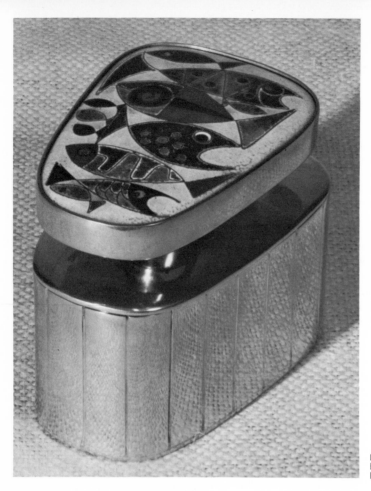

Fig. 10-44. Box with cloisonné enamel top by Hilda Kraus (photo by James Lubbock).

Fig. 10-45. Stamp box with ivory and cloisonné enamel cover by Shirley Charron.

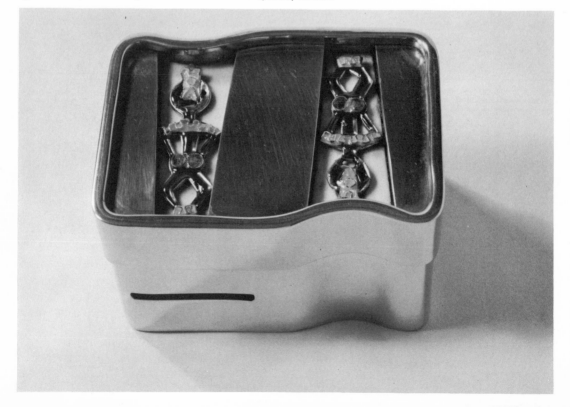

Remove the masking tape, clean the metal well at the point where it will be soldered, and solder the band together into a ring. Refit it in the box — you'll find that you have a perfect slip fit. The masking tape has taken up just enough room to space the band accurately. A piece of wrapping paper can also be used as a spacer between the box and the cover.

The band is then flattened with a mallet on a flat surface such as a surface plate or a piece of very level plywood so it will lie flat on the cover. Then it is leveled on an emery board so that it will fit perfectly onto the cover of the box. Solder the band onto the cover, making sure the band is exactly centered. Hold it with clamps and asbestos protection (see figs. 8-8, 8-9). Protect the inside seam with yellow ochre, use small pellets of 300 solder on each side of the seam, and solder the rest with 63-37.

If you find that the banding still seems to fit too tightly when the cover is put on the box, lay a piece of cloth over the box, and force the cover into it this way. When the cloth is removed, you'll find that your cover and box have been equalized so that the fit is perfect.

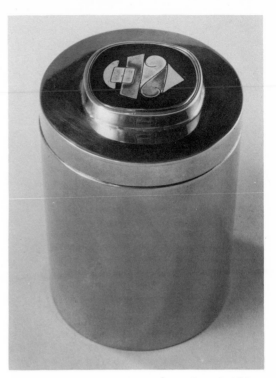

Fig. 10-46. Cigarette box with cloisonné enamel cover by Miriam A. Isherwood (photo by Paul Darling).

Fig. 10-47. Box by Frances Felten with cloisonné enamel by Margaret Seeler (photo by David Loeb).

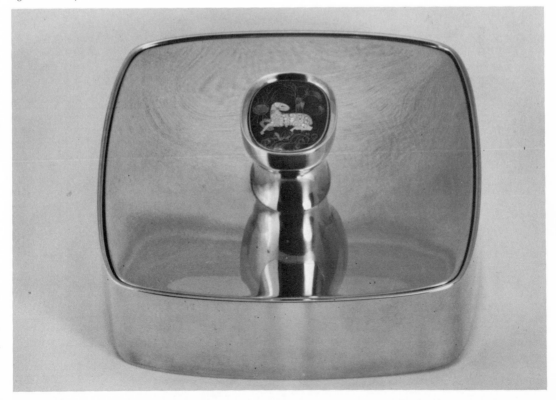

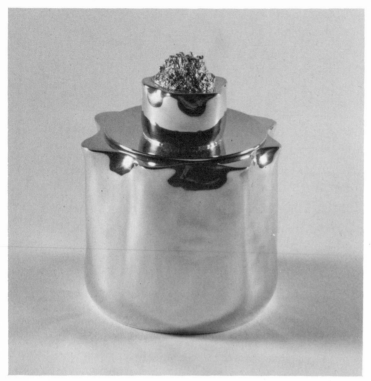

Fig. 10-49. *The Inner I,* box with moveable "eyelid" setting of a Brazilian agate, by Frances Felten. This is the closed position.

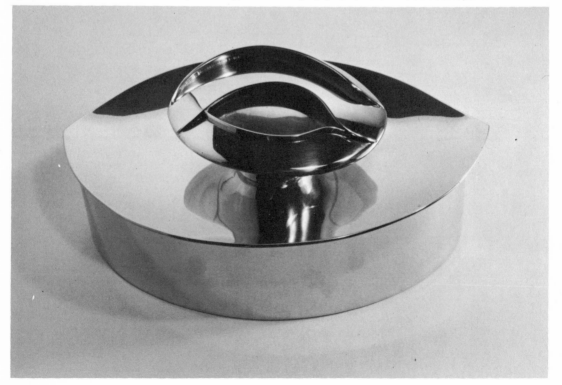

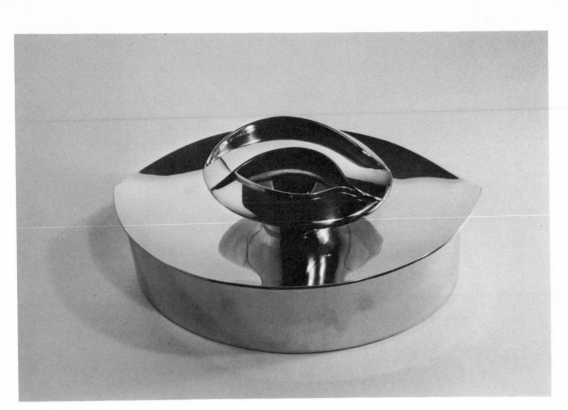

Fig. 10-50. *The Inner I,* half-opened position.

Fig. 10-51. *The Inner I,* opened position (collection of the author).

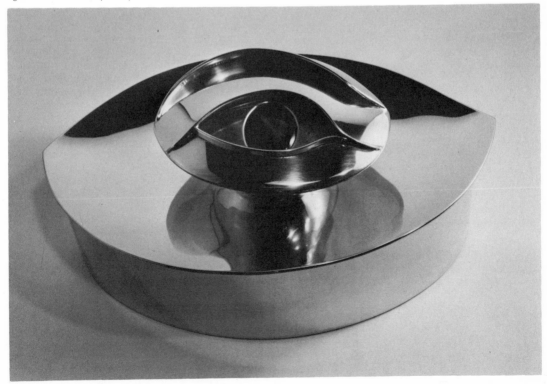

Fig. 10-52. Twin boxes by Frances Felten with cloisonné enamels by Margaret Seeler (collections of Mr. and Mrs. Daniel N. Lamb and Mr. and Mrs. Arthur F. Lamb).

Band attached to inside of box so cover sits "in" box. In making a cover that fits inside the box and comes level with the top of the sides, a band must be put inside of the box for the cover to rest on (figs. 10-53, 10-54). Measure the thickness of the cover and scribe a line just that far down inside the body of the box, where the cover will rest. Make the band and fit it so that it sits just slightly above this scribed line. This will enable you to force-fit the band after it is soldered together, by pressing it downward with a block of wood, so that it is exactly even with the scribed line.

Fig. 10-53. Box by Frances Felten with cloisonné enamel by Margaret Seeler.

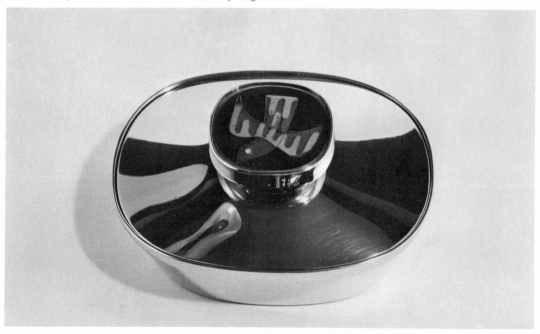

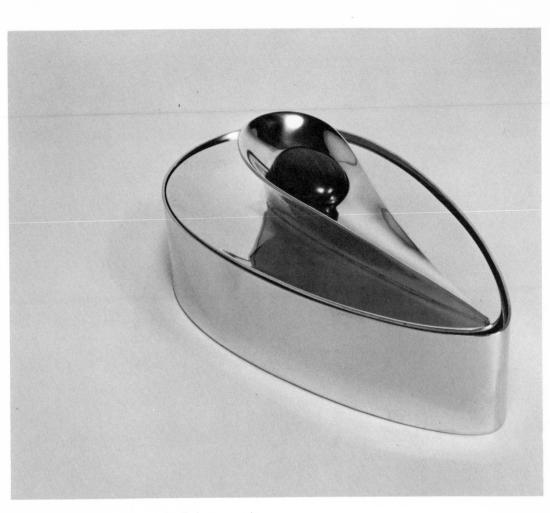

Fig. 10-54. Box with brown jasper set in handle, by Frances Felten.

Then solder it in place (fig. 10-55). How you finish the inside of the box will determine where you put the solder. If the box is going to be polished inside instead of having a lining, the solder pellets should be put at the top of the band and drawn through from the underside. If the box is to be lined, the solder pellets can be placed on the underside of the band, because it is more difficult to clean out the box body from below than above, and the lined box does not have to be cleaned.

The bottom of the box should not be applied until after the band is soldered and cleaned. It is possible to solder a band to the inside of a box that already has a bottom, but it takes an expert job of soldering to ensure that very little cleaning will be needed. If you are not an expert you probably will have to line the box with velvet or other suitable material if you have soldered after the bottom is attached.

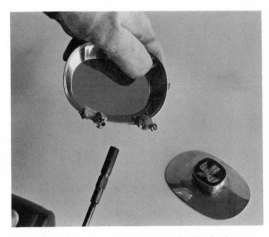

Fig. 10-55. Making a box with band on inside of body of piece.

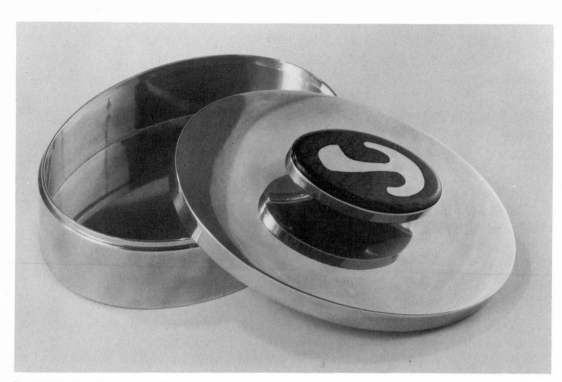

Fig. 10-56. Oval box with pewter inlaid in rosewood knob, by Miriam A. Isherwood (photo by Paul Darling).

Fig. 10-57. Box by Frances Felten (collection of Henry Pasco).

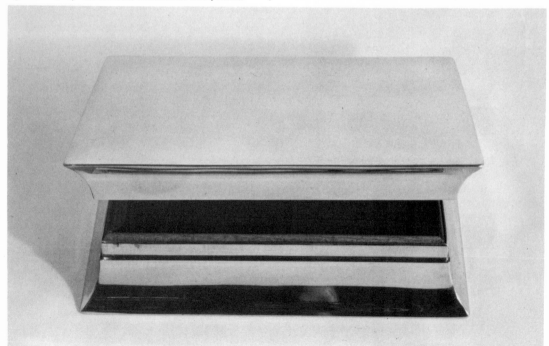

Band attached to inside of box so cover sits over band, flush with the side. This type of cover is recommended when a very tight or leak-proof fitting is required. In such cases a wide band, protruding out from the top as much as ½'' or more, is used. It is fitted cleanly and tightly and then soldered to the inside of the container using clamps and asbestos as before (fig. 10-58). The cover is fitted over that, tight and flush to the sides of the container, so that the meeting of the cover and box seems to blend into one piece (fig. 10-59).

Cover fitting loosely over top of box. This last way of fitting a cover does not involve the application of a separate band. Instead, the cover is planned and made with a slight allowance for slipping over the box body (see fig. 10-45). The band is part of the cover that fits over the box. It is treated like a band to get the fit and then the top is soldered to it to form the cover.

A strip of masking tape is placed between the outside of the container and the band part of the cover. This spacer is used to make sure the cover comes off easily and loosely. If the cover fits too tightly there is a danger that people will be tempted to pick up the box by the cover, which will not hold. When such a cover is put onto a box, some of the air is forced out, creating a partial vacuum. However, this vacuum is not strong enough to hold the weight of the box if it is picked up by the cover, and the box will fall off.

The cover band may be either narrow or wide, depending on your design. After the fit is right, a top is soldered to the band in the same way that a bottom is applied to a pitcher. The excess is trimmed away and filed. Now you have a cover that fits loosely over the top of the box.

Fig. 10-59. Then fit the cover tight enough to be flush with the sides when closed.

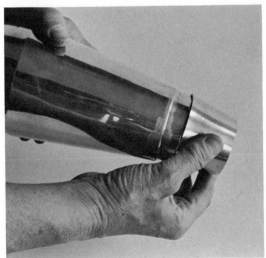

Fig. 10-58. Making a band for a very tight-fitting cover. Solder the band to the inside of the body of the piece.

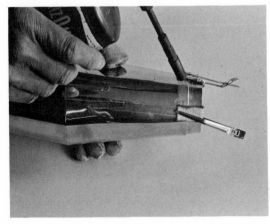

11. Flat Fabrication

Candlesticks
Salts

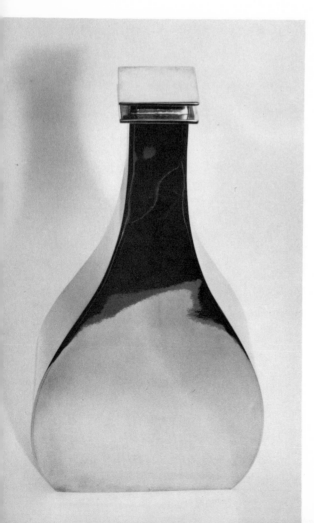

The skills acquired in bending metal and flat fabrication need not be limited to the making of boxes (figs. 11-1 through 11-4). The truly creative artist-craftsman will find endless possibilities for design by utilizing these techniques in the making of other objects and also, of course, by combining the various basic procedures (fig. 11-5, 11-6).

Wooden forms, wherever feasible, should be made to order to facilitate the work (see the description of hardwood forming stakes and molds in Chapter 4), especially in cases where production items are planned. These forms can act as aids in fitting, soldering, and buffing, and are extremely helpful when working with geometric or straight-line shapes, which must be kept true and regular.

Candlesticks (figs. 11-7 through 11-12) and "salts," the term for salt shakers in the early guild days in England, (figs. 11-13 through 11-17), have a long tradition in pewter-smithing, whether they are traditionally styled or "new fashion" as they once were called.

Fig. 11-1. Pewter bottle by Fred Pulsifer.

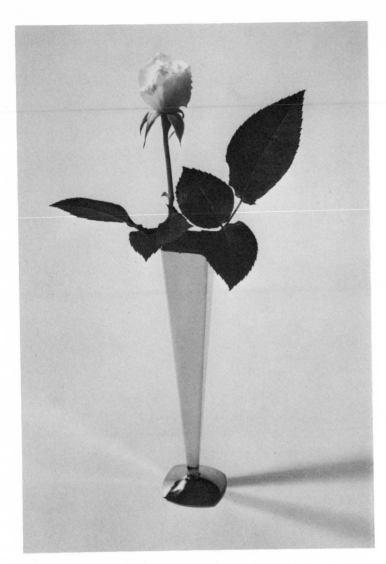

Fig. 11-2. Bud vase by Charles Maccalous.

Fig. 11-3. Candlestick by Shirley Charron.

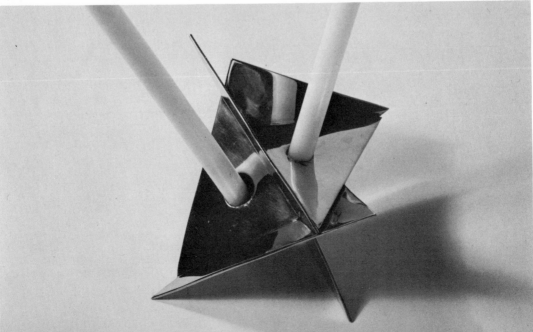

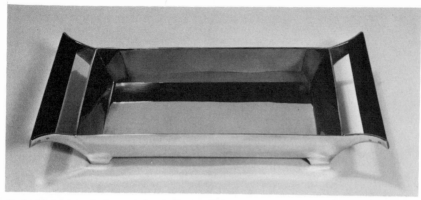

Fig. 11-4. Serving tray by Frances Felten (collection of Mrs. Harry Nair).

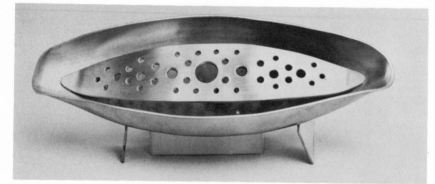

Fig. 11-5. Candlestick and flower container by Martha E. Overkamp (photo by Marion Wesp).

Fig. 11-6. Candlestick and flower container by Martha E. Overkamp (photo by Marion Wesp).

Fig. 11-7. Candelabra by Hilda Kraus (photo by Yvette Klein).

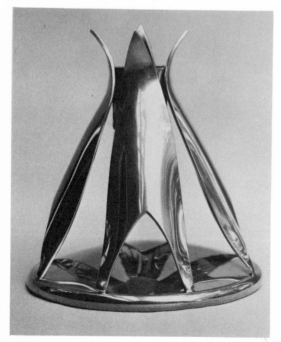

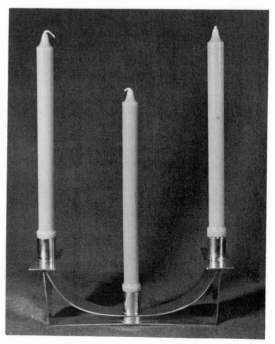

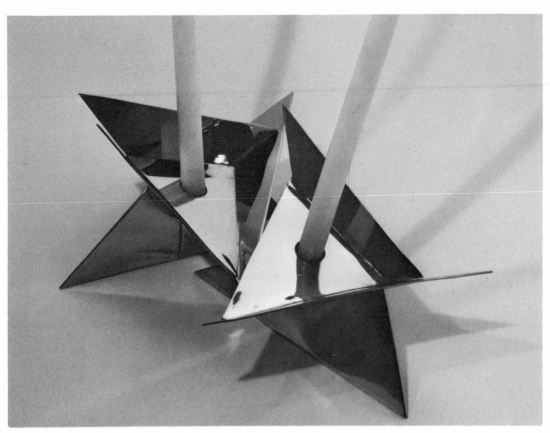

Fig. 11-8. Candlesticks by Shirley Charron (collection of Barbara Pennington).

Fig. 11-9. Candlestick with ebony inlay by Shirley Charron (collection of Barbara Herrick).

Fig. 11-10. Candlesticks by Fred Pulsifer (photo by Ben's Foto).

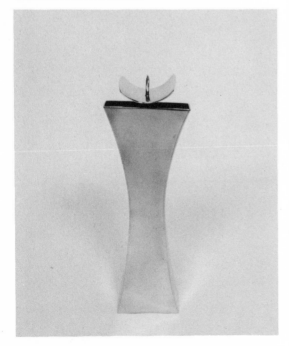

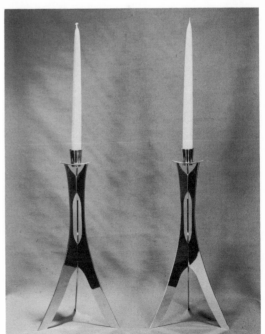

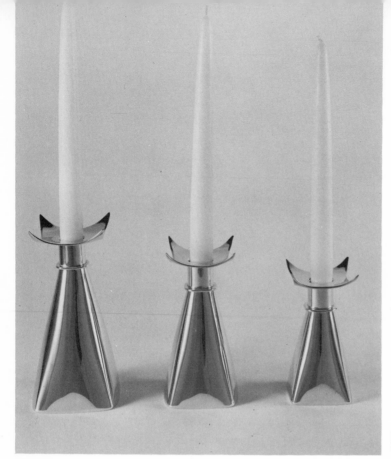

Fig. 11-11. Candlesticks by Marion Ray (photo by Hobbs Studio).

Fig. 11-12. Module candelabra by Frances Felten.

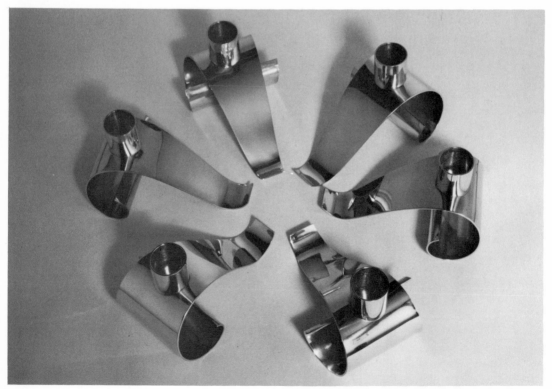

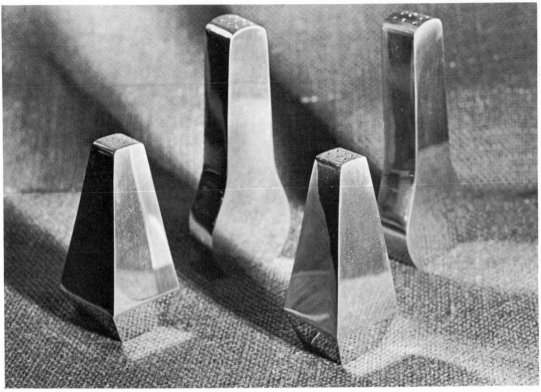

Fig. 11-13. Salt and pepper shakers by Ken Lundy (photo by Steven Levine).

Fig. 11-14. Salt and pepper shakers by Shirley Charron.

Fig. 11-15. Salt and pepper shakers by Frances Felten.

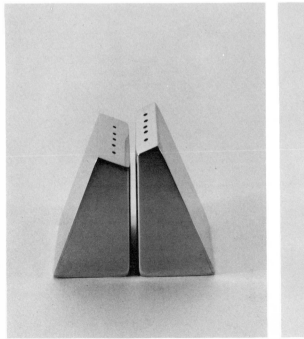

Fig. 11-16. Salt and pepper shakers by Shirley Wood

Fig. 11-17. Salt and pepper shakers by Shirley Wood.

Finishing is an art in itself. There are many ways to finish pewter. It may be antiqued, it may be finished with a soft, dull shine, or it may be finished with a soft, bright luster, as many contemporary pewtersmiths prefer it. Unfortunately much pewter is still finished with a dull patina. What this amounts to is a compliance on the part of manufacturers and craftsmen to the unenlightened taste of a general public who still think pewter must look tarnished. The early pewtersmith probably polished his pewter as brightly as we do ours, as it is man's nature to polish metal. Modern pewter has marvelous reflective qualities and should be given a chance

Fig. 12-1. Ice bucket by Frances Felten with enamel by Margaret Seeler (collection of Mrs. Edward Eyth). Flat surfaces offer a good opportunity for showing off the effects of high polish.

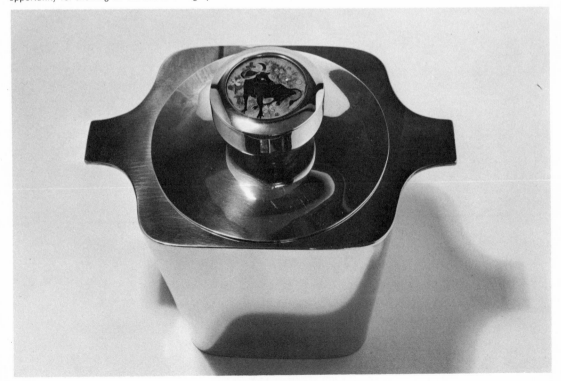

to shine — not with a bright, hard, surface gloss like chrome or stainless steel, but with a soft brilliant luster that permits it to pick up the color and life around it and give it back with a little of its own inherent quality. From the practical side, the highly polished surface is much easier to keep clean and, contrary to some beliefs, it does not pick up fingermarks as easily as some of the dull finishes. If it does pick them up, it's much easier to wipe them off a shiny surface.

Polishing materials and equipment

A variety of buffs, rakes, and gloves are shown in Figure 12-2. They are used, in conjunction with the polishing motor and compounds, in the finishing processes.

Motors. The best effects are obtained with motors of at least 2 speeds, and preferably 3 speeds. If a motor of only 1 speed is available (1750 RPM), it may be used with large buffs for work requiring speed — this set-up will travel more surface-feet-per-minute over the work.

The ideal set-up is a buffing head with a three-step pulley driven by a ⅓ HP, 1750 RPM motor and using matching pulleys with 2″, 3″, and 4″ steps. This will give you speeds of 3400—3500 RPM, 1750 RPM, and 900 RPM. (The fast speed can vary depending upon the individual equipment.) The fast speed is used for cutting, the medium speed for blending, and the slow speed for the lampblack process.

The buffing head should be fitted with a right-hand and left-hand tapered spindle. It is a good idea to have a long extended tapered spindle or a

Fig. 12-2. Polishing materials.

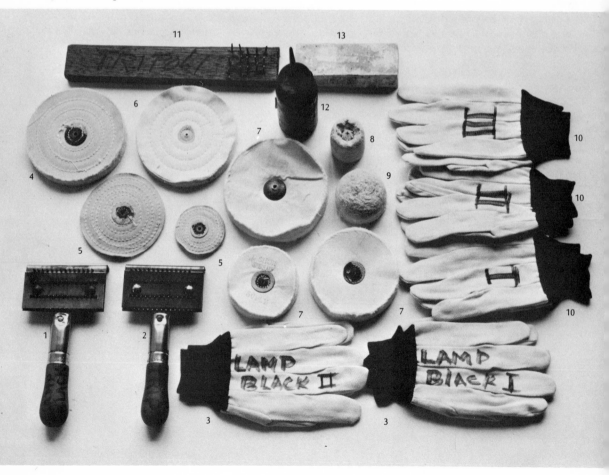

118

work arbor that will extend the spindle to twice its normal length. A ventilator, fan, or hood to collect debris, lint, and dust is essential.

A 1-speed motor can be changed to a 3-speed buffer by adding a 3-step pulley to the motor shaft and connecting the pulley with a belt to a pulley on the buffing arbor (fig. 12-3). This connects the driving pulley (motor) to the driven pulley (buffing shaft), allowing you to vary speeds by adjusting the diameters of the two. The diameter is proportional to the RPM, and the larger the buff, the higher the speed. Formulas that must be used are as follows:

$$d(driver) = \frac{d\ (driven)\ x\ RPM\ (driven)}{RPM\ (driver)}$$

$$d(driven) = \frac{d\ (driven)\ x\ RPM\ (driver)}{RPM\ (driven)}$$

$$RPM(driven) = \frac{d\ (driver)\ x\ RPM\ (driver)}{d(driven)}$$

Instead of RPM, buffing speeds are usually expressed in peripheral speed, or surface feet per minute (SFM), which can be found from the RPM as follows:

SFM = RPM of driven x diameter of buffing wheel

$$\frac{x\ 3.1416}{12}$$

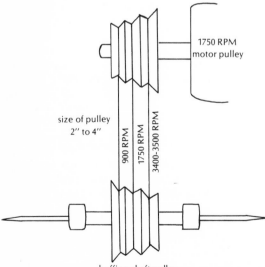

Fig. 12-3. Pulley diagram for converting a 1-speed motor to a 3-speed buffer.

Compounds. Experiments with countless numbers of different polishing compounds have proven tripoli to be most efficient for pewter. Tripoli (see fig. 12-2:13) is a form of amorphous silica composed of noncrystalline abrasive particles that are hard enough to cut metal yet soft enough to break down under polishing pressure. Because this compound breaks down, you can start with good cutting action and end with a buffing or "coloring" action that results from the finer cuts of the smaller particles. Although the use of a dust-collection system is advised, the silica contained in tripoli will do you no harm because it is not crystalline, but consists of screened particles set in a non-greasy base. This non-greasy base mixture, called "semi-dry tripoli," is in turn set in a vegetable fat. Some compounds are set in animal fats or tallows, but are too greasy for polishing pewter. You can usually tell by the odor of a compound if there's animal fat or tallow in it. If it has a sour smell, don't use it. The animal fat contains a stearic acid that tends to leave a clouded surface on the work, and is hard to remove. On the other hand, too dry a compound can cause friction burns on the work. One of the uses of the fat binder in the compound, beside holding the abrasive particles together, is to lubricate the work to keep it from being burned by friction. (Allcraft super tripoli is recommended; see Sources of Supply at the end of the book.)

Lampblack. Lampblack is not an abrasive compound but merely a cleaning and burnishing agent. It is used for the actual "buffing" process, the last of the finishing procedures. Genuine "Germantown" lampblack powder (oil-soluble) is mixed with kerosine to the consistency of a medium-thick cream (see fig. 12-2:12). It is thick enough to adhere to the work and thin enough to still function as a cleaning agent.

Buffs (wheels). Buffs are used in the polishing (cutting and blending) process as well as for buffing with lampblack. Hard-stitched muslin buffs are used for cutting and blending. The "high-count muslin" (very-fine muslin sheeting) is recommended for cutting down and general polishing (see fig. 12-2:4). The coarse muslin (unbleached, coarse weave) is good for blending (see fig. 12-2:6). For getting into tight places of crevices, use a razor-edge buff (see fig. 12-2:5). For getting into cups or cone shapes use either a cylindrical buff (fig. 12-2:8) or a goblet buff (fig. 12-2:9).

Do not use a felt wheel unless you absolutely

must, to reach a special inaccessible area that can't be buffed in any other way. Felt can cut pewter, and leave grooves or furrows that are difficult if not impossible to remove. A knife-edge felt buff is occasionally used.

Loose muslin buffs, stitched only at the center, are used for blending and lampblack buffing (fig. 12-2:7). You can make your own from hard-stitched muslin buffs by "ripping them back" to their first row of stitching. This handmade type is more effective than the commercial ones. Your work will determine what you're going to use, and with a little practice you'll soon find out which buff is best for what you're doing.

Wheel rakes. These tools for preparing and cleaning buffs can be purchased commercially, or they may be made by driving nails through a narrow board (fig. 12-2:11). In either case, you should have two, one for tripoli buffs (fig. 12-2:2), and one for lampblack buffs (fig. 12-2:1).

Gloves. Wear 8-ounce cotton work gloves during the various finishing steps. Three pairs should be kept for tripoli polishing, and numbered I, II, and III (fig. 12-2:10). Number III is used first, for hard cutting. When they become too soiled, they are discarded or washed and number II is renumbered to become number III; I becomes II. Pairs I and II are used for the blending steps, as the work at this stage must be kept fairly clean. Two additional pairs are reserved for the lampblack process, one for putting lampblack on, one for removing it (fig. 12-2:3).

Safety precautions

The same safety precautions apply to the finishing of pewter as apply to any metal finishing in which a power motor is involved.

1. Make sure that all loose clothing such as shirt cuffs, jewelry, scarves, and ties are kept away from the motor or removed to prevent them from becoming entangled. Long hair should be tied back.

2. Never hold a cloth or rag in your hand while polishing. It might become entangled in the wheel.

3. It is advisable to wear safety goggles, as a loose piece of compound could become dislodged from the bar and fly into your eyes. If the tripoli is applied as directed, however, this will not happen. It is highly unlikely that a piece of work torn from the hand by the wheel would ever hit the operator, as the action of the wheel would cause the piece either to fly up and away from the operator or catch in the wheel's motion and be taken under the wheel. Safety goggles are a recommended precaution, however, for the amateur operator.

4. Always hold work to be polished against the lower front quarter of the wheel (between 4 and 5 o'clock). Much lower, the work is apt to be grabbed from your hand; much higher, the buff will hit against it and knock it down out of your hand. It is possible to work on top of the wheel if the work is too large to be polished in any other way, but it is not good practice to do this unless you are very experienced.

5. Never try to polish all the way to the upper edge of a piece. When you reach the center, turn the piece around and polish from the edge again, working only on one half. If you don't polish away from the edge, the work will be torn from your hand. Never polish toward the edge.

6. Don't try to slow down a spindle by holding onto it. Especially not with a gloved hand!

7. Never walk away from a running motor.

8. Don't stand directly behind the buff while operating. Get into the practice of standing a little to one side so that you are out of the line of fire.

9. One special safety hazard peculiar to the polishing of pewter is the danger of getting gloves caught in the machinery. It is generally not a good safety practice to wear gloves in the polishing of metals. However, the rather delicate handling of pewter in the finishing process makes gloves necessary. Gloves help a great deal in keeping the metal clean enough to produce a bright finish. Holding pewter in your bare hands creates a film of moisture and grease on the surface of the metal, which in turn picks up the greasy content of the compound. The resulting smudges are hard to remove, and make the polishing operation longer than it need be. There is no great danger in wearing gloves when polishing hollow-ware, because most pieces are large enough to allow you to keep your hands well away from the wheel. Small articles that have to be held close to the wheel should be held in your bare hands or with very tight, close-fitting cotton gloves.

Gloves serve another function. The work can become quite hot during the cutting-down process, and the gloves prevent you from burning your fingers.

10. If something should get caught in the motor, or if a piece of work gets caught on the spindle, the first thing to remember is to STOP THE MOTOR. Cut the power. Know where the switch is, and turn it off immediately. The speeds used in polishing pewter are fairly low, and in most cases

the motor would stop itself anyhow as soon as something became entangled in it.

Finishing procedures

Finishing metal eliminates all surface scratches and blemishes, and achieves pewter's final clean, even, and lustrous appearance. Although "buffing" is a generally accepted and widely used term for the whole finishing process, and has been used to refer to it throughout this book, the correct terminology is more specific. The three steps are cutting, blending, and lampblack process. Cutting and blending are both polishing procedures; lampblack is the only one that can correctly be called buffing. The finishing process should be the most rewarding part of the work because the final appearance of the piece depends on finishing.

Preliminaries. First of all, cover yourself with something because you're going to get very dirty. Smocks that button down the front are not recommended because buttons can scratch the work when you hold it against you. A shirt worn backward is a suitable substitute. To protect and keep your hands socially acceptable, apply a handsaver cream before you begin. Rub it all over your hands, especially under the fingernails. Then, any dirt or grease that gets on your hands will readily wash off.

Set the buff onto the spindle by starting it on the taper, setting the motor in motion, and gently bringing a stick of compound into light contact with the buff. Increase your pressure until the buff is firmly placed on the spindle. Let the motor draw it on. Do not try to screw it on tightly by hand or you might fit it on unevenly; the machine won't. Always put the buff on with the larger side of the hole toward the inside of the buffing head. If you keep turning it around each time you put it on, it will wear out, slip and slide around, and soon become ineffective.

Check to see that the wheel is running true. An unbalanced wheel may spring the spindle and damage the bearings. It also lowers the life of the buff by hitting only high spots, and this will certainly produce an uneven finish on the work. To true a wheel, set the machine in motion, take a red pencil (red will show up better if the buff is dirty), and hold it against the side of the buff. If, when you stop the motor, you find that the pencil has marked only one side of the buff, then you know the wheel is not true. If it goes all the way around, the buff is true in the longitudinal sense. It may possibly be out across the face, but there's

very little you can do about this. It just means you have a defective buff.

If the buff is running unevenly because of its position on the spindle, change it by unscrewing it and lightly screwing it back onto the spindle, applying a little more pressure against the side that's marked by the pencil. Although ordinarily you should let the machine draw the buff on, in this case you have to twist the buff onto the spindle by hand to make it run true. Keep testing it with your pencil line until the line marks all the way around — a true circle.

When the buff runs true, it should be raked out. A new one needs to be broken in and one encrusted with metal by previous use needs to be cleaned. You can break in a new buff by combing vigorously with a wheel rake from side to side while the motor is on low speed. Hold the rake firmly. Trim off the ravelings or they will make lines in the pewter. Hold a cake of polishing compound against the revolving wheel until the wheel is loaded with abrasive. This will result in more ravelings, which must again be trimmed away. It is a good idea automatically to clean out any previously used buff by raking before you begin to work.

Notice the flexibility of the buff. It should be stitched fairly close to the edge and be soft enough not to scallop the edge of the work. Old buffs get too hard because they have been worn back close to the first row of stitching. They can be "ripped back" a row to become soft buffs for awhile, and you can continue ripping back each row of stitching until only the tiny core of the buff is left. It can also be utilized inside of small cones and cylinders.

Apply the compound while the wheel is in motion. Always apply it across the buff's surface and distribute it evenly. Do not dab it on so that you hit only a part of the buff, and be sure that the buff has circled over the stick of compound at least a couple of times. Always keep the buff well impregnated with compound, and the cake of compound as square as possible. This is an economical measure as well as a safety feature. It keeps little "ears" from forming on the compound that might possibly break off and hit you or some passerby.

It's difficult to say how much compound you'll use. You'll probably be told by your piece of work. If it is collecting many smudges, you need more compound. Smudges occur when all the abrasive particles have broken down, and only the grease is left on the buffing wheel. Smudges can also be an indication that the buff needs to be raked out, but this is usually shown first by the

surface of the buff itself, which becomes caked, glazed over, and hard. It should be raked out as soon as it is apparent that there is no more flexibility in the buff. Another indication that you need more compound is lack of efficiency. The buff stops cutting — you buff and buff, and get nowhere.

Cutting. Cutting is an abrasive action to wear down or eliminate the metal surrounding a scratch or indentation until the surface is all the same level. Deep blemishes, scratches, pits, or any other imperfections in the surface of the metal may be cut out. Do not stay on one spot or scratch, therefore, but polish the area around it. This will result in the surface being covered with many fine scratches going in different directions. A motor speed of 3400 RPM, hard-stitched muslin buffs, tripoli compound, and number III gloves are used.

The cutting action is usually a downward sweep. You hold the piece in firm but light contact with the wheel — firm enough to get action, light enough not to get pressure marks. Important: never use great pressure in polishing pewter because it will only bend or groove the surface, or overheat the metal so that there are friction burns on it. These brown blotches are difficult to remove, and require a repetition of the whole cutting down procedure. At no point in the finishing process should you apply great pressure. Rather, use a firm contact with the buff, and go over and over the piece until the blemishes disappear. A light touch is more effective than heavy pressure, which creates heat and forces compound into the scratches, making deep pits.

Moving the work down in a rather diagonal sweep and then in an upward stroke naturally increases the speed of the action — but it also leaves a cloud on the work so that you can't see what action is taking place. This is why a good operator usually moves his piece of work in a downward action only. You may pull the piece up against the wheel (and sometimes this will be very effective over a bad scratch) but then you have to run downward again to clean it so you can see how much of the scratch has been removed.

After the first cutting of blemishes in this downward action, you should run the buff transversely across the piece of work in a very even up-and-down motion. This brings your strokes into line with one another, making it easier to do the blending operation, which is next.

Blending. The cutting operation will leave the surface of the metal covered with many fine scratches going in different directions, and blending is an attempt to overlap them, to make them blend in. Use a motor speed of 1750 RPM, a loosely stitched muslin buff, tripoli compound, and numbers II and I gloves.

Blending requires a lighter touch than cutting, and you must move the buff over the surface of the work in one direction only, as follows. Go across the surface to the middle in one direction, then turn the piece around and go across the surface back to the middle again in the same direction. In the middle, where the strokes overlap, use a "feathering" technique so that the overlapping won't show. Feathering is accomplished by pulling the work very slowly away from the buff until the buff is no longer running on it. Use a light touch against the wheel, but do not release your grip on the work. Relaxed pressure automatically leads to a relaxed grip, unless a conscious effort is made to hold on.

If there are still scratches going in different directions, go back and blend the area over again. On a very large piece of work, such as a large bowl, you cannot go all the way across with one stroke. Instead, polish with the contour of the bowl, moving the piece around with a very firm even touch. Uneven blending will show up very badly here. Keep going around without much pressure until all of the strokes are blended, and the finish is even. There will be some lines showing, but this is what breaks up the reflection of light, which keeps the piece from looking like chrome plate. This breaking up of light is important, but scratches shouldn't appear as scratches. They must definitely "read" as a finish.

Lampblack process. The lampblack process, a dirty procedure to make things clean, brings out all of the luster and life in the metal. It brings out dark shadows as well as the highlights, and increases the reflective quality. There is no abrasive action here, as this is merely a cleansing and burnishing process. Use a motor speed of 900 RPM, a loosely stitched muslin buff, Germantown lampblack powder, kerosine, and lampblack gloves numbers I and II.

Lampblack powder is mixed with kerosine to a consistency of medium cream. Mix just a small jar — not too much because very little is used. A cheap paint brush can be used to apply it. Important: do not put lampblack on the buff as you do with tripoli. If you try that, it will fly all over the place — and you! Put just a small dab on the work. A square inch of coverage is enough to buff both the outside and inside of a 10" bowl. No pressure at all is applied in lampblack buffing. If

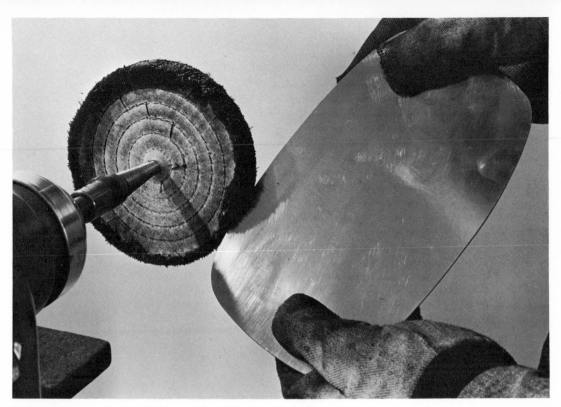

Fig. 12-4. Polishing an edge. Run the edge on a diagonal line across the buff.

you overpress you will get some very ugly brown stains, from the kerosine this time. Kerosine, if properly used, is a very fine cleaning agent. It will remove any compound still clinging to applied parts on the work, and clean superbly.

One test for pressure in the buffing process is to stop your motor, and, by very lightly batting the buffing wheel toward you with the palm of your hand, see if it can be removed. If you have to twist the buff off, you've been pressing too hard.

The lampblack process is divided into two steps — putting on and taking off. The surface of the work is covered with the dab of lampblack and kerosine that you previously applied. Spread it all over the work in the same direction as the blending lines. You'll find that it goes quite far. The second step is taking the mixture off with a cleaner, soft buff made of good-quality muslin. It should be very soft and ripped right back to the first row of stitching. Lampblack is taken off with an even, gentle action. You simply go over the work, again moving in the same direction as the blending lines, until all the black has disappeared, and the work is clean. The piece usually doesn't need to be washed until it goes into use, unless it has applied parts that need to be cleaned with a soft cotton swab and hot soap suds.

Fig. 12-5. This diagram shows the correct relation between the center of the buff (only the shaft is shown) and the piece. Buff the edge by moving the piece diagonally, as shown by the dotted line.

Hints for polishing and buffing special areas. An edge is polished by running it on a diagonal line across the buff (fig. 12-4, 12-5). Polishing straight up and down vertically would make a groove in the surface of the buff that later would be picked up in the work as a ridge. Polishing directly across would scrape a great deal of compound off in your face, and also wear away the edge in an irregular manner. Polish the edge using long diagonal sweeps.

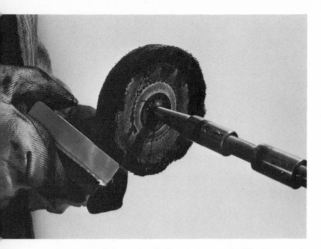

Fig. 12-6. Polishing a box body. Insert a wooden block covered with cloth to prevent distortion of the box.

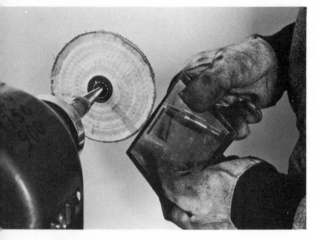

Fig. 12-7. Polishing a cover. A razor-edge buff is used around hinges and other applied parts.

Fig. 12-8. Polishing the inside of a cylinder or cone. Use an extended shaft if necessary to reach the deep places, and be very careful not to overheat the piece while buffing.

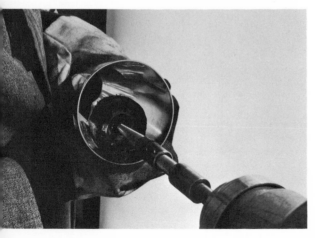

In polishing a box body, it is highly advisable to have a wooden block that fits inside of it to prevent distortion of the box (fig. 12-6). Cover the block with a piece of cloth so that smudges don't collect between the block and the work, and scratch the inside of the box. Try to keep the inside as clean as possible. If you don't, hand finishing is your only resort. In running over the seams, be very careful not to apply too much pressure, as the solder can very easily be pulled out of the seams. Light pressure is extremely important.

In polishing the cover of a box, a razor-edge buff is used in the area around the applied hinge (fig. 12-7). Back the cover with a piece of covered Masonite or hardboard to prevent distortion. This is for getting into crevices, and will clean up the hinge very nicely. Be very careful to move the **razor-edge buff** a little bit crosswise as well as up and down or you will get a groove in the work that is difficult to remove. Around hinges, it is very easy to fit the corner of the buff into any crevices and stay with them until all the excess solder pockets, flux residue, etc. are removed. The rest of the surface of course, is polished with a regular wide cutting buff. If you use the razor-edge buffs on flat surfaces, they will soon lose their effectiveness for getting into crevices. Keep them for special problems.

In polishing the inside of a cylindrical or conical object it is usually necessary to have an extended spindle on the buffing head (fig. 12-8). The buff used should be of a smaller diameter than the object being buffed so that it doesn't cause overheating. The buff should hit the work at only one point — at a tangent — as it is most effective in this way because you are assured of having contacted every point. Buff until the seam is clean and almost disappears. Be sure there are no particles of solder or any file scratches remaining.

You must be very careful to avoid overheating while polishing the inside of a cone or cylinder. The inside will heat up faster than the outside because there is no place for the heat generated by friction to dissipate. Two things can happen if you overheat here. You can pull the solder out of the seam or you can cause pits in the metal. Compound embedded in scratches causes little pits all over the work. These little three-cornered lines are called "drags" or "flying geese", and are extremely difficult to remove. The only way you can remove them is by reducing the pressure and buffing in criss-cross strokes in different directions. Use a push and pull action, but light pressure. If this doesn't work, take a bit of fine steel wool and go over them in every direction.

Go back to the buff, reduce the pressure, and cross buff.

The importance of not over-pressuring in polishing pewter cannot be stressed strongly enough. Pewter is composed of soft metals and hard metals. Sometimes there are hard spots in it, called antimonial or tin oxides, that very easily can be heated and driven farther in. This causes pits, but only if you over-pressure. The inside of a cone or cylinder should be as nicely polished as the outside. This is a mark of craftsmanship, and indicates your level of proficiency.

In blending a flat piece, go across from left to right, and right to left, back and forth across the piece with a very even light pressure so that the strokes overlap (fig. 12-9). Move the work along gently and slowly as if you were a machine. As previously mentioned, when you come to the center, or a little past the center, turn the whole piece around and do the second half in the same way as before. Never try to polish all the way up to the upper edge of a piece. It will be knocked out of your hand. Go part way across, turn the piece, go back toward the center until the strokes overlap. The overlap is then "feathered off" by gently releasing the pressure and very slowly pulling the work away from the wheel as you approach the overlap section. Feather the stroke so that it disappears and the finish is smooth and fine all over.

In polishing around and under applied parts such as the handle of a pitcher, use a soft buff that will flutter under pressure. More pressure than ordinary is necessary in order to make the buff really flutter out and travel in under the handle and down into the crevices where it is attached (fig. 12-10). Use a buff with very soft, loose stitching on a low-speed motor. Put on plenty of compound and approach from all angles so that the entire surface under the handle is covered. Be very careful not to let the handle touch the revolving spindle — you can cover the spindle with masking tape to prevent this.

Lampblack is applied to the work, not to the buff (fig. 12-11). Use a buff that is suitable to the size of the work you're doing. Two buffs are used in the operation, one for putting on, one for taking off. Pewtersmiths facetiously call the one for taking off the "clean buff." It won't be clean long, but it is the cleaner looking of the two, and that is how you can distinguish them. Important: lampblack buffs and tripoli buffs should never be mixed! If tripoli gets on a lampblack buff, it is no longer good for lampblack. If lampblack gets on a tripoli buff it will make it too wet, causing smudges on the work. Keep the two kinds of buffs

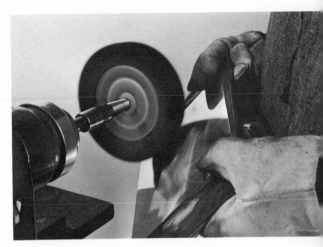

Fig. 12-9. Blending a flat piece. Go from left to right and right to left across the piece with light strokes.

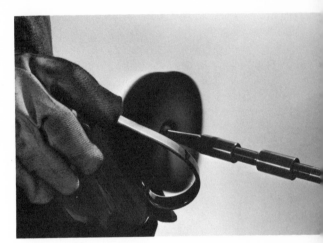

Fig. 12-10. Polishing under handles. Use a soft buff that will flutter under and around the part, and employ slightly more pressure than usual.

Fig. 12-11. Lampblack process. A dab as small as this is enough to cover the whole piece. It should be applied on the piece, not on the buff.

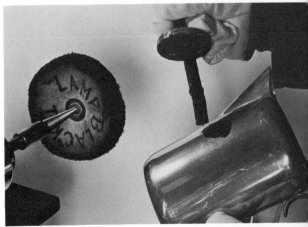

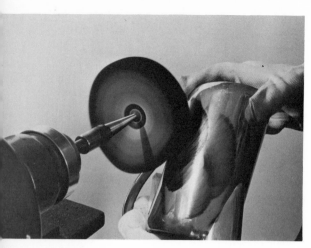

Fig. 12-12. To spread the dab, use a very light touch and move the piece in the direction of the blending lines.

Fig. 12-13. After the putting-on operation, remove the lampblack with the number 2 "clean" buff.

in separate places, or mark them with a colored pen or pencil.

When applying lampblack, use a very light and gentle touch (fig. 12-12), and remember to move the work in the same direction as the blending lines. For removing lampblack, use an even lighter touch, lampblack II gloves, and the "clean" II buff (fig. 12-13). The whole process is done very quickly. It is not something that you go over and over, and it is not a cutting operation. You're no longer removing surface. Just put it on and wipe it off. It's done in minutes. If you overwork it, you'll get brown stains. If you find that the buffs don't come off the spindles with a flick of the fingers, you'll know you have been over-pressing.

Reminders and Suggestions.

1. Keep the motor and buffing head clean, or the motor can catch fire.
2. Keep your bench free of dust and sludge, or dirt will get all over the buffs, gloves, and work.
3. Do not over-press. You can actually stop a motor by pressing too hard, which may result in a blown fuse.
4. Don't wipe your work with your gloves. Keep the gloves as clean as possible.
5. Keep a buff as square across its face as possible. A lopsided buff is detrimental to the work.
6. Stock two or more buffs of each kind and size for each purpose, because buffs tend to overheat. If you're doing a time-consuming buffing job, switch the buffs when they won't cut effectively any more. They become ineffective when over-heated.

Problem	Cause
black specks or grease smudges on work	not enough compound, dirty buff, humidity or water on buff
small pits or drags on work	overheating caused by over-pressure; defective pewter; antimonial or tin-oxide deposits
brown film on work	over-pressure causing burns

Although I'm assuming that you will read this book carefully, follow the instructions implicitly, and never have to make a repair, this chapter is included for the benefit of those of us who are human, and make mistakes once in a while.

Patching a burn or crack

It is possible when beating a bowl to beat too hard, and open a crack in the bottom of it. It is also possible — actually very easy — to burn a hole in a piece of work that is good enough to save. All is not lost! Any work that you put your time in is worth saving, as time is very precious. It is also good experience to learn the art of patching because you may some day be asked to repair work for your customers.

Figure 13-1 shows how you can repair a burn made in applying a base to a small bowl. The burned hole is first scraped clean with a knife blade — steel wool is not enough here — to make sure it is clean enough for patching. Place very small snippets of very clean pewter all around and over the hole and then flux the hole and pellets generously. It will probably be necessary to tape a piece of thin sheet asbestos under the hole so that the pewter pellets will have something to rest on. Remember that the melting point of these pellets is the same as the melting point of the body of the bowl. The only thing that will cause them to melt first is their size. Small pieces will melt faster than large ones; therefore it is important that they be as small as you can make them.

Apply the heat all the way around the burned

area. Don't hurry it, just apply plenty of heat until the flux begins to boil. Shortly after the flux boils the small pellets of pewter will melt, as solder does, and you can apply the heat. Remember that molten metal will also follow the heat of the torch flame. You may have to add pellets a few at a time, melt those, and then add more until the hole is

Fig. 13-1. Patching a burn.

Fig. 13-2. Unsoldering a seam.

Fig. 13-3. Unsoldering a hinge.

well filled. The patch should stand a little higher than the bowl surface, and the convexity can later be filed away and polished until the applied metal has blended into the body of the bowl. The inside may be a little more difficult to finish than the outside. You will probably have to file down little melted bumps of pewter on the inside with a tongue-shaped riffle file. Then polish the inside down level with the surface of the bowl.

Unsoldering a seam, a hinge, or an applied part

Occasionally a seam is soldered together unevenly and really should be taken apart and done over. If it can be cut apart without marring the work in any way and making it impossible to repair, then it's best to take the seam apart this way. In many cases, however, it must be unsoldered, which is a little more difficult than cutting. First, tie a cord to the work and fasten it to some stationary object such as the handle of a vise (fig. 13-2). This is only necessary if you have no one to assist you — another pair of hands would be more efficient. Next flux the seam very well, and begin heating at the large end where the pull is strongest. Put a little tension on the piece, but not enough to distort it. Distortion can easily occur during the heating necessary to make the seam pull apart. It should pull apart fairly easily when the solder in it has been remelted. Apply the heat just as though you were soldering the seam for the first time, and pull it gently as the solder begins to flow.

Removing an applied part, such as a hinge that has gone on in the wrong way, is a little easier to do than unsoldering a seam. Usually a wire can be fastened around the part to give the necessary leverage. On a hinge, the wire is inserted through the hinge tube. The piece is then held in an elevated position, high enough so that the weight of the body of the piece will pull downward and away from the applied part when the solder melts (fig. 13-3). Use plenty of flux, and apply the heat just as if you were soldering the piece. Place a piece of flannel or soft cloth under the work so that it will fall on a soft surface when the solder gives way.

128

Pewter by Beginner's;
The Trifler's Art

The art of the pewtersmith is a unique metal craft. Its ease makes it something that can be attempted by people of all ages, interests, and walks of life, regardless of previous technical background. A master craftsman well versed in the skills of hand-forming and finishing pewter must spend many years practicing before he reaches the level of craftsmanship he desires. On the other hand, the special qualities of pewter — its malleability, its highly reflective surface, its low melting point — make it a metal that can be worked with very professional results by craftsmen who are just learning the necessary techniques.

The degree of difficulty of pewtersmithing lies only in the demands of the craftsman upon himself. In keeping with the finest traditions of pewtersmithing, I hope your demands will be as high as your capabilities allow.

Pewter by beginners

The work shown here (figs. 14-1 through 14-7)

Fig. 14-1. Module candelabra with walnut base, by a beginning student.

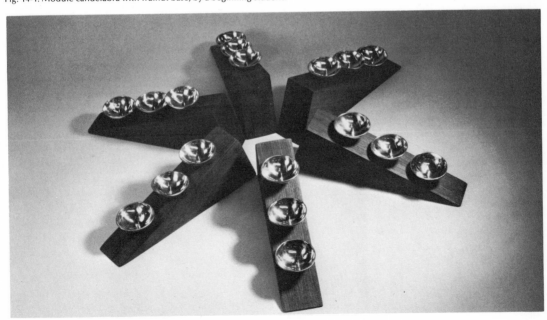

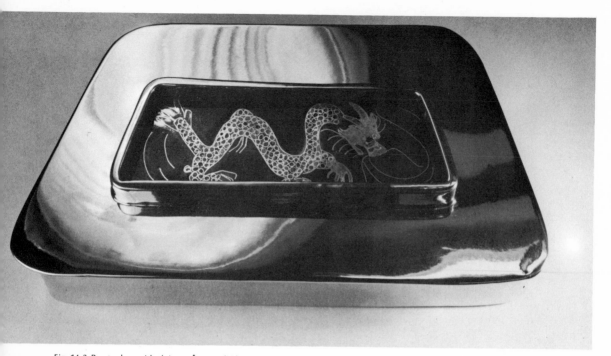

Fig. 14-2. Pewter box with cloisonné enamel. This was the student's first attempt

Fig. 14-3. Wall mask by an advanced student.

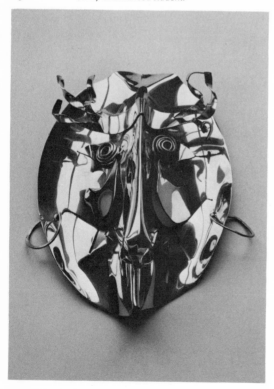

represents beginning efforts by students of the author in the crafts classes at Norwalk High School, Norwalk, Connecticut. Most of the work has been honored on the state or national level with Scholastic Art Awards.

As space does not permit the inclusion of all the fine pewter work done by first- and second-year students in my crafts classes, the pieces here have been selected as a sample. They serve as proof that the pewtersmithing art is not restricted by age barriers. They are also an indication of the professional, creative results beginners can achieve.

All the students whose work is represented here were given a chance to study the work of professional pewtersmiths and enamelists collaborating with them. There is evidence of this influence in the approaches that the students chose, but it is most encouraging to see that they applied some of the more traditional techniques in a new, completely refreshing way.

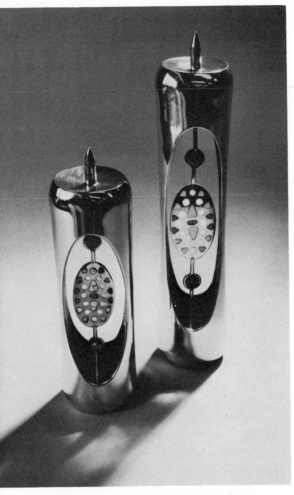

Fig. 14-4. An advanced student made these plique à jour enamels and set them in candlesticks she had made.

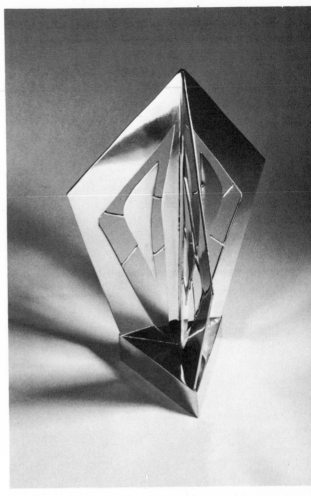

Fig. 14-5. Pewter sculpture by an advanced student. A study in flat fabricating.

Fig. 14-6. *Sunburst,* an experiment in bending metal.

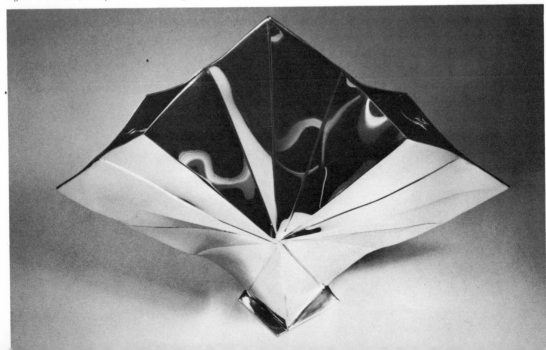

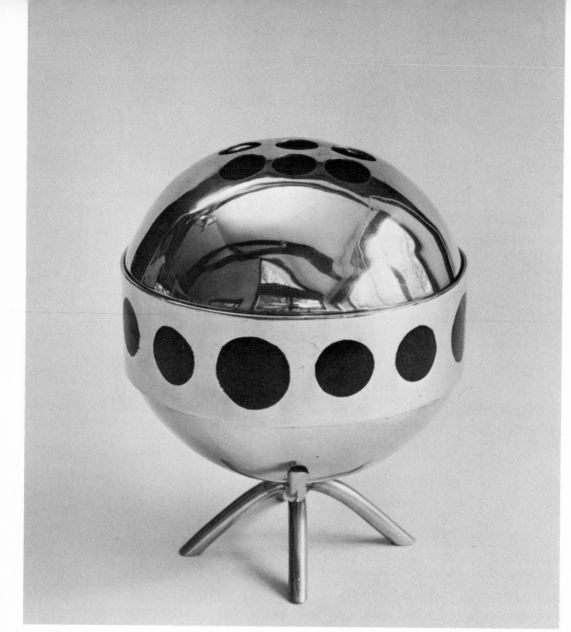

Fig. 14-7. Holder for dry foliage by an advanced student. Ebony
dust, mixed with epoxy, was inlaid in the circular cut-out areas,
and then sanded flush with the surface.

The trifler's art

It is obvious from the name given to them that the early English pewtersmiths called triflers were not highly respected. Their productions of buttons, spoons, salts, and other odds and ends were not as expensive as the work of other pewtersmiths, and the alloy they used was inferior. Today, although there is only one acceptable formula for pewter alloy, there are still many triflers at work. And a good thing, too, because there are still many people who can't afford to buy large, expensive items and who still want to collect pewter.

It would be rare to find a craftsman today who confined his entire production to the making of pewter trifles, merely because he lacked ability to do more ambitious work. Most professional craftsmen break their work down into three categories: show and exhibit work (expensive), production-line items (priced reasonably, to sell), and bread-and-butter-items, or trifles (inexpensive, for mass appeal; see figs. 14-8 through 14-10). Trifles will never end up in museums, but they provide a form of financial security that enables the craftsman to go on to greater things. Besides, a craftsman has to eat! They can also serve as an introduction for a wide audience to the appreciation of handmade pewter. Better that handmade trifles decorate the homes of America than dime-store reproductions. Also, no up-and-coming pewtersmith should discount the fact that trifle collectors may some day develop into sad-ware and hollow-ware collectors.

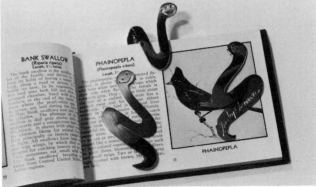

Fig. 14-8. *The Bookworm,* "trifle" bookmarks by Shirley Charron. "Trifles" are small pieces of pewter that are inexpensive enough to be sold and purchased on a wider scale than larger pieces. They have a long tradition in pewtersmithing.

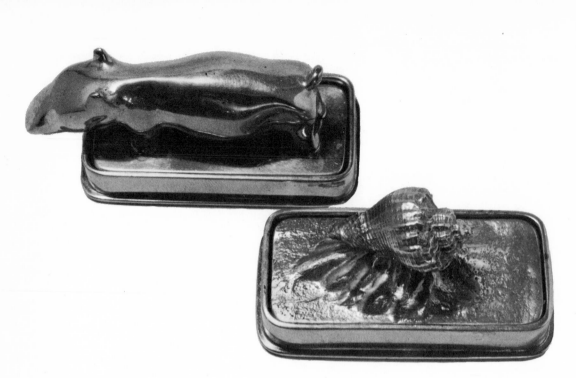

Fig. 14-9. Stamp pads with cast pewter tops, by Frances Felten (collection of Rebecca Strominger).

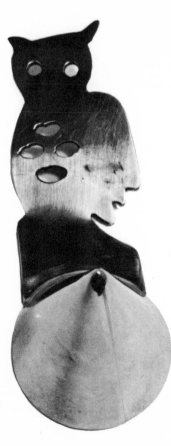

Fig. 14-10. *The Night Owl,* candle-snuffer by Shirley Wood.

Bibliography

Some of the listings below are out-of-print or hard to find. However, these references are well worth a trip to the library or secondhand store, or a letter of inquiry to the source.

Periodicals and pamphlets

"American Pewter Treasury," *American Home,* Vol, 74, No. 4, April, 1971

"Care and Use of Drawing Instruments," Eugene Dietzgen Co., 1930

Catalog No. 68, Allcraft Tool & Supply Co., Hicksville, N.Y., 1968

News releases and reprints, all numbers, American Pewter Guild, 483 West Sixth Avenue, Columbus, Ohio 43201

Tin Research Institute Quarterly Journals, Nos. 47, 49, 53, 58, 60, 64, 70, 71, 72, 76, 77, 78, 81, 85, 1959–1970, 483 West Sixth Avenue, Columbus, Ohio 43201

Books

Choate, Sharr. *Creative Gold and Silversmithing.* New York: Crown Publishers, 1970

Cuzner, Bernard. *Silversmith's Manual.* London: N.A.G. Press, 1935

Daugherty, James S. and Robert E. Powell. *Sheet Metal Pattern Drafting.* Peoria, Ill.: Chas. A. Bennett & Co., 1922

Franke, Lois E. *Handwrought Jewelry.* Bloomington, Ill.: McKnight and McKnight Publishing, 1962

Hughes, Graham. *Modern Silver.* New York: Crown Publishers, 1967

Kauffman, Henry J. *The American Pewterer.* Camden, N.J.: Thomas Nelson Publishers, 1970

Kerfoot, J.B. *American Pewter.* New York: Crown Publishers, 1924

Masse, H.J.L.J. *Chats on Old Pewter.* New York: Dover Publications, 1971

Meilach, Dona Z. *Contemporary Art with Wood.* New York: Crown Publishers, 1968

Moore, N.H. *Old Pewter, Brass, Copper & Sheffield Plate.* New York: Garden City Publishing, 1905

Nelson, Norbert N. *Selling Your Crafts.* New York: Van Nostrand Reinhold, 1967

Osburn, Burl Neff and Gordon Owen Wilber. *Pewter, Spun, Wrought, Cast.* Scranton, Pa.: International Textbook, 1938

Seeler, Margaret. *The Art of Enameling.* New York: Van Nostrand Reinhold, 1969

Untracht, Oppi. *Metal Techniques for Craftsmen.* New York: Doubleday, 1968

Varnum, William H. *Pewter Design and Construction.* New York: Macmillan, 1926

Winebrenner, D. Kenneth. *Jewelry Making as an Art Expression.* Scranton, Pa.: International Textbook, 1953

SOURCES OF SUPPLY

Pewter sheet and discs

Golden Metal Industries
50 Taylor Drive
East Providence, Rhode Island
02916

Meriden Rolling Mills
Meriden, Conn.

J.C. Boardman & Co.
86 Hartford Turnpike
South Wallingford, Conn. 06492

Pewter sheet, discs, and wires

White Metal Rolling & Stamping Corp.
80 Moultrie St.
Brooklyn 22, N.Y.

These rolling companies will usually require at least a 25-pound minimum for sheet and a 5-pound minimum for wires. Smaller quantities can be ordered from general craft supply houses such as Allcraft Tool & Supply Co., and Anchor Tool and Supply Co.

Miscellaneous and general pewtersmithing supplies

Allcraft Tool & Supply Co.
22 West 48 St.
New York, N.Y. 10036

Anchor Tool and Supply Co.
12 John St.
New York, N.Y. 10007

William Dixon, Inc.
Carlstadt, N.J. 07072

Specially treated muslin buffs

I. Shor Inc.
71 Fifth Ave.
New York, N.Y. 10003

Commercial buff rakes

The LEA Manufacturing Co.
237 East Aurora St.
Waterbury, Conn. 06720

Nickel-silver hinge stock

Horton-Angell Co.
Attleboro, Mass.

Belmont 300 solder

Anchor Tool and Supply Co. (see above)

Buffing heads for 3-speed pulleys

Poly-Products Corp.
Monrovia, Calif.

Hardwoods, precious woods

Albert Constantine, Inc.
2050 Eastchester Road
Bronx, New York 10461

Cummings Wood Co.
641 Hull St., P.O. Box 27
East Hartford, Conn. 06108

"Cadillac" files

Allcraft Tool & Supply Co. (see above)

Anchor Tool Supply Co. (see above)

"ALL" pencils

Arthur Brown & Bros.
2 West 46th St.
N.Y., N.Y.

Pewter flux

This can be mixed at drug stores — 7 drops of hydrochloric acid to 1 oz. of glycerine

Miscellaneous items

The following items can be obtained at local hardware or paint stores: glass caster cups, Bernz-o-matic torches, carbon tetrachloride, trichloroethylene, aluminum flashing for patterns, white cotton buffing gloves, genuine Germantown lampblack powder (oil soluble), greaseless steel wool

Molds for large bowls

These can be turned on a lathe to order, or you can obtain waste stock from salad-bowl manufacturers

Tables

Table I a,b. Price of pewter is determined by weight and can fluctuate from day to day. These weight charts can be used to estimate the cost of an order.

Table Ia **APPROXIMATE WEIGHTS OF PEWTER DISCS.**

DIA.	14 GAUGE	15 GAUGE	16 GAUGE	17 GAUGE	18 GAUGE	19 GAUGE	20 GAUGE
2" -	4/5 oz.	3/4 oz.	2/3 oz.	3/5 oz.	1/2 oz.	2/5 oz.	1/3 oz.
3" -	2	1 3/4	1 1/2	1 2/5	1 1/4	1 1/10	1
4" -	3 2/3	3 1/5	2 7/8	2 1/2	2 1/4	2	1 3/4
5" -	5 2/3	5	4 1/3	4	3 1/2	3	2 2/3
6" -	7 3/4	6 4/5	6	5 1/3	4 3/4	4 1/5	3 2/3
7" -	11	9 2/3	8 1/2	7 3/5	6 3/4	6	5 1/8
8" -	14 1/4	12 1/2	11	9 7/8	8 3/4	7 3/4	6 2/3
9" -	18 1/4	16 1/8	14	12 2/3	11 1/4	10	8 1/2
10" -	22	19 1/3	16 7/8	15 1/8	13 1/2	11 7/8	10 1/4
11" -	26 7/8	23 2/3	20 2/3	18 1/2	16 1/2	14 1/2	12 1/2
12" -	31 7/8	28 1/8	24 1/2	22	19 2/3	17 1/4	15
13" -	37 1/3	33	28 3/4	25 7/8	23	20 1/4	17 1/2
14" -	43 1/2	38 1/3	33 1/2	30	26 3/4	23 1/2	20 1/3
15" -	50	44 1/8	38 1/2	34 1/2	30 3/4	27	23 1/3
16" -	56 7/8	50 1/5	43 3/4	39 1/3	35	30 7/8	26 2/3
17" -	63 3/4	56 1/3	49	44 1/8	39 1/4	34 1/2	29 7/8
18" -	72	63 1/2	55 1/3	49 3/4	44 1/4	39	33 2/3
19" -	80	70 2/3	61 1/2	55 2/5	49 1/4	43 1/3	37 2/5
20" -	88 1/2	78 1/4	68 1/8	61 1/3	54 1/2	48	41 1/2

Table Ib **APPROXIMATE WEIGHTS OF SHEETS**

GAUGE	LBS. PER SQUARE FOOT	GAUGE	LBS. PER SQUARE FOOT
2 (.258)	9 - 11 oz.	17 (.045)	1 - 12 oz.
3 (.229)	8 - 12	18 (.040)	1 - 8
4 (.204)	7 - 12	19 (.036)	1 - 6
5 (.182)	6 - 14	20 (.032)	1 - 3
6 (.162)	6 - 0	21 (.0285)	1 - 1
7 (.144)	5 - 8	22 (.025)	- 15
8 (.128)	4 - 12	23 (.0226)	- 13 3/4
9 (.114)	4 - 6	24 (.020)	- 12
10 (.102)	3 - 14	25 (.018)	- 11
11 (.091)	3 - 7	26 (.016)	- 9 3/4
12 (.081)	3 - 1	27 (.014)	- 8 3/4
13 (.072)	2 - 12	28 (.0125)	- 7 1/2
14 (.064)	2 - 7	29 (.011)	- 6 3/4
15 (.057)	2 - 3	30 (.010)	- 6
16 (.051)	1 - 15		

Table II. Many books published in England or other European countries give Centigrade temperatures. In order to convert these temperatures to our Fahrenheit scale, follow the directions given on the chart or use the conversion formula. Compiled by Professor Albert Sauveur.

Table II **TEMPERATURE TABLE**

The column in bold face refers to the given temperature either in degrees Centigrade or Fahrenheit.

The equivalent will be the corresponding figure in the column to which the conversion is being made.

Conversion Formulas

Temperature $°F. = (9/5 \times °C.) + 32°$.

Temperature $°C. = 5/9 (°F. - 32°)$

C.		F.	C.		F.	C.		F.	C.		F.
149	**300**	572	432	**810**	1490	716	**1320**	2408	999	**1830**	3326
154	**310**	590	438	**820**	1508	721	**1330**	2426	1004	**1840**	3344
160	**320**	608	443	**830**	1526	727	**1340**	2444	1010	**1850**	3362
166	**330**	626	449	**840**	1544	732	**1350**	2462	1016	**1860**	3380
171	**340**	644	454	**850**	1562	738	**1360**	2480	1021	**1870**	3398
177	**350**	662	460	**860**	1580	743	**1370**	2498	1027	**1880**	3416
182	**360**	680	466	**870**	1598	749	**1380**	2516	1032	**1890**	3434
188	**370**	698	471	**880**	1616	754	**1390**	2534	1038	**1900**	3452
193	**380**	716	477	**890**	1634	760	**1400**	2552	1043	**1910**	3470
199	**390**	734	482	**900**	1652	766	**1410**	2570	1049	**1920**	3488
204	**400**	752	488	**910**	1670	771	**1420**	2588	1054	**1930**	3506
210	**410**	770	493	**920**	1688	777	**1430**	2606	1060	**1940**	3524
216	**420**	788	499	**930**	1706	782	**1440**	2624	1066	**1950**	3542
221	**430**	806	504	**940**	1724	788	**1450**	2642	1071	**1960**	3560
227	**440**	824	510	**950**	1742	793	**1460**	2660	1077	**1970**	3578
232	**450**	842	516	**960**	1760	799	**1470**	2678	1082	**1980**	3596
238	**460**	860	521	**970**	1778	804	**1480**	2696	1088	**1990**	3614
243	**470**	878	527	**980**	1796	810	**1490**	2714	1093	**2000**	3632
249	**480**	896	532	**990**	1814	816	**1500**	2732	1099	**2010**	3650
254	**490**	914	538	**1000**	1832	821	**1510**	2750	1104	**2020**	3668
260	**500**	932	543	**1010**	1850	827	**1520**	2768	1110	**2030**	3686
266	**510**	950	549	**1020**	1868	832	**1530**	2786	1116	**2040**	3704
271	**520**	968	554	**1030**	1886	838	**1540**	2804	1121	**2050**	3722
277	**530**	986	560	**1040**	1904	843	**1550**	2822	1127	**2060**	3740
282	**540**	1004	566	**1050**	1922	849	**1560**	2840	1132	**2070**	3758
288	**550**	1022	571	**1060**	1940	854	**1570**	2858	1138	**2080**	3776
293	**560**	1040	577	**1070**	1958	860	**1580**	2876	1143	**2090**	3794
299	**570**	1058	582	**1080**	1976	866	**1590**	2894	1149	**2100**	3812
304	**580**	1076	588	**1090**	1994	871	**1600**	2912	1154	**2110**	3830
310	**590**	1094	593	**1100**	2012	877	**1610**	2930	1160	**2120**	3848
316	**600**	1112	599	**1110**	2030	882	**1620**	2948	1166	**2130**	3866
321	**610**	1130	604	**1120**	2048	888	**1630**	2966	1171	**2140**	3884
327	**620**	1148	610	**1130**	2066	893	**1640**	2984	1177	**2150**	3902
332	**630**	1166	616	**1140**	2084	899	**1650**	3002	1182	**2160**	3920
338	**640**	1184	621	**1150**	2102	904	**1660**	3020	1188	**2170**	3938
343	**650**	1202	627	**1160**	2120	910	**1670**	3038	1193	**2180**	3956
349	**660**	1220	632	**1170**	2138	916	**1680**	3056	1199	**2190**	3974
354	**670**	1238	638	**1180**	2156	921	**1690**	3074	1204	**2200**	3992
360	**680**	1256	643	**1190**	2174	927	**1700**	3092	1210	**2210**	4010
366	**690**	1274	649	**1200**	2192	932	**1710**	3110	1216	**2220**	4028
371	**700**	1292	654	**1210**	2210	938	**1720**	3128	1221	**2230**	4046
377	**710**	1310	660	**1220**	2228	943	**1730**	3146	1227	**2240**	4064
382	**720**	1328	666	**1230**	2246	949	**1740**	3164	1232	**2250**	4082
388	**730**	1346	671	**1240**	2264	954	**1750**	3182	1238	**2260**	4100
393	**740**	1364	677	**1250**	2282	960	**1760**	3200	1243	**2270**	4118
399	**750**	1382	682	**1260**	2300	966	**1770**	3218	1249	**2280**	4136
404	**760**	1400	688	**1270**	2318	971	**1780**	3236	1254	**2290**	4154
410	**770**	1418	693	**1280**	2336	977	**1790**	3254	1260	**2300**	4172
416	**780**	1436	699	**1290**	2354	982	**1800**	3272	1266	**2310**	4190
421	**790**	1454	704	**1300**	2372	988	**1810**	3290	1271	**2320**	4208
427	**800**	1472	710	**1310**	2390	993	**1820**	3308	1277	**2330**	4226

TABLE III **MELTING POINTS**

Elements	Symbols	Degrees Centigrade	Degrees Fahrenheit
Aluminum	Al	660.16	1220.29
Antimony	Sb	630.5	1166.9
Arsenic	As	814*	1497*
Barium	Ba	850	1562
Beryllium	Be	1350	2462
Bismuth	Bi	271.3	520.3
Cadmium	Cd	320.9	609.6
Calcium	Ca	810	1490
Carbon	C	3500	6332
Chromium	Cr	1765	3209
Cobalt	o	1480	2696
Copper	Cu	1083.0	1981.4
Gold	Au	1063.0	1945.4
Iron	Fe	1535	2795
Lead	Pb	327.4	621.3
Lithium	Li	186	367
Magnesium	Mg	651	1204
Manganese	Mn	1260	2300
Mercury	Hg	−38.87	37.97
Molybdenum	Mo	2620	4748
Nickel	Ni	1455	2651
Phosphorus (yellow)	P	44.1	111.4
Platinum	Pt	1773	3223
Silicon	Si	1420	2588
Silver	Ag	960.5	1760.9
Tin	Sn	231.9	449.4
Tungsten	W	3400	6152
Vanadium	V	1710	3110
Zinc	Zn	419.5	787.1

*At 36 atmospheres.

Table III. These melting points are included for your reference. Pewter is a eutectic alloy, which means that it melts at a lower temperature than any of its components. Tin, the major component of the alloy, melts at 449.4° F. Used with permission of T.E. Conklin Brass & Copper Co., Inc.

Table IV. This chart, necessary when using European books on metal craft, converts the American standard measurement of gauge to the English standard measurement. The Brown & Sharpe gauge is the American standard of thickness of metals, and the Birmingham or Stubs gauge is the English standard of thickness. Used with permission of T.E. Conklin Brass & Copper Co., Inc.

Table IV **GAUGE NUMBERS AND MILLIMETER EQUIVALENTS**

Gauge No.	American or Brown & Sharpe's		Birmingham or Stubs	
	Inches	Millimeters	Inches	Millimeters
000000	.5800	14.732		
00000	.5165	13.119		
0000	.4600	11.684	.454	11.532
000	.4096	10.404	.425	10.795
00	.3648	9.266	.380	9.652
0	.3249	8.252	.340	8.636
1	.2893	7.348	.300	7.620
2	.2576	6.543	.284	7.214
3	.2294	5.827	.259	6.579
4	.2043	5.189	.238	6.045
5	.1819	4.620	.220	5.588
6	.1620	4.115	.203	5.156
7	.1443	3.665	.180	4.572
8	.1285	3.264	.165	4.191
9	.1144	2.906	.148	3.759
10	.1019	2.588	.134	3.404
11	.09074	2.305	.120	3.048
12	.08081	2.053	.109	2.769
13	.07196	1.828	.095	2.413
14	.06408	1.628	.083	2.108
15	.05707	1.450	.072	1.829
16	.05082	1.291	.065	1.651
17	.04526	1.150	.058	1.473
18	.04030	1.024	.049	1.245
19	.03589	.912	.042	1.067
20	.03196	.812	.035	.889
21	.02846	.723	.032	.813
22	.02535	.644	.028	.711
23	.02257	.573	.025	.635
24	.02010	.511	.022	.559
25	.01790	.455	.020	.508
26	.01594	.405	.018	.457
27	.01420	.361	.016	.406
28	.01264	.321	.014	.356
29	.01126	.286	.013	.330
30	.01003	.255	.012	.305
31	.008928	.227	.010	.254
32	.007950	.202	.009	.229
33	.007080	.180	.008	.203
34	.006305	.160	.007	.178
35	.005615	.143	.055	.127
36	.005000	.127	.004	.102
37	.004453	.113		
38	.003965	.101		
39	.003531	.090		
40	.003145	.080		
41	.002800	.071		
42	.002494	.063		
43	.002221	.056		
44	.001978	.050		

Index